From earth to sky, the region is unsurpassed in wonders.
The star-filled nights and natural quiet of the Bears Ears
area transport visitors to an earlier eon. Protection of
the Bears Ears area will preserve its cultural, prehistoric,
and historic legacy and maintain its diverse array of natural
and scientific resources . . . for the benefit of all Americans.

—FROM THE *PRESIDENTIAL PROCLAMATION: ESTABLISHMENT OF BEARS
EARS NATIONAL MONUMENT* (DECEMBER 28, 2016), BY BARACK OBAMA,
44TH PRESIDENT OF THE UNITED STATES OF AMERICA

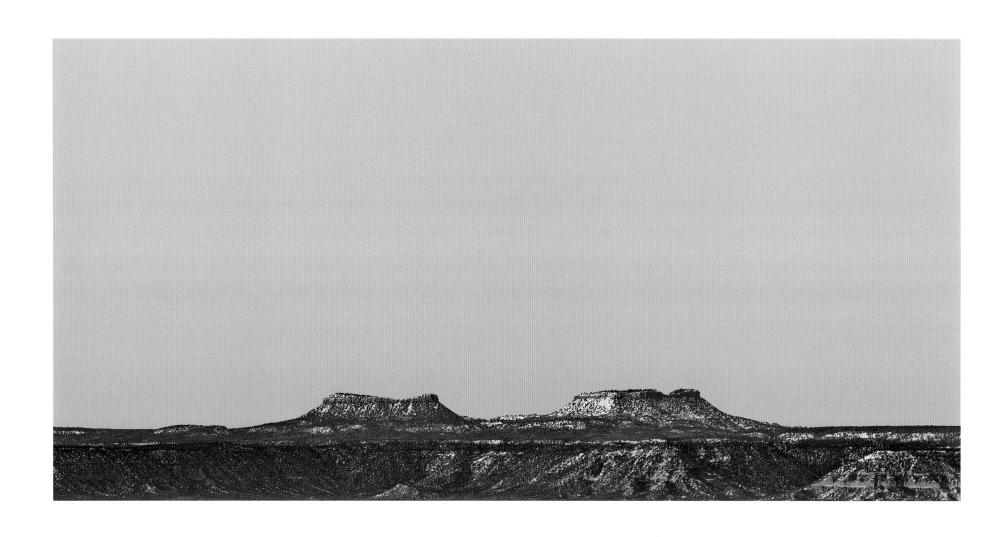

THE TWIN BUTTES KNOWN AS BEARS EARS, SACRED COUNTRY TO ALL WHO HAVE CALLED THE AREA THEIR HOME.

BEARS EARS

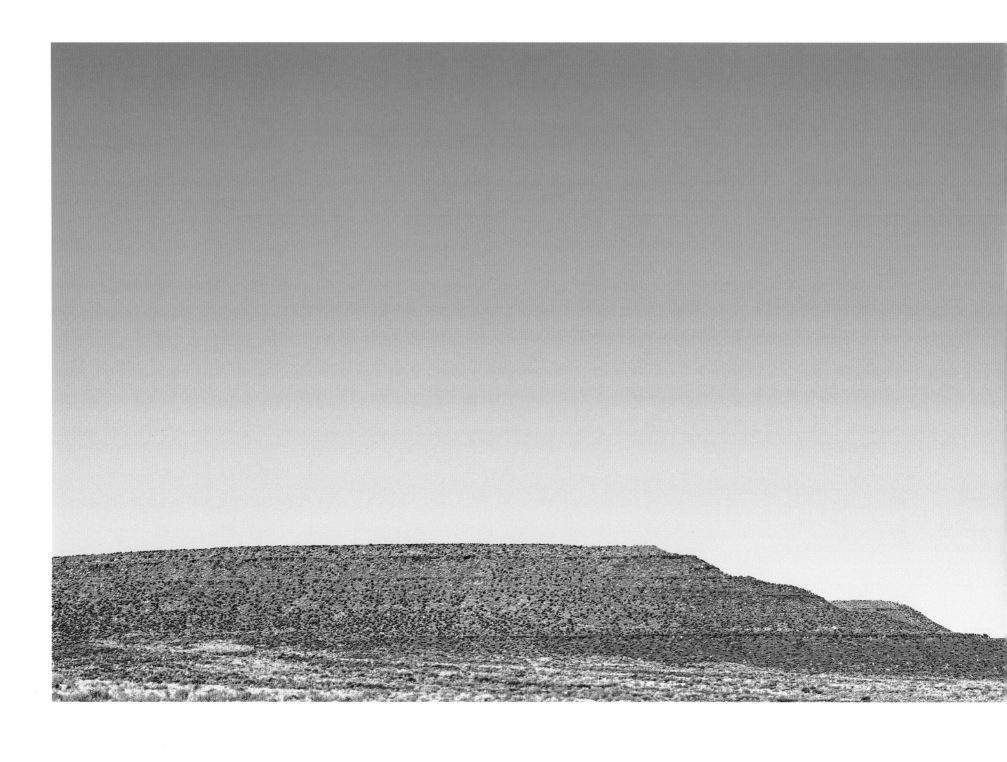

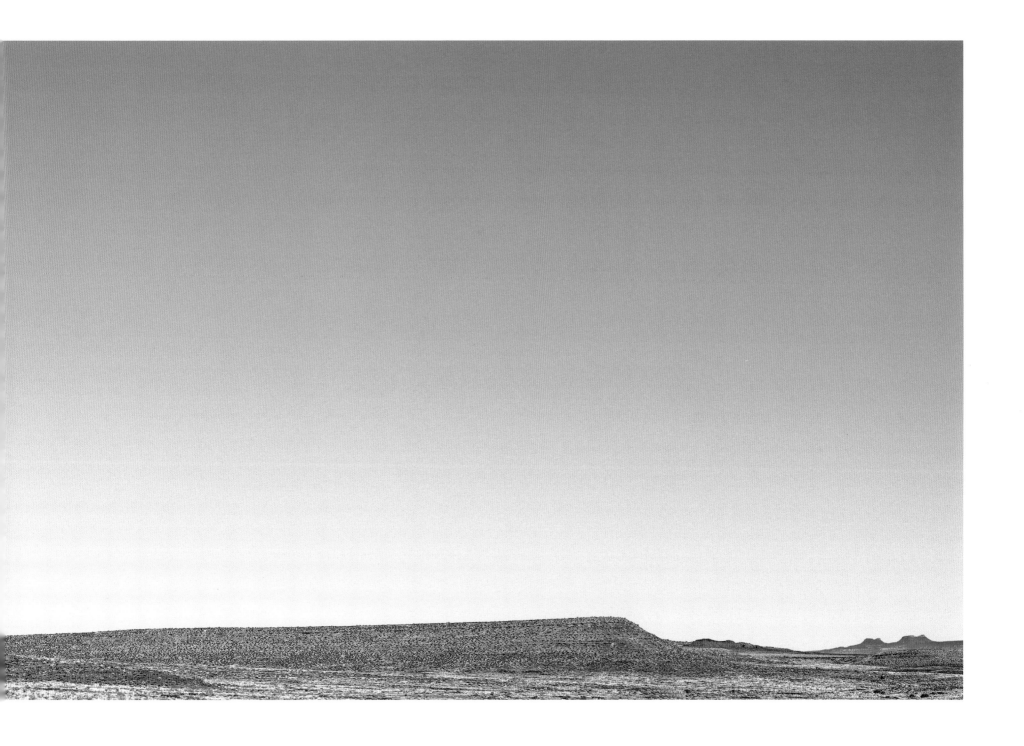

MESAS, WITH BEARS EARS (TWIN BUTTES, FAR RIGHT) IN THE DISTANCE.

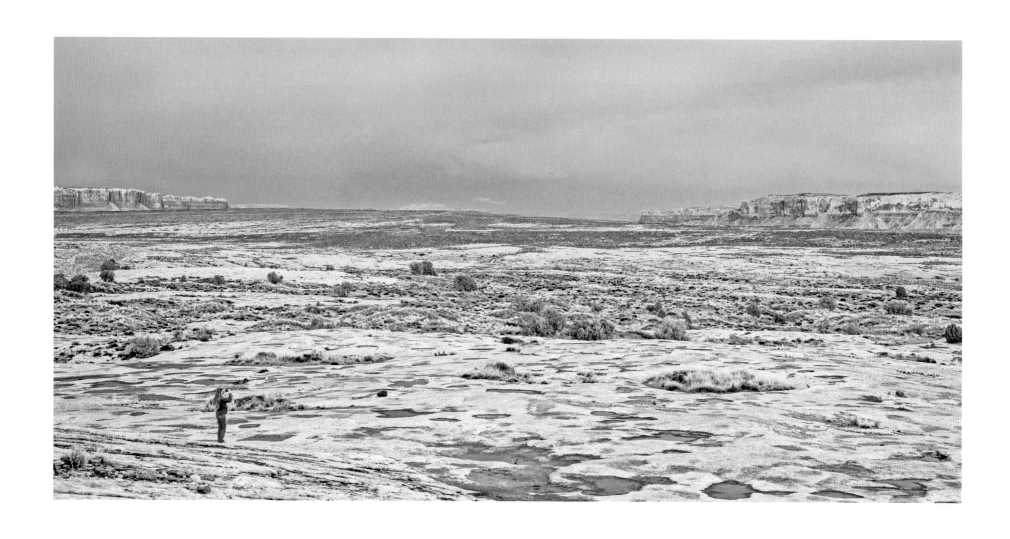

REBECCA M. ROBINSON TAKING A PHOTO LOOKING EAST FROM COMB RIDGE AT MESAS WEST OF BLUFF.

BEARS EARS

VIEWS FROM A SACRED LAND

PHOTOGRAPHS and TEXT by Stephen E. Strom

INTRODUCTION by Rebecca M. Robinson

POEM by Joy Harjo

GEORGE F. THOMPSON PUBLISHING
in association with
THE AMERICAN LAND PUBLISHING PROJECT

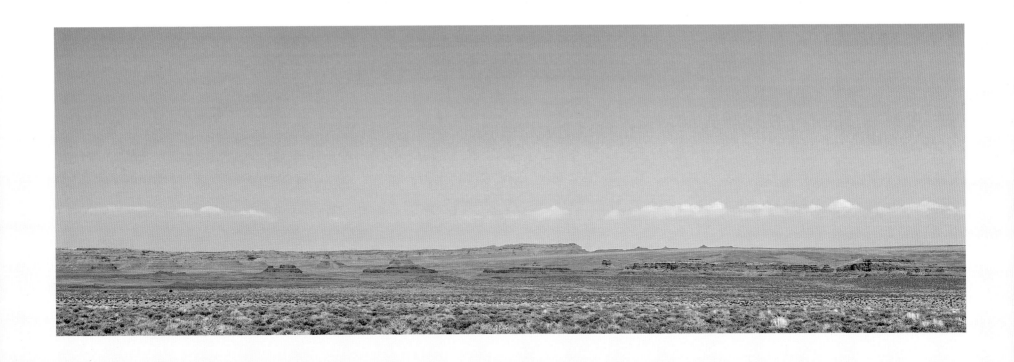

VALLEY OF THE GODS.

We dedicate this book to those who embrace the quest to find common ground on this sacred land. May Bears Ears serve as a meeting place where historical wounds can heal and future generations can nourish their souls.

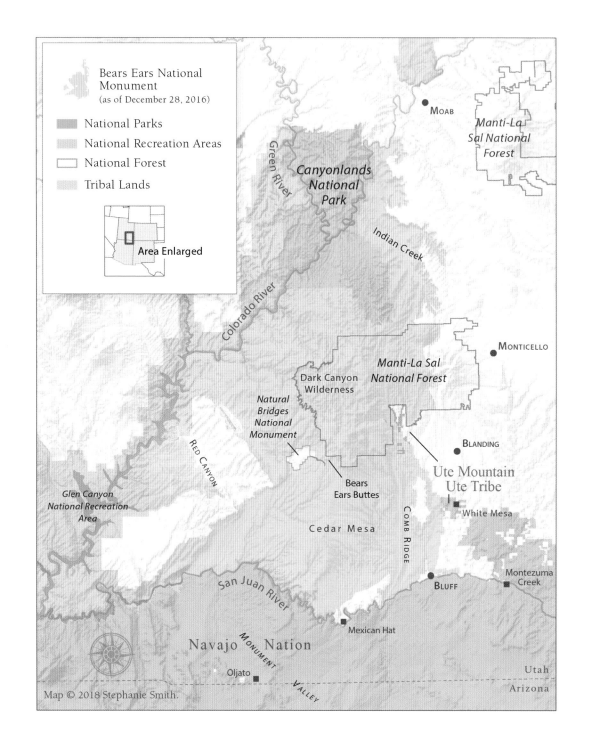

CONTENTS

Introduction: The Story of Bears Ears 13
BY REBECCA M. ROBINSON

Let There Be No Regrets 22
BY JOY HARJO

The Photographic Journey 25
BY STEPHEN E. STROM

Photographer's Reflection: A History of the Colorado Plateau 221
BY STEPHEN E. STROM

About the Craft 233

Credits 235

Acknowledgments 237

About the Author, Essayist, and Poet 239

About the Book 240

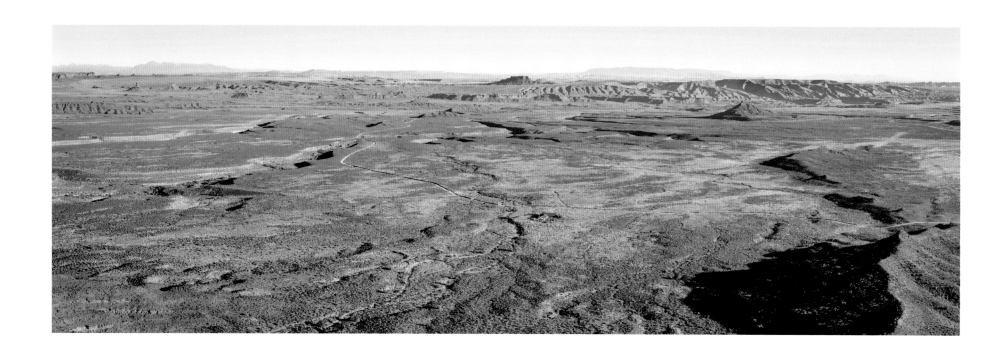

This is everybody's land. We're all God's children. This is all of us.

—JONAH YELLOWMAN
SPIRITUAL ADVISOR, UTAH DINÉ BIKÉYAH

The Story of Bears Ears

Rebecca M. Robinson

Should an eighth wonder of the world ever be proclaimed, a strong case could be made for the landscape of southeastern Utah, a region so striking it has become a visual shorthand for the wild majesty of the American West. Visitors to Utah's portion of the Four Corners region find themselves mesmerized by its endless ridges, buttes, spires, natural bridges, and exquisite canyons—each one, like a sandstone fingerprint, completely unique.

The vivid vermillion hues that define the region's red-rock country are complemented by softer, cream-colored layers and the subtle green of sagebrush, whose ubiquity and resilience testify to stubborn survival in a harsh land. This vast terrain bears scars as well: of explosive emergence and tectonic shifts that shaped Earth into otherworldly formations of stark cinder cones, rainbow bentonite hills, and impossibly steep anticlines. These landmarks, formed millions of years ago, painted and sculpted by water and wind, provide a visible record of deep time.

Evidence of the prehistoric abounds in the region. Fossils of plant and marine life, along with those of early amphibians and mammals, inspire awe in visitors and scholars alike. The stories of eons past, preserved within the layered landscape, illuminate how life on the Colorado Plateau—of which Bears Ears is a part—evolved and adapted to the land's slow march northward from the equator as it endured radical shifts in climate and inundations by oceans and inland seas. Today's rich and diverse assemblage of plant and animal life is as fragile as it is tenacious. Each patch of lichen, herd of mule deer, and field of sagebrush plays a vital role in a delicately balanced ecosystem in which Nature's rhythms must be respected to ensure their survival.

Talk to people who know and love this landscape, and you'll quickly discover that it's impossible for them to describe a favorite canyon, trail, or vista without a touch of reverence. Sometimes they will point, tracing the path of a raptor or the

meanders of a river. Some will subconsciously place their hands over their heart, an unspoken expression of deep love for a land that lives within them—and, in some cases, changed them forever.

Connection to the land is profound, especially for the Native Americans who live here and for members of tribes whose Pueblo ancestors migrated to present-day Arizona and New Mexico but whose physical and spiritual ties to the region endure.[1] For them, the land is sacred, and Earth is a living, breathing entity that must be cared for, protected, and respected for what it provides.

In a landscape that often seems empty, one is constantly reminded that Native Americans made a life here long before there was a United States of America or a state of Utah. Hidden within labyrinths of canyons lies evidence of ancient civilizations—dwellings, utensils, pots, tools, and jewelry—artifacts that bear silent witness to the ancestors of today's Pueblo peoples. As deeply spiritual people, they believe these sites are still inhabited by the spirits of those who came before them. Within this land, too, are faded tipi rings and half-collapsed hogans, evidence of the presence of early Ute, Paiute, and Navajo peoples. Their descendants are still here, continuing to draw spiritual and material sustenance from the land.

The descendants of Anglo Mormons who settled the region in 1880 also express a deep spiritual attachment to the land. Called by the leaders of the Church of Jesus Christ of Latter-day Saints to establish a settlement in southeastern Utah, Mormon pioneers traversed some of the harshest terrain in the West, chiseling paths down steep canyons and up the other side and negotiating wagons through narrow passageways. The successful completion of an arduous six-month journey, enshrined in local Mormon lore, reinforced their belief that the land was given to them by God to steward and use for generations to come. Weathered cattle corrals and long-abandoned log cabins dot thousands of square miles of open range, visual testimony to the early lives of these pioneers in what is now San Juan County, Utah, an area the size of New Jersey in the state's southeastern corner.

This land of rugged beauty and rich history is Bears Ears, a new national monument declared by President Barack Obama on December 28, 2016, invoking his powers under the Antiquities Act of 1906. Named for twin buttes visible for sixty miles in all directions, Bears Ears National Monument protects an area spanning 1,350,000 acres—more than 2,000 square miles; larger than the state of Delaware. "From earth to sky, the region is unsurpassed in wonders. The star-filled nights and natural quiet of the Bears Ears area transport visitors to an earlier eon," the presi-

dential proclamation states, noting the importance of preserving the region's dark skies, silence, and remoteness. "Protection of the Bears Ears area will preserve its cultural, prehistoric, and historic legacy and maintain its diverse array of natural and scientific resources . . . for the benefit of all Americans."[2]

Significantly, the declaration of the monument provides Native Americans with a powerful voice in managing Bears Ears, whose lands contain the history of their settlements, cultural evolution, and adaptation to a harsh and sometimes unforgiving environment. Representatives of the tribes with current and ancestral ties to the area—the Hopi, Navajo, Ute Mountain Ute, Zuni, and Ute Indian Tribe of the Uintah Ouray, whose leaders formed the Bears Ears Inter-Tribal Coalition—will, for the first time in U.S. history, work with their federal counterparts to set policies for preserving ancestral sites and artifacts and for ensuring continued access to monument lands for traditional cultural and spiritual uses. The proclamation's assertion that Native Americans' traditional ecological knowledge "is, itself, a resource to be protected and used in understanding and managing land" represents a powerful acknowledgment of the role the Coalition will play in developing culturally sensitive guidelines for land use.[3]

The Inter-Tribal Coalition's collaborative management arrangement with the federal government represents far more than a political victory. In advocating for a joint role in managing Bears Ears, the tribes articulated a message of healing between American Indian nations and the federal government: not a forgetting of the injustices perpetrated against Native Americans but a willingness to move beyond them in service of working together to achieve a common goal of land protection and stewardship for all Americans. The tribes' newly forged unity as a coalition of sovereign nations not only provides them with a stronger voice in representing their views to the federal government; it also strengthens the bonds between them and holds the potential for beginning a process of healing current-day and centuries-old inter-tribal divisions.

Tribal knowledge of the riches and perils of the natural world, woven into the fabric of their cultures, has been passed down over millennia through generations of storytellers and healers with an intimate relationship to place. Native elders and spiritual leaders know the rhythms of the seasons, where to find firewood, water sources, plants, and animals that provide essential resources and remedies for ailments physical and spiritual.

There is a growing awareness and appreciation of how such traditional ecological knowledge can inform scientific approaches to addressing long-term changes in

temperature and precipitation—an issue of some urgency, given the prospect of a hotter, drier Southwest anticipated by all but a few scientists studying the potential effects of climate change on the region. Traditional knowledge can be used in concert with Western scientific tools to imagine how to adapt our current ways of living on the land to what may become a new normal.

The declaration of Bears Ears National Monument represents the culmination of conservation efforts spanning more than a century. Indeed, it was the illegal looting of archaeological resources in the Four Corners region, including sacred places in the shadow of Bears Ears, that inspired President Theodore Roosevelt (1858–1919) to craft and sign into law the Antiquities Act: an act passed in 1906 by the 59th Congress that provides the President of the United States with the ability to create national monuments to protect historically, archaeologically, and geologically significant landscapes and regions across the United States. All but one of Utah's national parks began as a national monument.

The story of how Bears Ears received protection as a national monument is anchored, appropriately, in indigenous traditional knowledge and native resilience. Starting in 2010, a group of Navajos who live in the northernmost part of the Navajo Nation, in southeastern Utah, set out to make a compelling case for protection of a regional landscape they have considered sacred since time immemorial. They began by collecting stories and documenting traditional knowledge to create a database of cultural resources—including hunting grounds, sacred and ceremonial sites, and areas for collecting medicinal plants and firewood—in and near the land that would eventually become Bears Ears National Monument. As the group accelerated its cultural mapping efforts, it incorporated as Utah Diné Bikéyah ("People's Sacred Lands" in Navajo).

Elders shared a history of their people, rooted in place. They imparted traditional stories of times long past and also spoke of the deep pain and loss experienced by their people during the past 150 years. In the 1860s, the U.S. Army forced the Navajo off their lands in present-day northeastern Arizona and marched them hundreds of miles south on what became known as the Long Walk, in which many died and countless suffered. For many decades, the federal government pursued a policy of cultural assimilation: taking native youth from their homes and placing them in government-run boarding schools and penalizing native youth for speaking their language, all part of a plan to eradicate native culture. If the Navajo could secure protection for lands they consider sacred and a critical part of their cultural

heritage, it would represent a first step toward healing multigenerational wounds of the first Americans.

In partnership with the Navajo Nation, Utah Diné Bikéyah (UDB) for years attempted to forge a compromise with local, state, and federal elected officials. They sought an agreement that would honor tribes' connection to and uses of public lands within San Juan County while keeping some areas open for ranching, mining, and oil and gas drilling. But, in the end, UDB's board and staff came to believe they were ignored or disrespected by Utah's politicians, who, in their eyes, cared more about short-term gain from resource extraction than protecting land for future generations.

Still determined to have their voices heard, UDB turned to sovereign tribal nations that, in addition to the Navajo Nation, lived within or had ancestral ties to the Bears Ears region: the Hopi, Zuni, Ute Mountain Ute, and Ute Indian Tribe of the Uintah and Ouray. After meetings between tribal leaders, the tribes put aside past and present inter-tribal conflicts to advocate for protection of Bears Ears. They viewed collective action as essential to preserving their common cultural, historical, and spiritual connections to the land and for protecting it from development, looting, and further desecration.

Following months of negotiation, the tribes formalized creation of the Bears Ears Inter-Tribal Coalition in July 2015. Shortly thereafter, they submitted a proposal for a 1,900,000-acre Bears Ears National Monument to then-President Barack Obama. Essential to the proposal was a plan for co-management of the monument by the tribes and the federal agencies—the Bureau of Land Management and the U.S. Forest Service—tasked with stewarding the land.

The campaign for the national monument was supported by many environmental organizations, outdoor-recreation groups, and large outdoor-industry retailers. It was heralded by advocates not only as an opportunity to protect a spectacular landscape along with its archaeological treasures, but as an historic example of tribes asserting their sovereign rights to negotiate directly with the federal government. By contrast, efforts to preserve the area around Bears Ears as a national monument was generally and even forcefully opposed by San Juan County's and the state's most prominent elected officials, who called it an attempt at a federal "land grab" that ignored the opinions and needs of many citizens as well as *their* cultural attachments to the land.

As the clock wound down on the Obama administration's final weeks in office, there was still uncertainty as to when and whether the outgoing President would designate a monument. The tribal leaders prayed for guidance and strength to

the Higher Power who had called each of them to lead the coalition. Their prayers were answered on December 28, 2016, when President Obama declared Bears Ears National Monument, protecting 1,350,000 acres from future development and calling for a tribal commission to guide the monument's policies and practices in collaboration with federal agencies.

Even as the new national monument was celebrated by tribes, environmentalists, and many conservation-minded citizens and businesses throughout the region and nation, Utah's political leadership bitterly denounced the monument as yet another example of federal overreach and urged President Trump's administration to reduce the size of Bears Ears drastically or even rescind the designation. And while many citizens in towns surrounding the monument feared that their economic future and, indeed, their way of life would be undermined if plans for the monument went forward, many others noted the economic benefits associated with visitation and tourist dollars to Utah's other national parks and monuments. Still, some of San Juan County's residents claimed that their voices either had not been heard in Washington, D.C., or had been dismissed by those whom they believed have no connection to or understanding of rural life.

Nearly lost among the conflicting stories of celebration and citizen fury was the fact that, in President Obama's consideration of such local concerns, 600,000 acres were excluded from the original 1,900,000 acres proposed by the Indian Nations for the national monument, among them areas that hold potential for resource extraction or are considered culturally significant by San Juan County's large Mormon population. But political polarization, coupled with heated ideological rhetoric, masked essential truths and drove the two sides farther apart in the all-too-familiar duality of "us" versus "them."

In response to President Donald J. Trump's executive order to Secretary of the Interior Ryan Zinkle in April 2017 that he review the size and boundaries of 27 of the nation's current 129 national monuments, Zinkle submitted to President Trump on August 24, 2017 a proposal to reduce the size and boundaries of some national monuments, including Bears Ears. The proposed reduction in the size of Bears Ears would be from the 1,350,000 acres designated by President Barack Obama on December 28, 2016 to approximately 160,000 non-contiguous acres. Previous Presidents of the United States have occasionally made modest adjustments—both increases and decreases—to the size of an existing national monument, but no U.S. President or Secretary of the Interior has rescinded or reduced a national monument to such extremes as Interior Secretary Ryan Zinkle proposed for Bears Ears on August 24,

2017. The tribes that lobbied for the designation immediately vowed to sue.[4] If history is a guide, the resulting litigation may extend for the better part of a decade. The ultimate fate of Bears Ears thus likely lies with the courts.

The movement to protect Bears Ears is the product of a unique moment in time, the result of an unprecedented effort by Native American tribes and a powerful endorsement of tribal sovereignty by a receptive U.S. President. At the same time, it is yet another chapter in America's long history of conflicts over how best to protect and steward public lands. Similar debates predate it, and similar struggles will succeed it. Taken together, these debates and attempts to resolve them speak to the ongoing search for common ground in deeply divided communities. But therein lies a sense of hope for the future: Polarized as each group is, they collectively express the same belief that the land is not just a place to live in, explore, or make a living: It is *everything*. The land is a source of strength, renewal, and identity to all who call Bears Ears country home. Natives and Anglos in San Juan County, regardless of their spiritual beliefs or world view, have used the same words to explain their connection to Bears Ears: "The land is who we are."

What both the land and people of Bears Ears country yearn for is healing: between the tribes and the federal government; among the region's tribes who share histories of bitter conflict; among the tribes and residents of San Juan County—Native and Anglo, Mormon and non-Mormon, staunch supporters and steadfast opponents of the national monument; and of the land, protecting an eighth wonder of the world from efforts to exploit its riches for private financial gain.

In many ways, San Juan County's challenge to find common ground and common purpose mirror those of the nation as a whole. True healing can only be achieved through collective listening, respect, compassion, and leadership—an acknowledgment that past wounds are many and, in some cases, shared. The future will depend on the courage of all to speak truths, to commit to hear and respect all voices, and to seek mutual understanding that will allow citizens to create a just and sustainable future that benefits all.

Stephen E. Strom's photographs capture the singular beauty of Bears Ears country in all seasons, its textural subtleties portrayed alongside the drama of expansive landscapes and skies, deep canyons, mystifying spires, and towering mesas. To Strom's alert and sensitive eyes, a scrub oak on a hillside or a pattern in windswept sand is as essential to capturing the spirit of the landscape as the region's most

iconic vistas. In seeing red-rock country through his lens, viewers can begin to discover the rich beauty, remarkable diversity, seductive power, and disarming complexity that embody Bears Ears National Monument's sacred lands.

Strom's photographs attempt to convey what so many have fought to preserve for so long. They document a landscape unlike any other on Earth. Like the land itself, they evince the full spectrum of emotional responses: exhilaration, disorientation, contemplation, serenity, passion, and gratitude for the wild places and archeological treasures that belong to all Americans and that captivate millions of visitors from around the world.[5]

NOTES

1. Whenever possible, Stephen E. Strom and I refer to specific Indian tribes; otherwise, we comply with the National Park Service's guidelines in the general use of "Native Americans" for unspecified or unknown "native peoples."

2. Barack Obama. *Presidential Proclamation: Establishment of the Bears Ears National Monument.* For the complete document, see https://obamawhitehouse. archives.gov (Presidential Actions: Proclamation on December 28, 2016).

3. Ibid.

4. See Julie Turkewitz and Lisa Friedman, "Interior Secretary Proposes Shrinking Four National Monuments," *The New York Times* (August, 24, 2017); Juliet Eilperin and Darryl Fears, "Interior Secretary Recommends Trump Alter at Least Three National Monuments, Including Bears Ears," *The Washington Post* (August 24, 2017); and Kim Baca, "Zinkle Recommends Reducing Bears Ears," *Indian Country Today* (August 29, 2017). All three sources are available online.

5. See, also, our companion book, *Voices from Bears Ears Country: Seeking Common Ground on Sacred Land* (Tucson: University of Arizona Press, in association with George F. Thompson Publishing, 2018), which approaches Bears Ears differently. In *Voices from Bears Ears Country*, the focus is on Robinson's extensive historical narratives and profiles of stakeholders that are complemented by 91 of Strom's color photographs, original maps, and supplementary material.

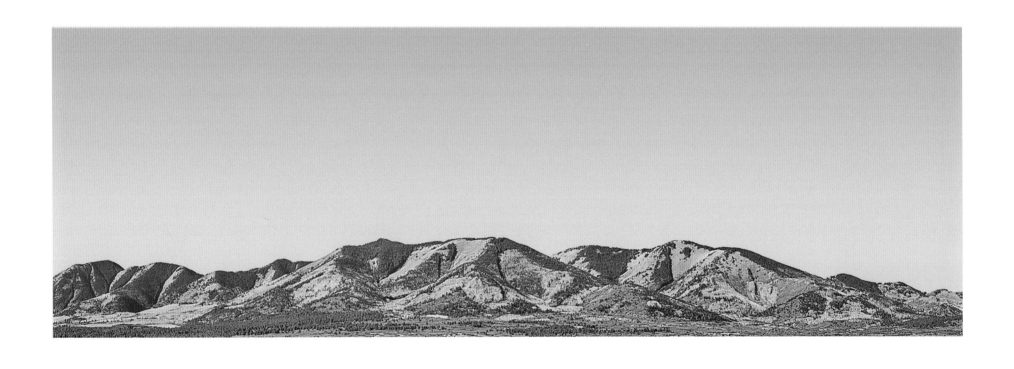

THE ABAJO MOUNTAINS IN AUTUMN.

Let There Be No Regrets

Joy Harjo

A knot of turmoil coils in the dark.
It is struck by light. It makes a heart. The heart sings.
Earth appears, but it is lonely. It aches for another. Sky leans down
And listens, lies down next to curved Earth.
Soon, without time, the elements, plants, and animals emerge.
Humans are much later and are younger in the dreaming.

We are all dreaming.

We used to know the stones, plants, and winds by name.
We grew our food, hunted.
Now our children are struggling to remember who they are, as they become.
The stories and songs they consume are without nourishment.
They are made for money, created to sell cars, processed food, and pharmaceuticals.
Now plastic tumbleweeds of trash line the washes. Broken bottles glitter in the sun.

The songs and stories that formed our bones, blood and earth mind are restless
And need a place to live in the world of our grandchildren.

Earth is still dreaming, though destructive thoughts roam the earth.
They were planted by money hunger. To the destroyers, Earth is not a person.
With their huge shovels and trucks, they will dig more than anyone needs.
Oil will spill over and kill everything but their greed.

They sign papers in their offices, sitting behind their computers, their stacks of money.
They think they have everything, yet they want more and will want more until
There is no more to steal.

Where are the monster slayers to destroy that which would destroy these lands?

Who will be born with precise thoughts honed to a fine point, with an aim directed
By warrior ancestors?

Do not ask these lands about time. There is no word for time in Earth language.
Earth says the destroyers will destroy themselves.

It will storm, and the rain people will dance with lightning. Disturbance will spin violently
In the air. Fierce water will clean the earth after it burns.

This is how we know we will continue, will sing the plants as they called for the rain,
Under the lightening sky. Rainclouds will bend close because they love the singing.
The whole earth will continue lit with this love.

Each of us is a song, a wash of color on a cliff wall.
We are a shimmer in a flick of wind, a tear of rain.

The skin of the earth is all colors. There is no hierarchy of value.

There are no words to adequately speak the beauty of these lands. Birds can sing it.
The winds weave their beauty, and the mountains uphold integrity steadfast.
Human language is often not enough.

Earth architecture is carved by rhythm. Ancient ocean is caught here in memories
Of seashells, fish, and seaweed. The wind keeps the ocean's songs for it,
Until the ocean returns.

So many earth spirits take care of this place. See them emerge from the cliff walls.
Listen to them singing us back into place.

Our ancestors are not only human ancestors. What do you see when you fly to the top
Of the ancestor tree?

Sun wraps in a blanket with red designs. It goes west over the mountains to dream all
possibilities with Earth.

Let there be no regrets, no sadness, no anger, no acts of disturbance to these lands.

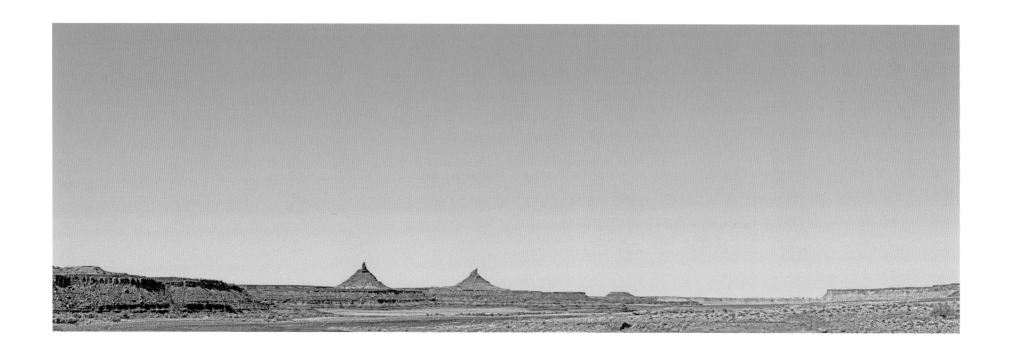

SIX SHOOTER PEAKS WEST OF DUGOUT RANCH.

MESAS and SPIRES

I consider myself a traditional Navajo, having a strong tie to the environment and the earth. I grew up taught how to pray to Mother Earth every day. Earth, air, sun, water.

The river, the water, the sun, the earth, they're all everlasting. They've been here long before us, and they'll be here [long afterwards]. And that's in [our] prayer. In Navajo, we call it "everlasting beauty." When we pray, we close by saying, "May it be in Beauty."

—MARK MARYBOY
NAVAJO AND BOARD MEMBER UTAH DINÉ BIKÉYAH

We share a reverence for our earthly home and all of God's creations. Furthermore, our LDS faith guides us to respect the belief practices of other cultures, especially those closest to us. We intuitively understand that they hold their faith histories to be sacred, just as we do ours.

—TY MARKHAM
MORMON ENVIRONMENTAL STEWARDSHIP ALLIANCE

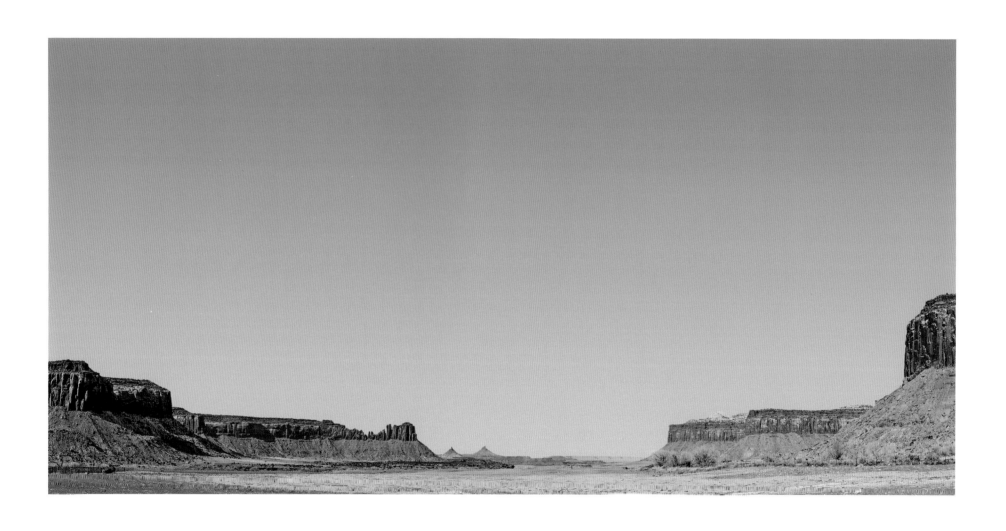

RED MESAS, WITH SIX SHOOTER PEAKS IN THE DISTANCE.

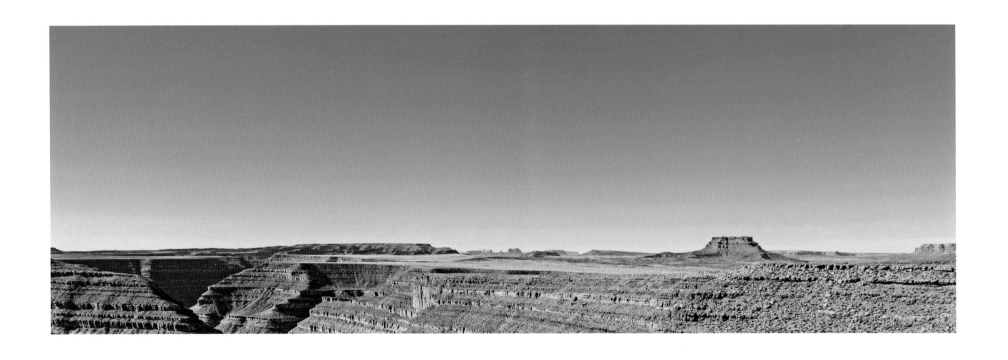

MESAS ALONG GOOSENECKS OF THE SAN JUAN RIVER FROM LIME RIDGE, WITH MONUMENT VALLEY (TOP CENTER) IN THE DISTANCE.

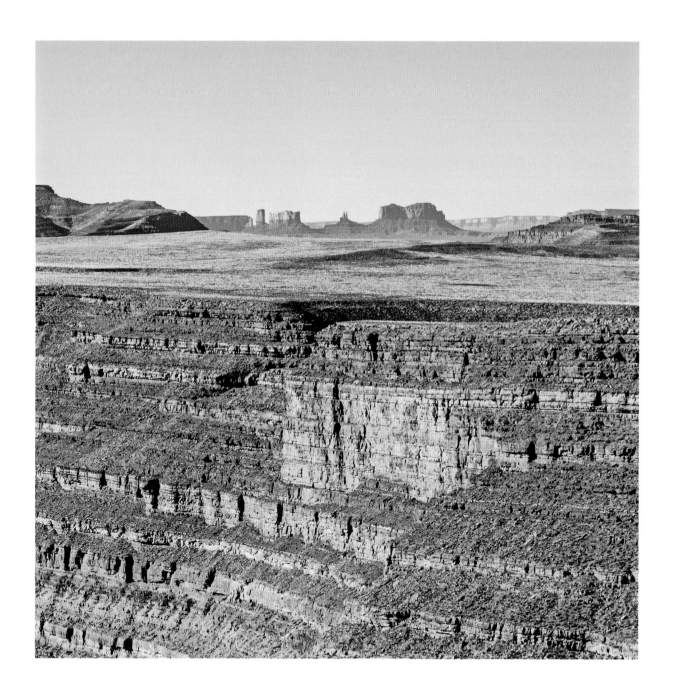

MESA OF THE SAN JUAN RIVER FROM LIME RIDGE, WITH MONUMENT VALLEY IN THE DISTANCE.

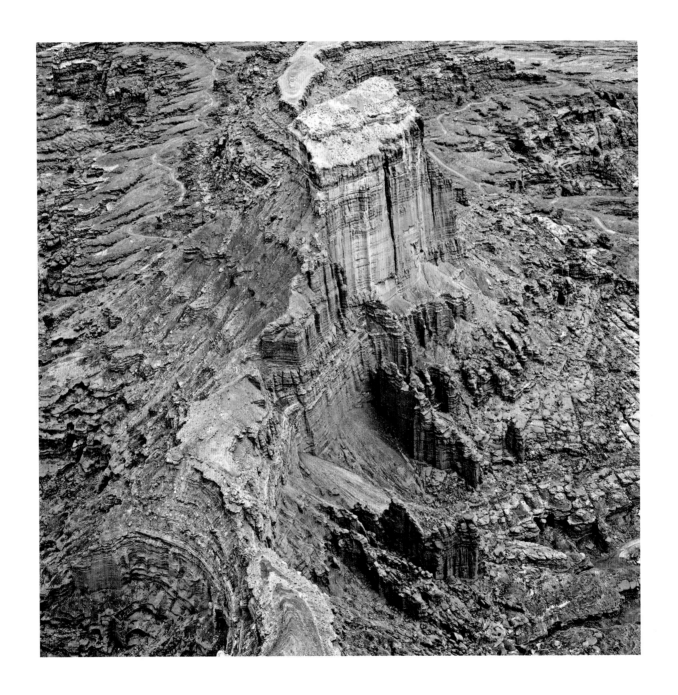

SPIRE NEAR HURRAH PASS ROAD FROM ANTICLINE OVERLOOK.

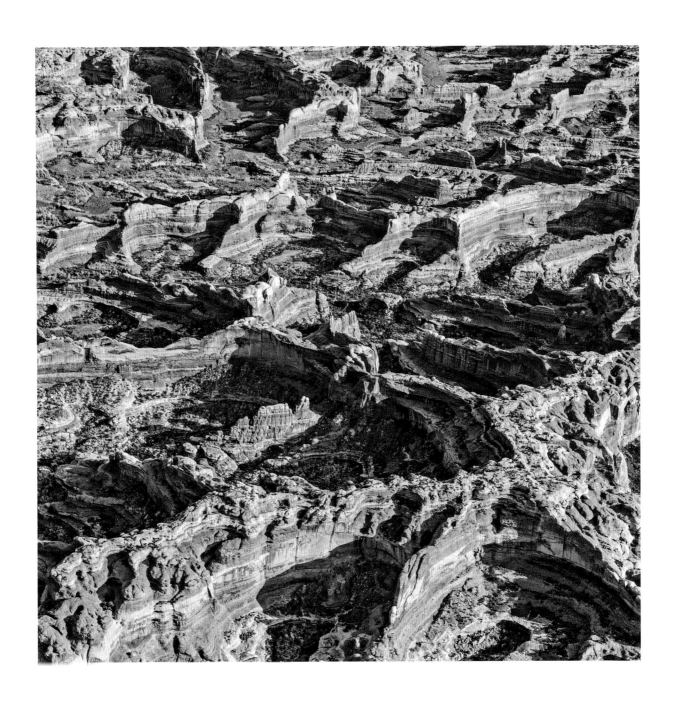

SALT CREEK CANYON (AERIAL IMAGE).

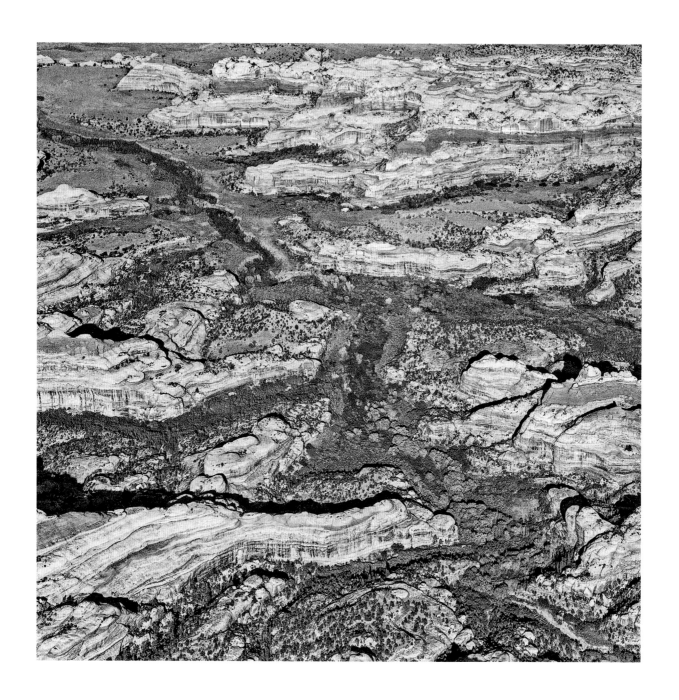

SALT CREEK CANYON (AERIAL IMAGE).

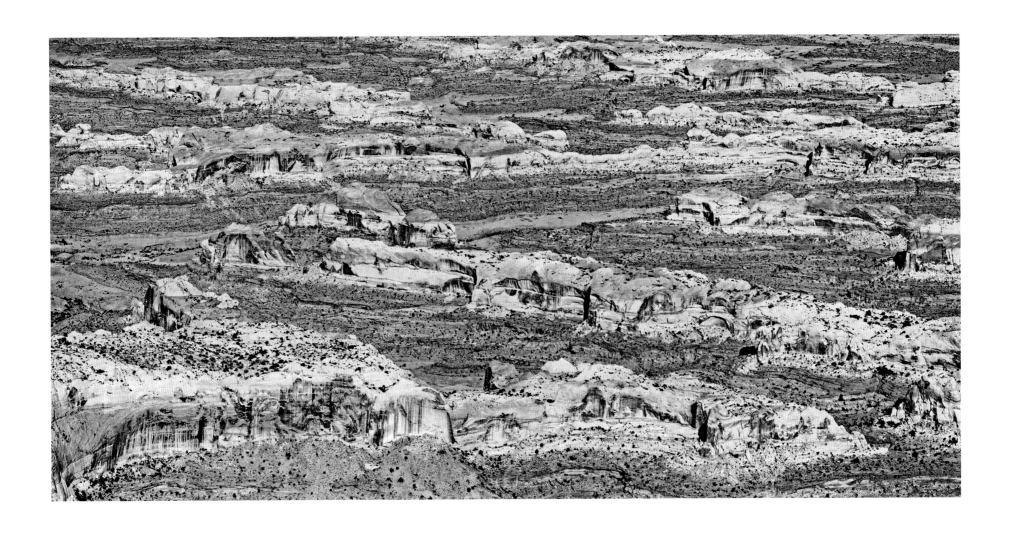

MIDDLE MOODY CANYON FROM AN UNNAMED ROAD.

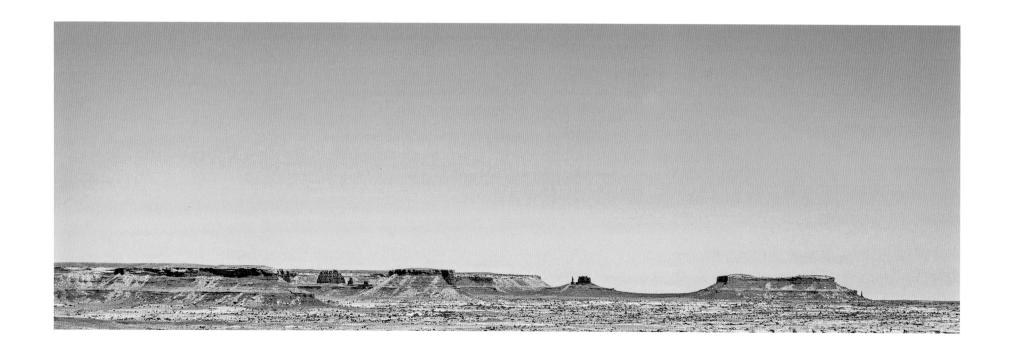

MESAS AND SPIRES LOOKING EAST FROM HITE CROSSING.

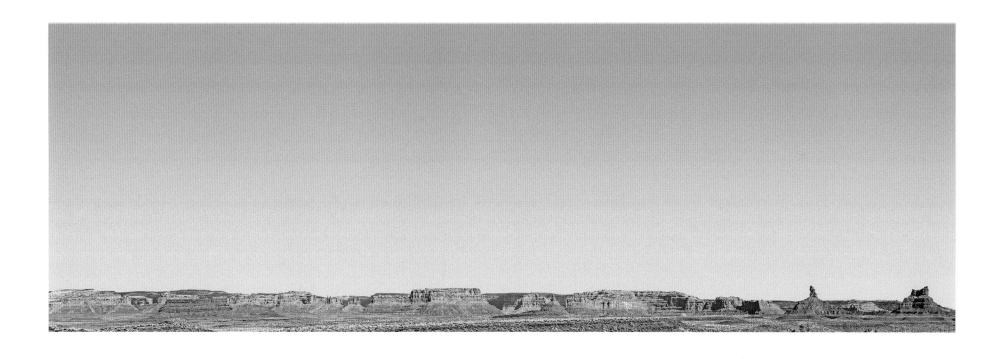

MESAS AND SPIRES LOOKING EAST FROM HITE CROSSING.

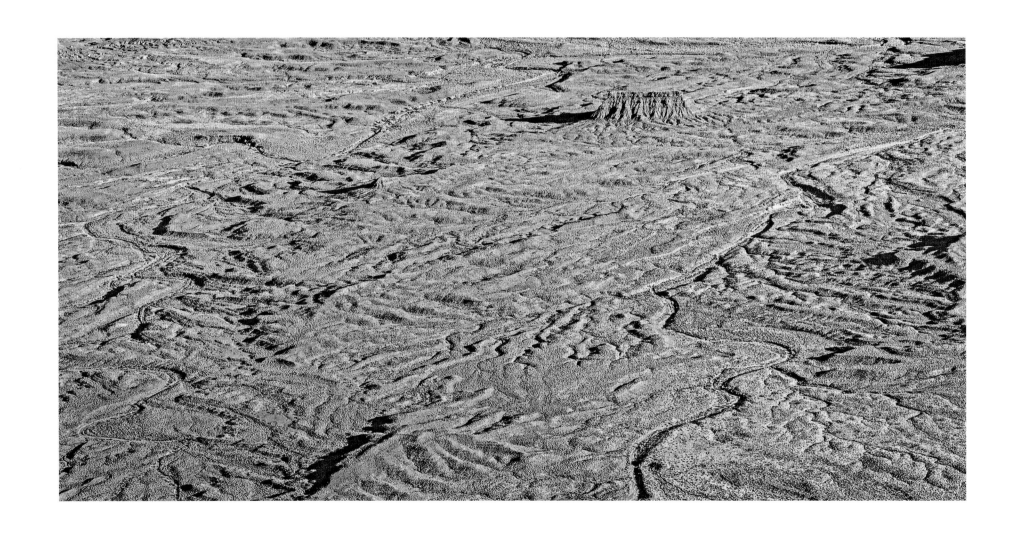

MESA IN VALLEY OF THE GODS (AERIAL IMAGE).

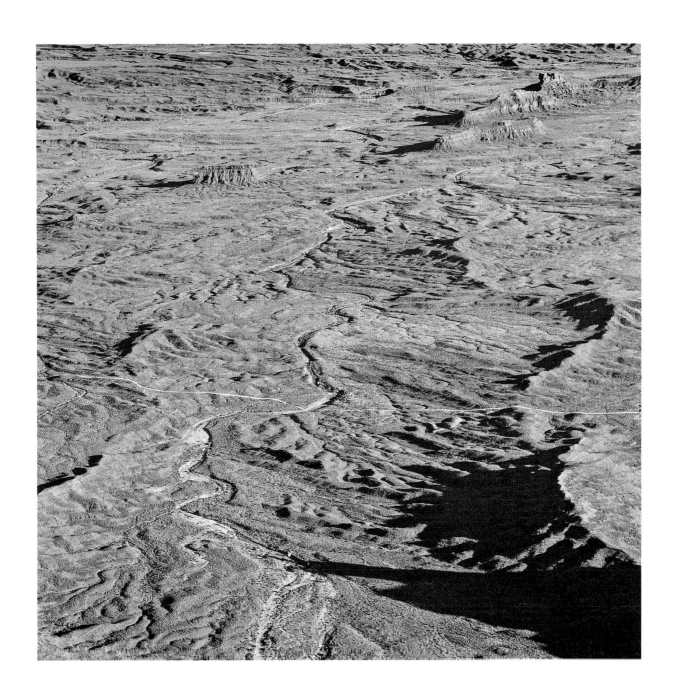

MESAS IN VALLEY OF THE GODS (AERIAL IMAGE)

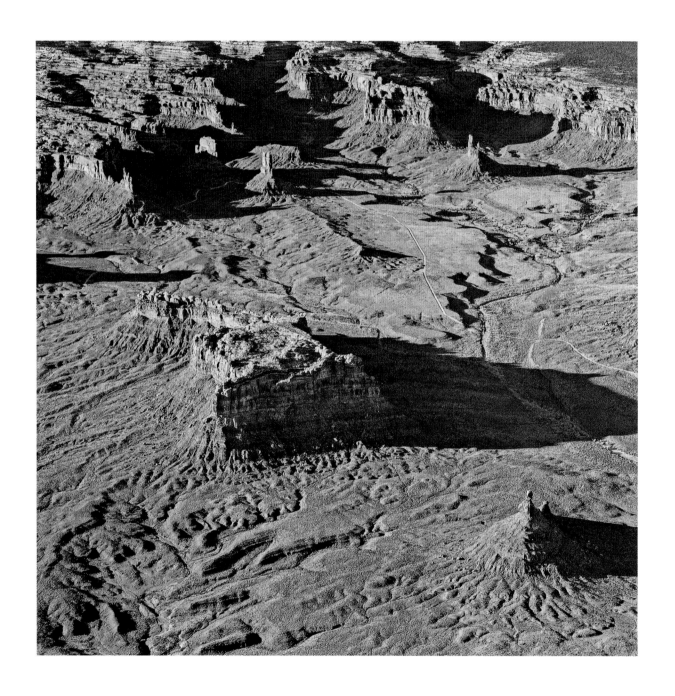

SPIRES AND MESAS IN VALLEY OF THE GODS (AERIAL IMAGE).

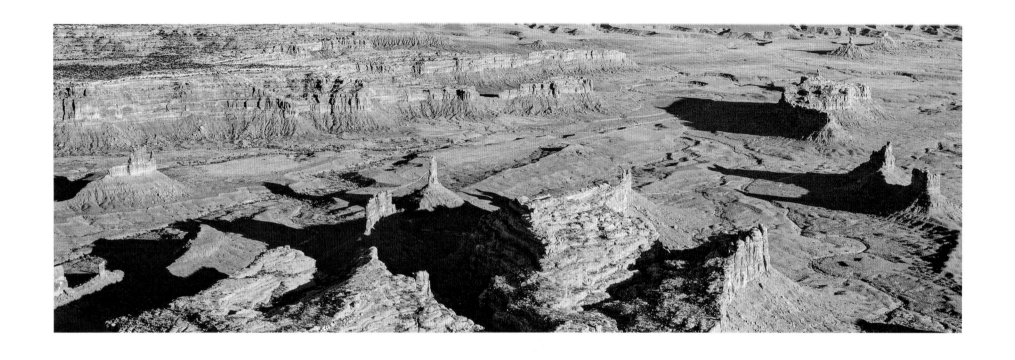

SPIRES AND MESAS IN VALLEY OF THE GODS (AERIAL IMAGE).

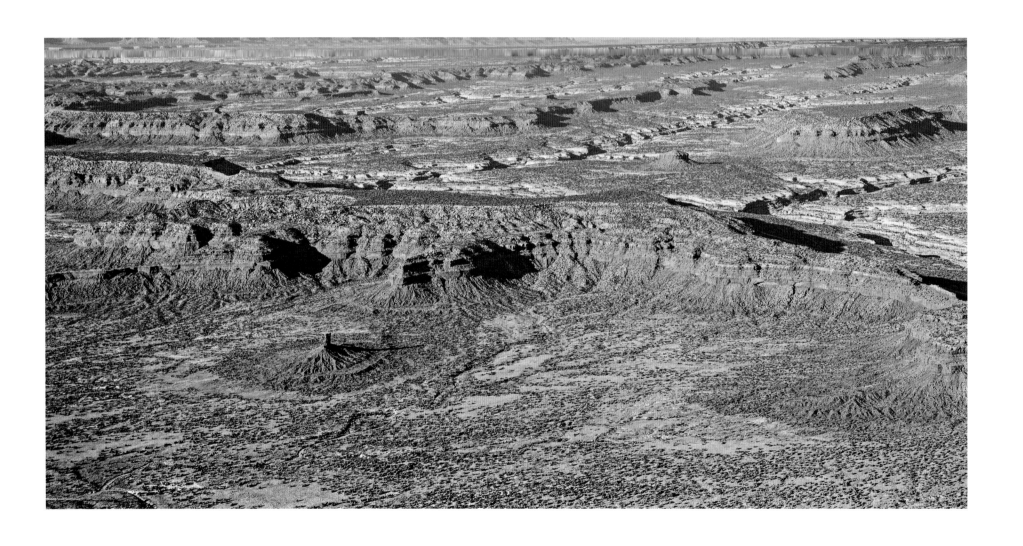

SPIRE AND MESAS NEAR FRY CANYON (AERIAL IMAGE).

CANYONS

Everything is all rooted from our Mother Earth that provides [for us].
Our strong tie to the earth from a very young infancy helps us to pass
along this comfort to our children.

—REGINA LOPEZ-WHITESKUNK
UTE MOUNTAIN UTE

As we nurture and appreciate nature, we will become better acquainted
with our God, for unspoiled nature is designed to inspire and uplift humankind.
Nature in its pristine state brings us closer to God, clears the mind and heart of
the noise and distractions of materialism, lifts us to a higher, more exalted sphere.

—MARCUS NASH
ELDER, CHURCH OF LATTEER DAY SAINTS

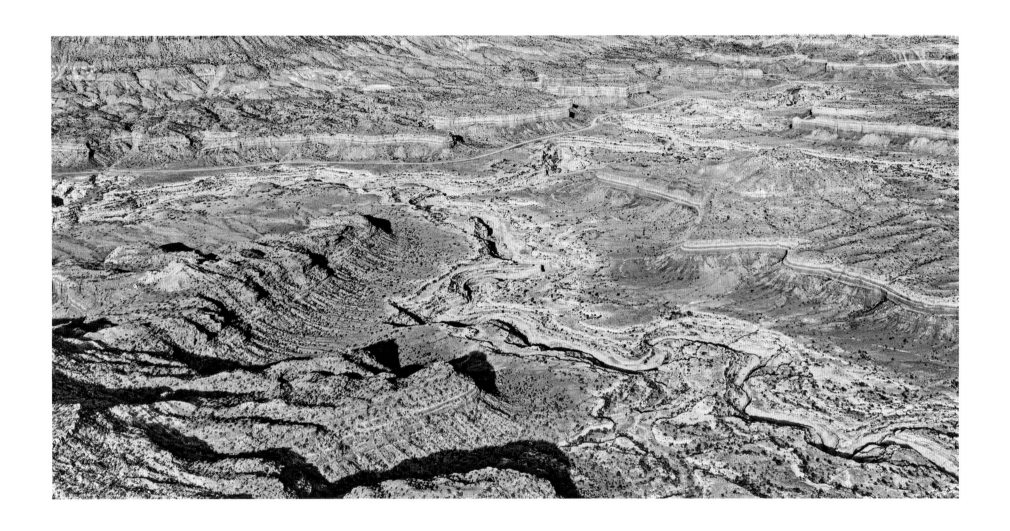

MESAS SURROUNDING WHITE CANYON (AERIAL IMAGE).

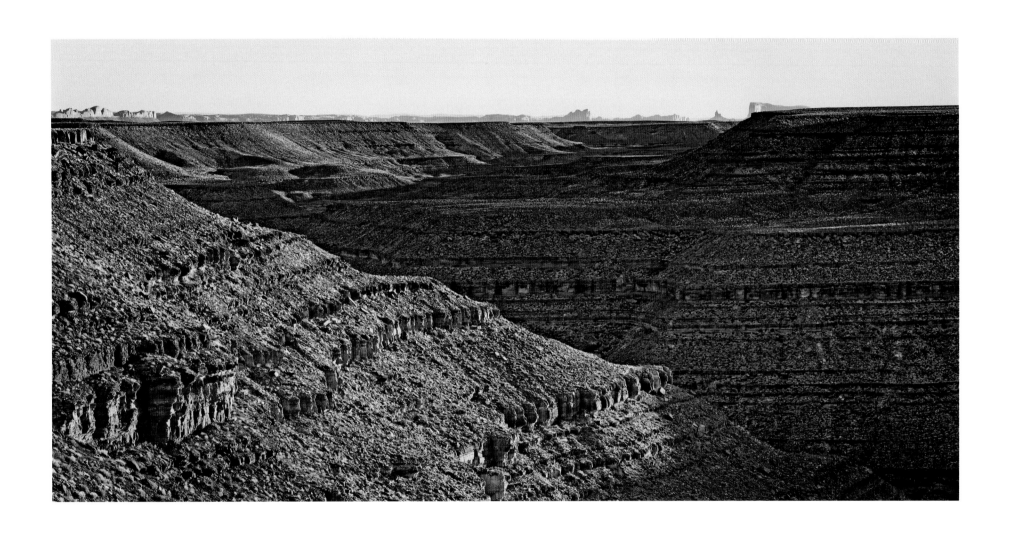

MESAS ALONG GOOSENECKS OF THE SAN JUAN RIVER, WITH MONUMENT VALLEY (TOP RIGHT) IN THE DISTANCE.

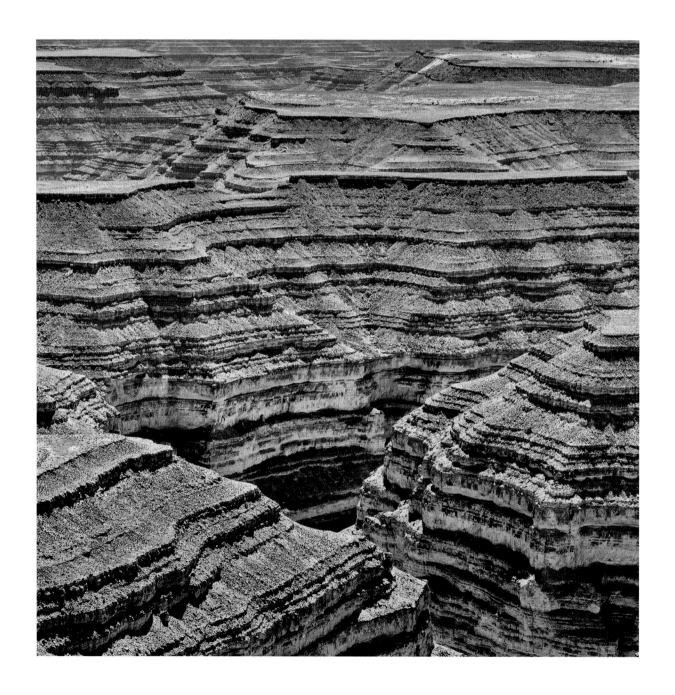

MESAS ALONG GOOSENECKS OF THE SAN JUAN RIVER.

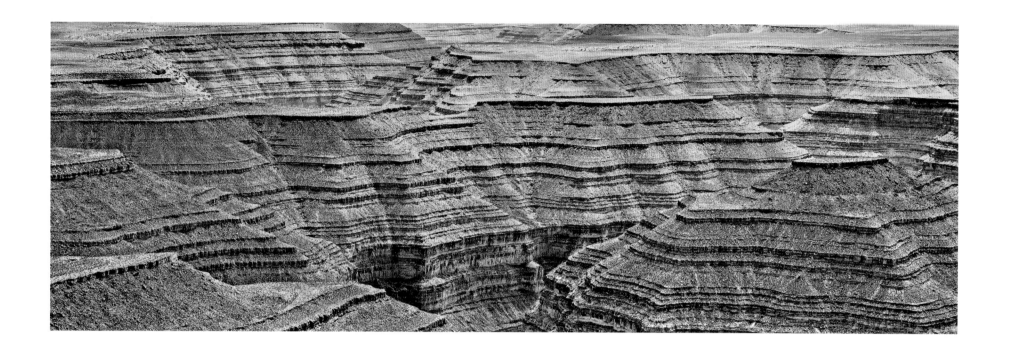

MESAS ALONG GOOSENECKS OF THE SAN JUAN RIVER.

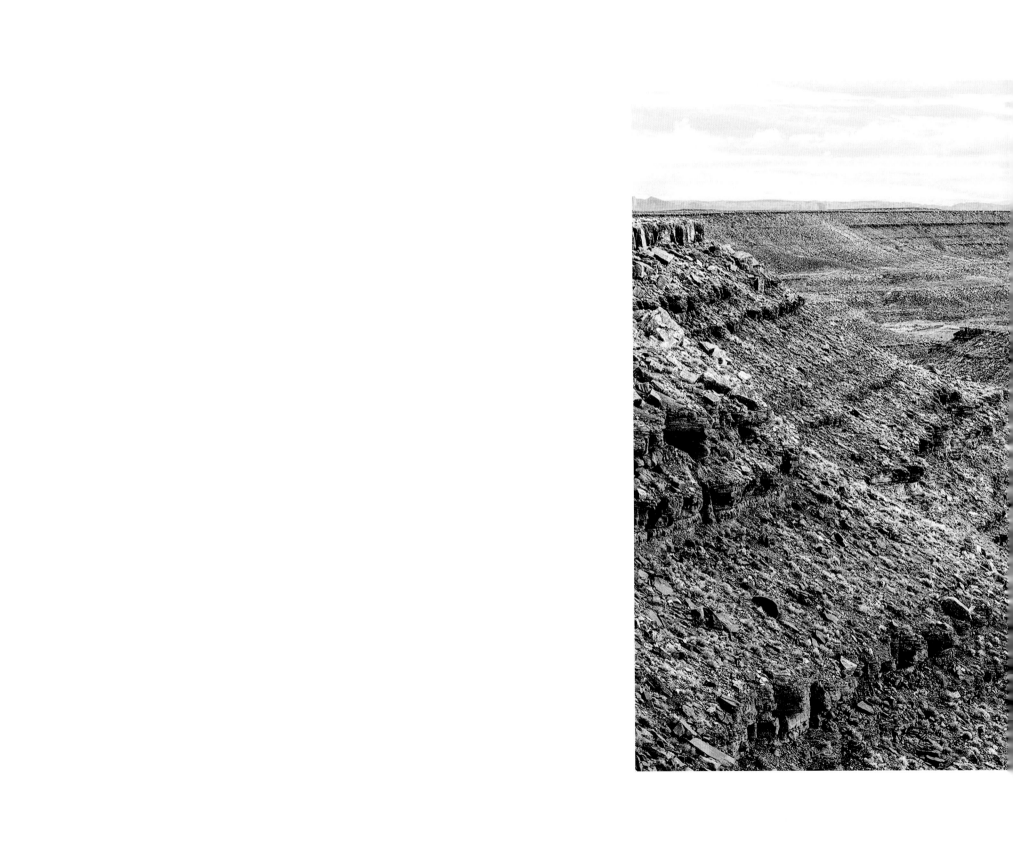

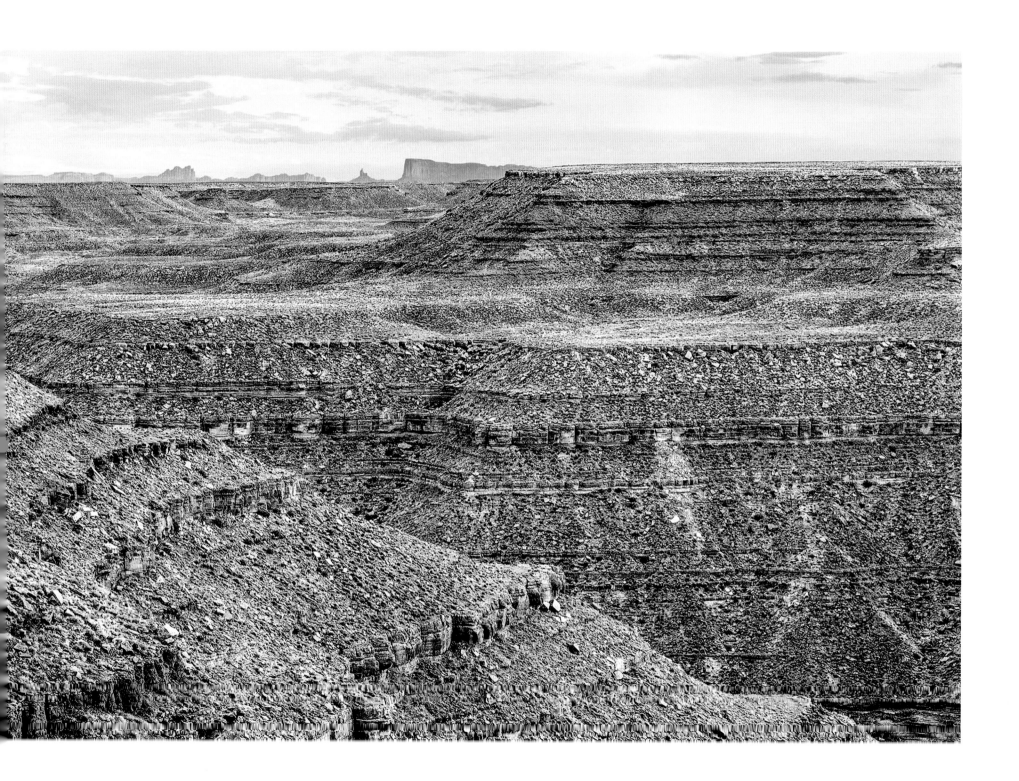

MESAS ALONG GOOSENECKS OF THE SAN JUAN RIVER, WITH MONUMENT VALLEY (TOP CENTER) IN THE DISTANCE.

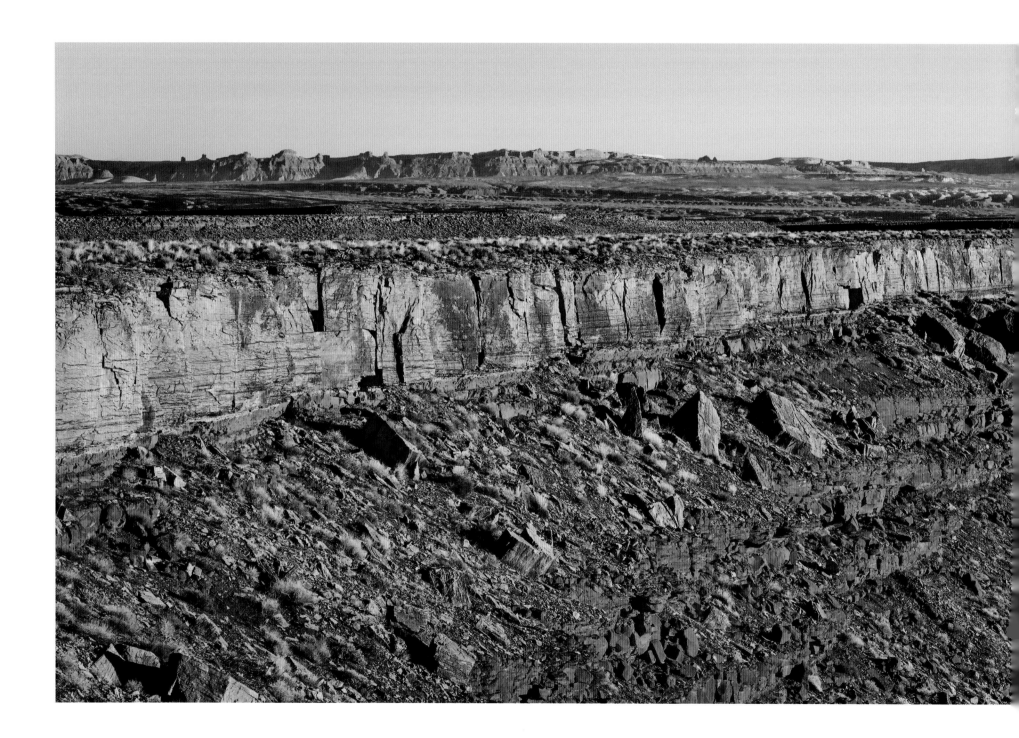

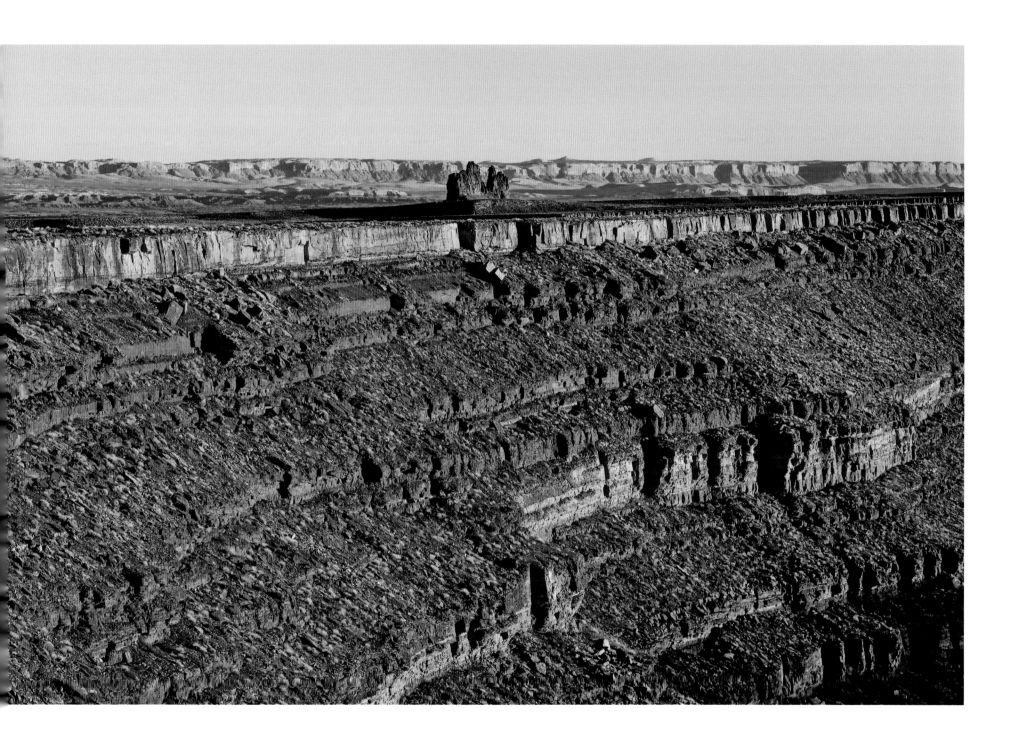

MESAS ALONG GOOSENECKS OF THE SAN JUAN RIVER.

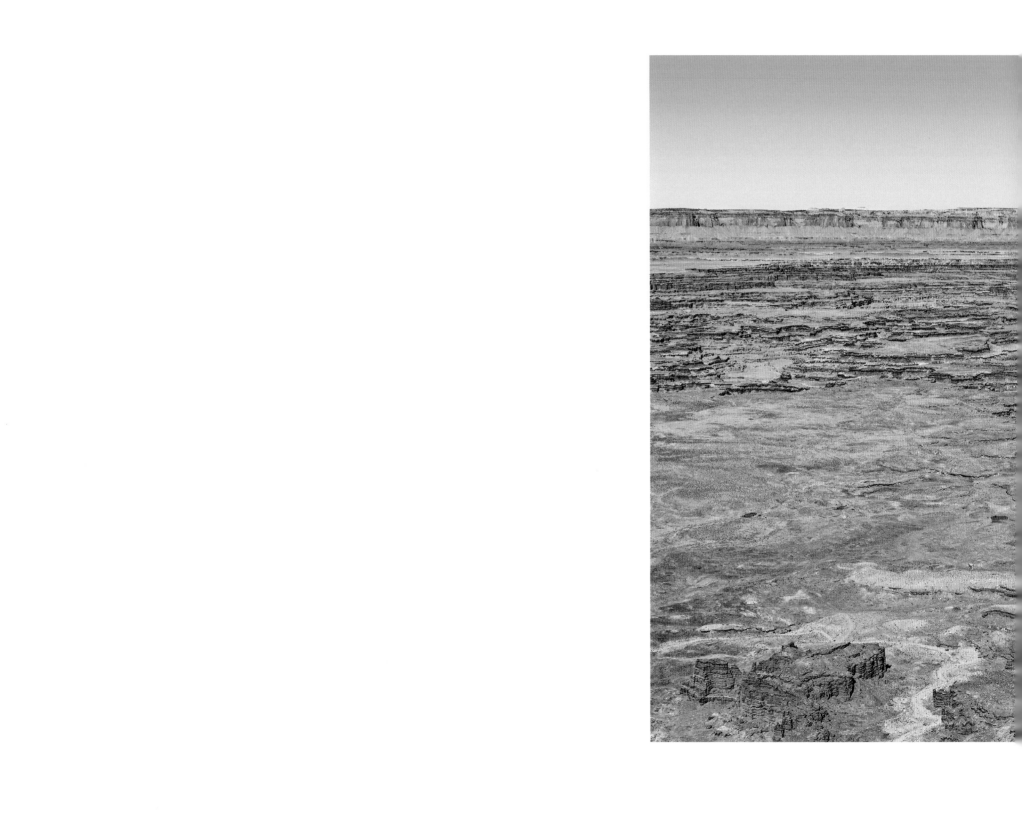

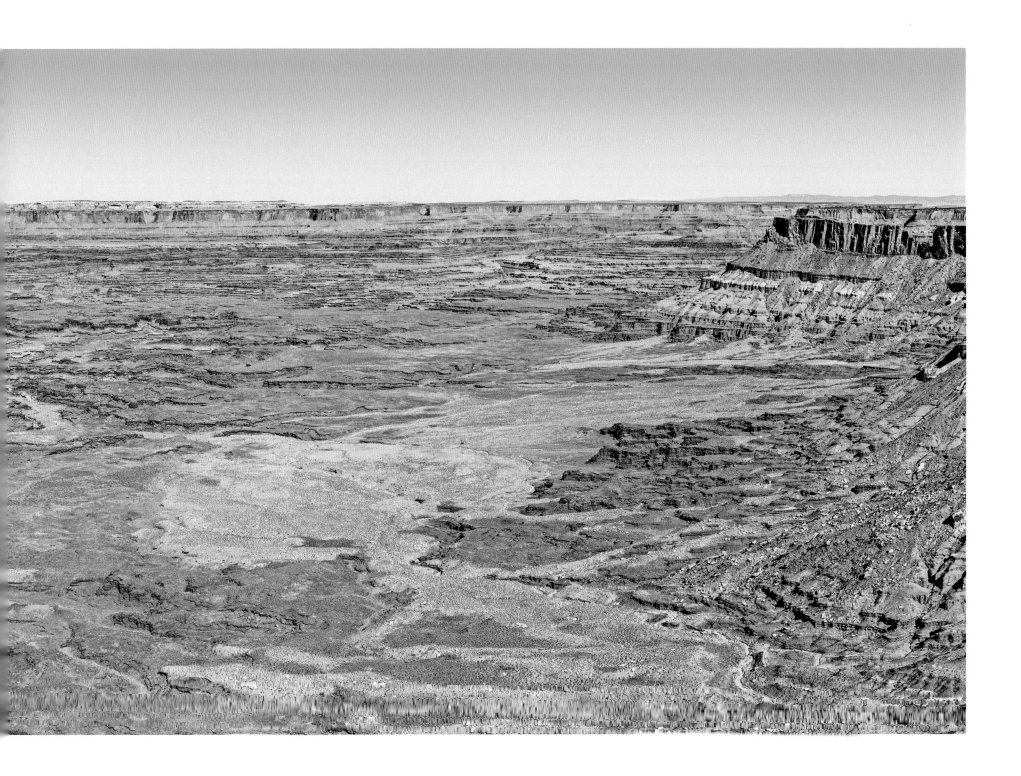

LAYERED LANDSCAPE OF LOCKHART BASIN FROM NEEDLES OVERLOOK.

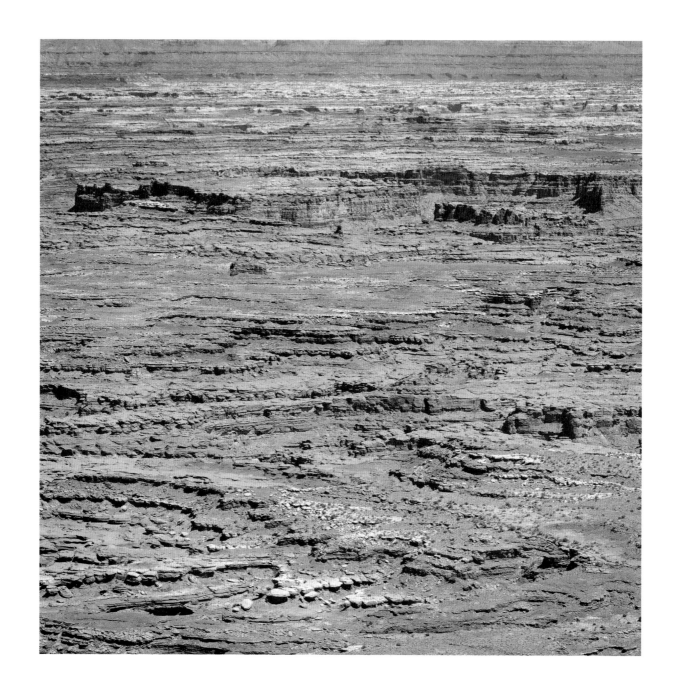

LAYERED LANDSCAPE OF ADJACENT CANYONLANDS NATIONAL PARK.

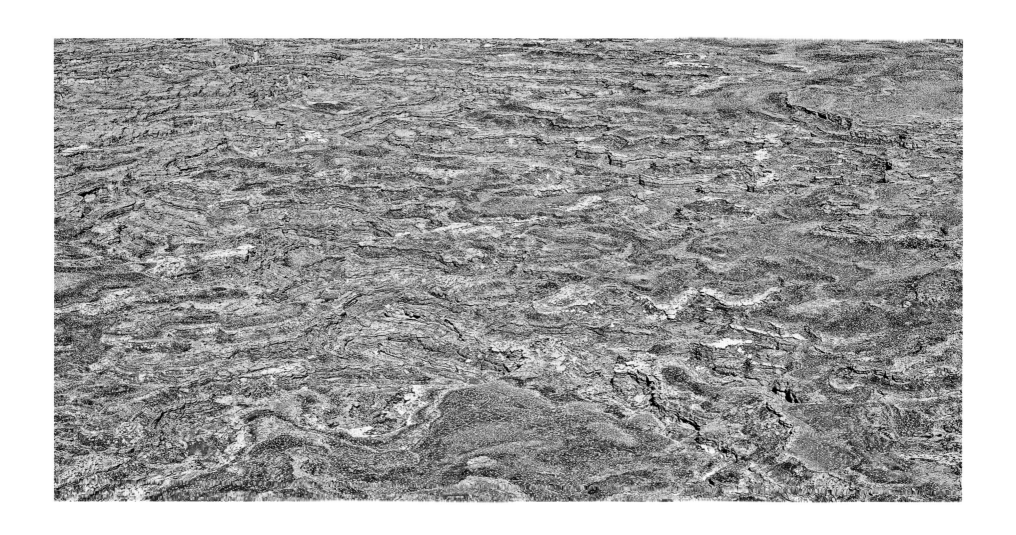

ERODED LANDSCAPE FROM NEEDLES OVERLOOK.

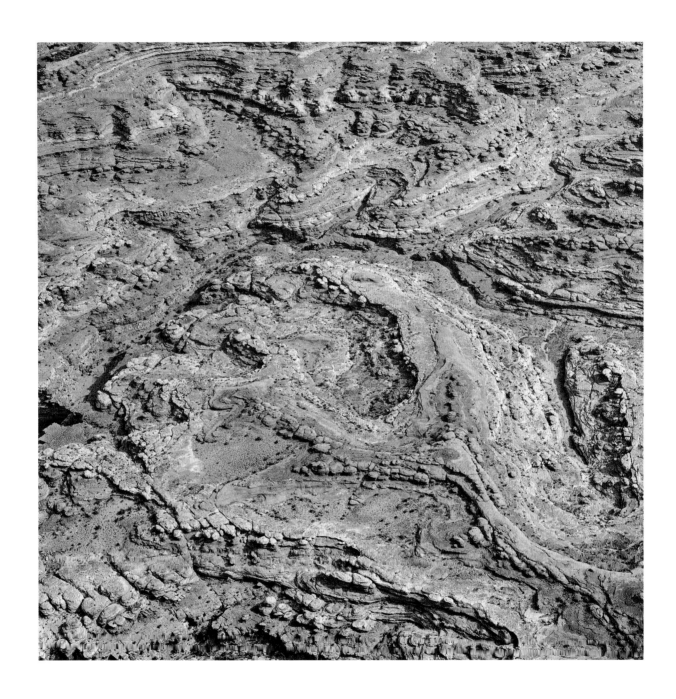

ERODED LANDSCAPE NEAR SALT CREEK CANYON (AERIAL IMAGE).

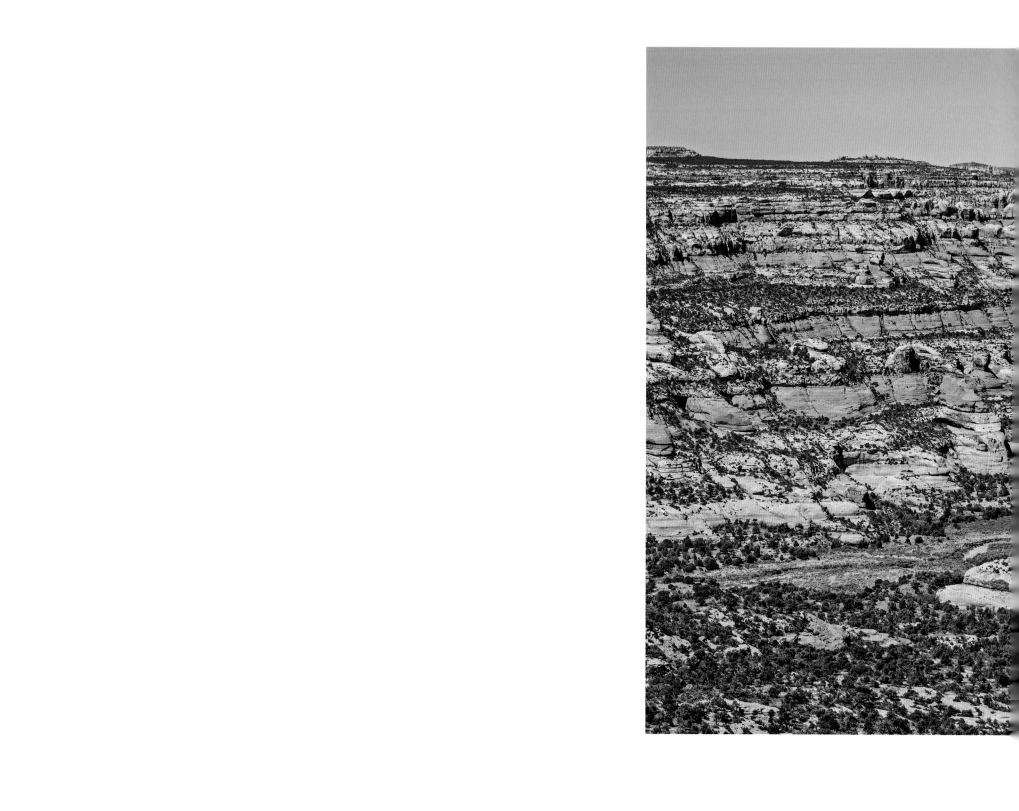

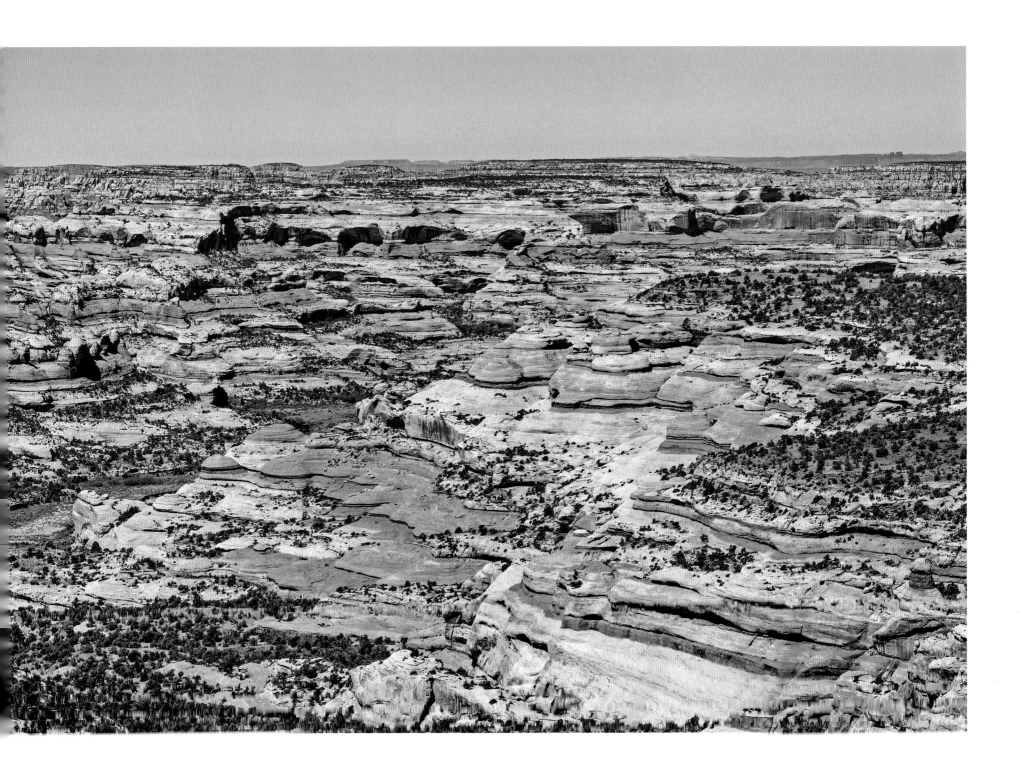

SALT CREEK CANYON FROM BEEF BASIN ROAD.

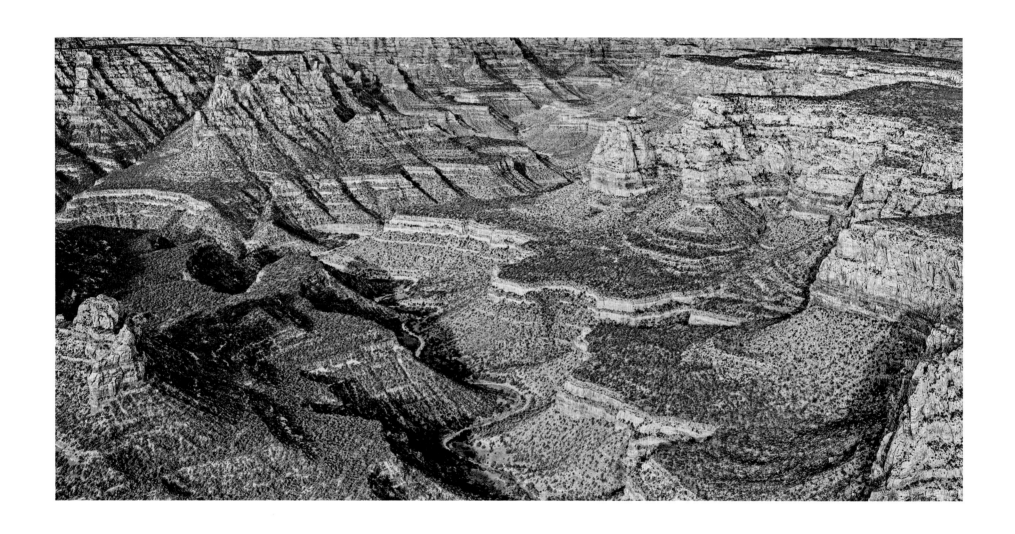

DARK CANYON (AERIAL IMAGE).

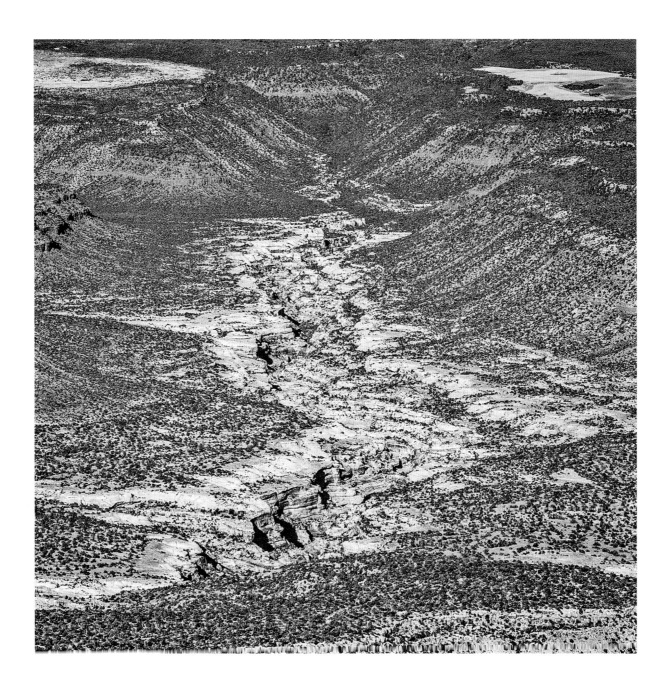

WHITE CANYON (AERIAL IMAGE).

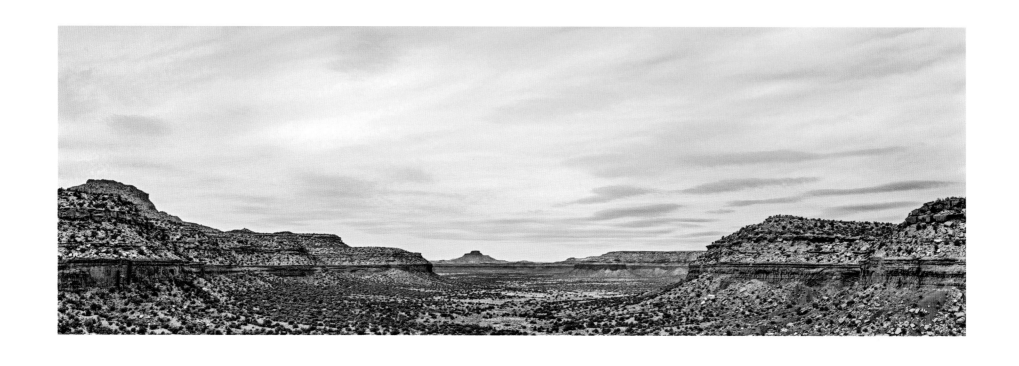

MESAS IN FRY CANYON.

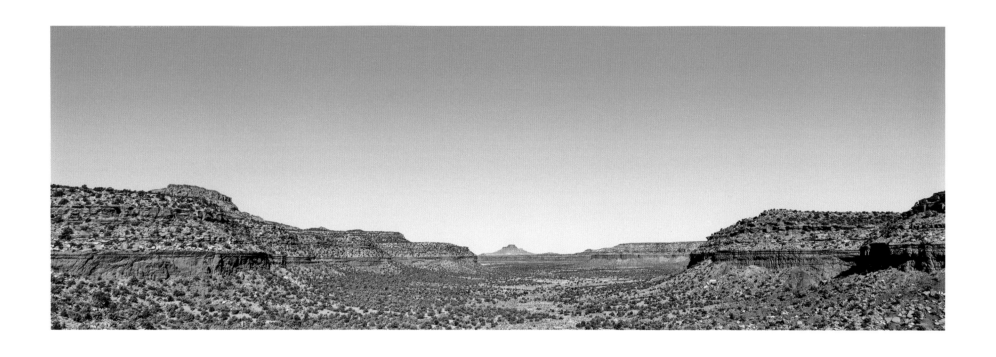

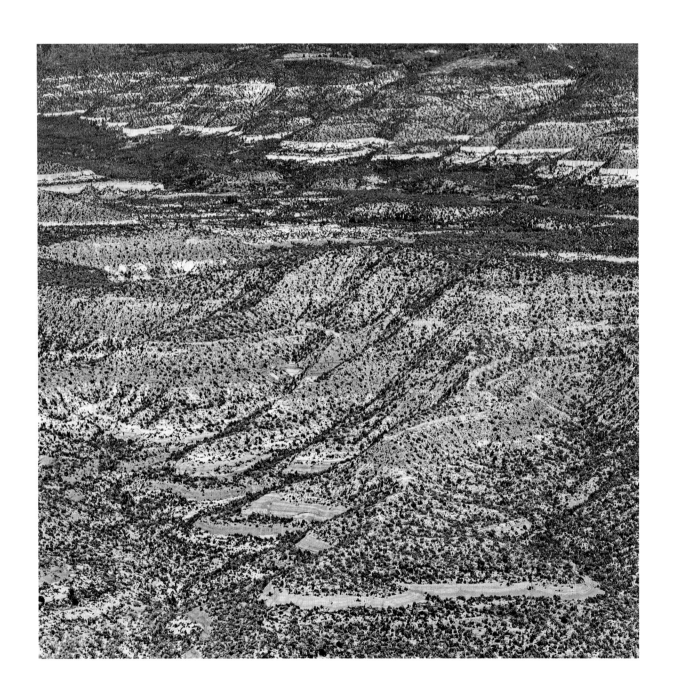

POSEY CANYON (AERIAL IMAGE).

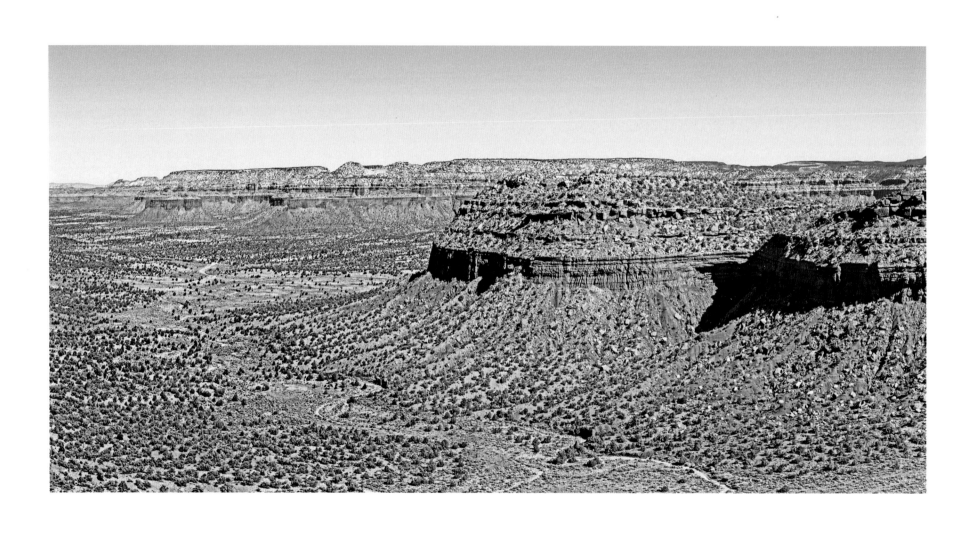

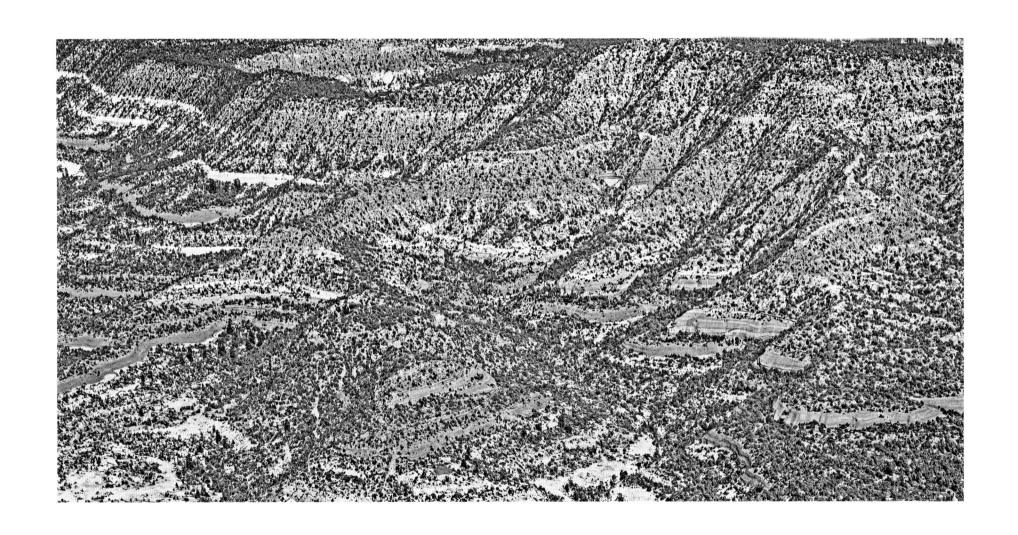

POSEY CANYON (AERIAL IMAGE).

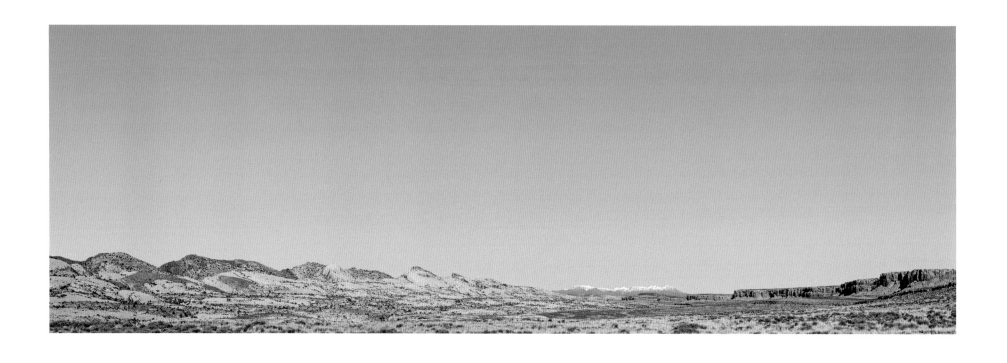

COMB RIDGE (LEFT), THE SNOW-CAPPED ABAJO MOUNTAINS (CENTER), AND TANK MESA (RIGHT).

ANTICLINES, MONOCLINES, and MESAS

What really connects us [to the Bears Ears area] are the prayers and the stories that go along with a lot of those prayers. You start making those connections back to that history. We know we've been here. We know we have family here. We know we have ancestors here. In a way, it identifies our path in life.

—CARLETON BOWEKATY
ZUNI COUNCILMAN AND CO-CHAIR OF BEARS EARS INTER-TRIBAL COALITION

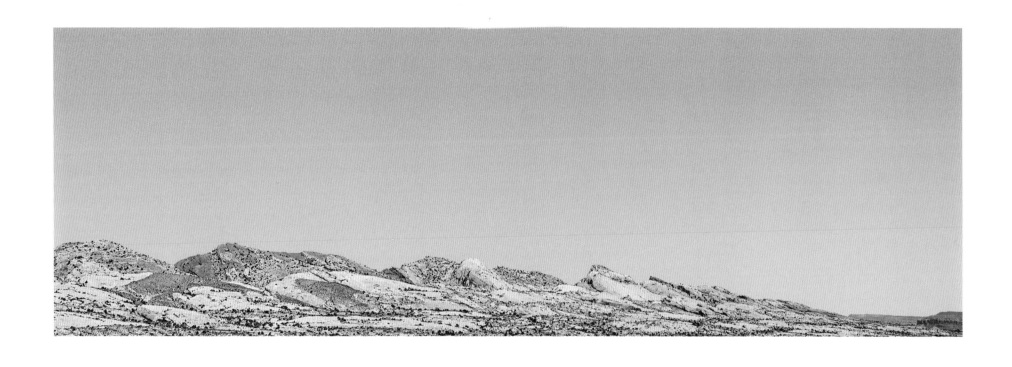

COMB RIDGE WEST OF BLUFF.

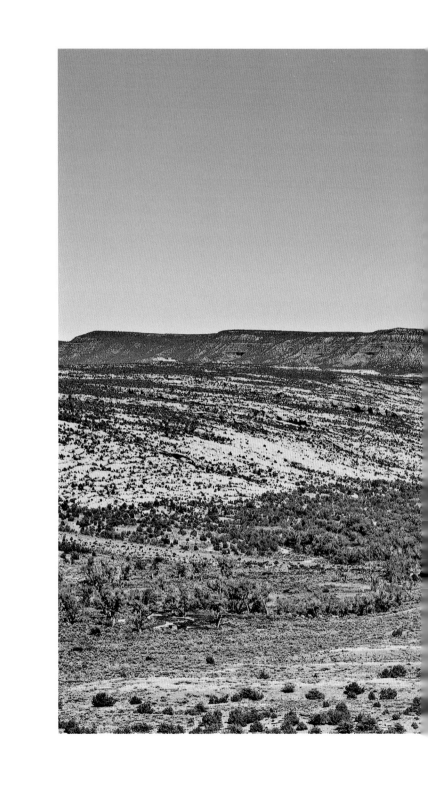

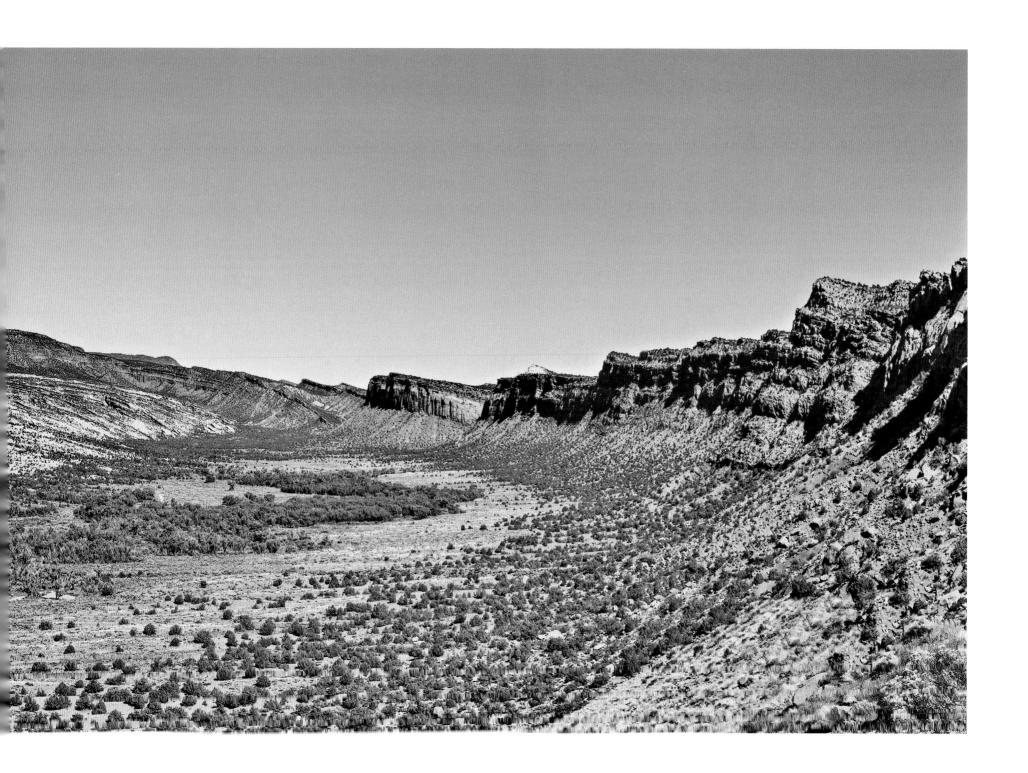

COMB RIDGE FROM UT 95, THE BICENTENNIAL HIGHWAY.

71

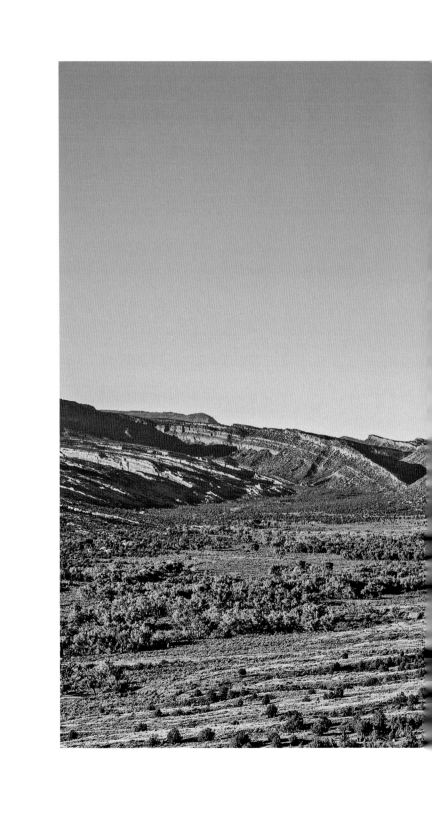

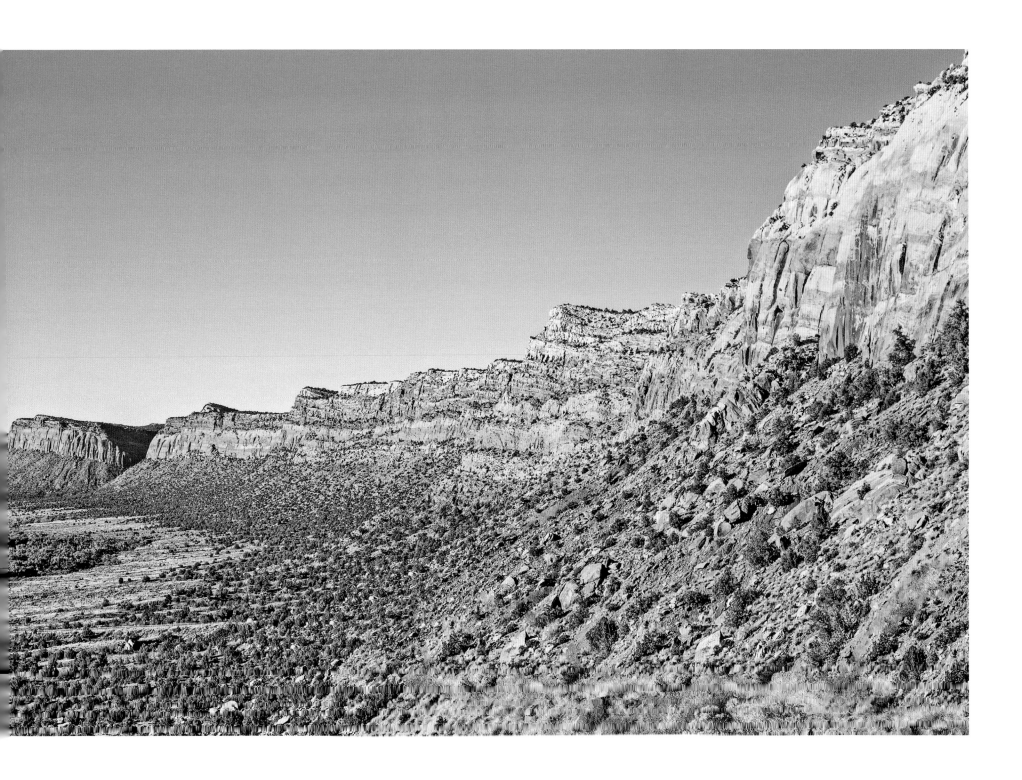

COMB RIDGE FROM UT 95, THE BICENTENNIAL HIGHWAY.

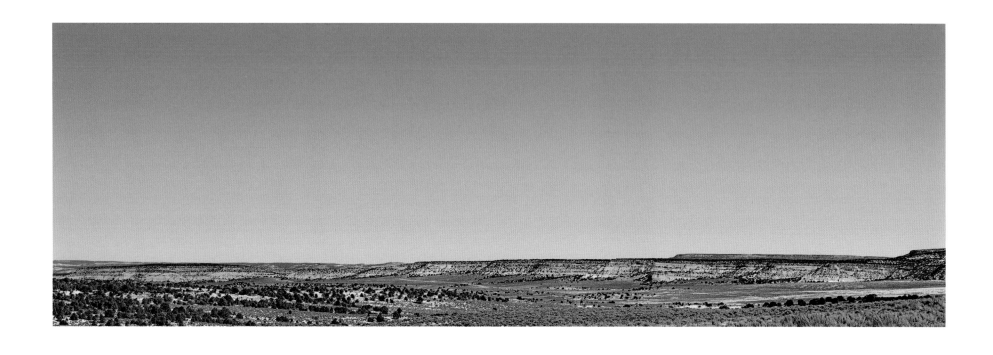

MESAS NEAR HARTS DRAW FROM NORTH FLATS ROAD.

MESAS AT LIME RIDGE.

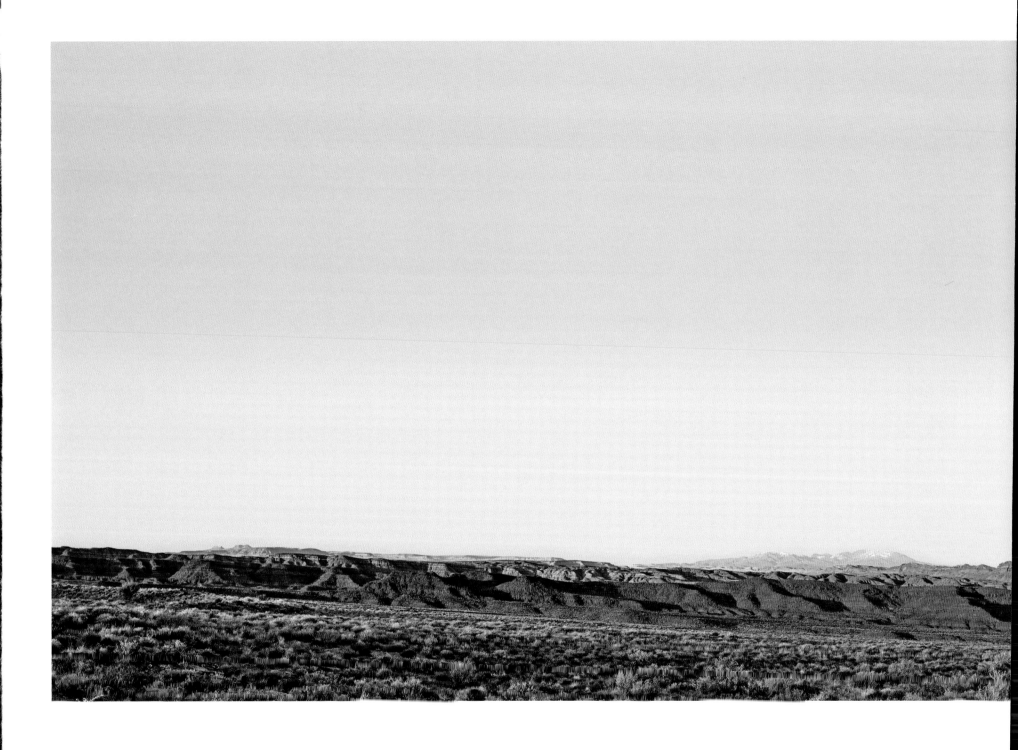

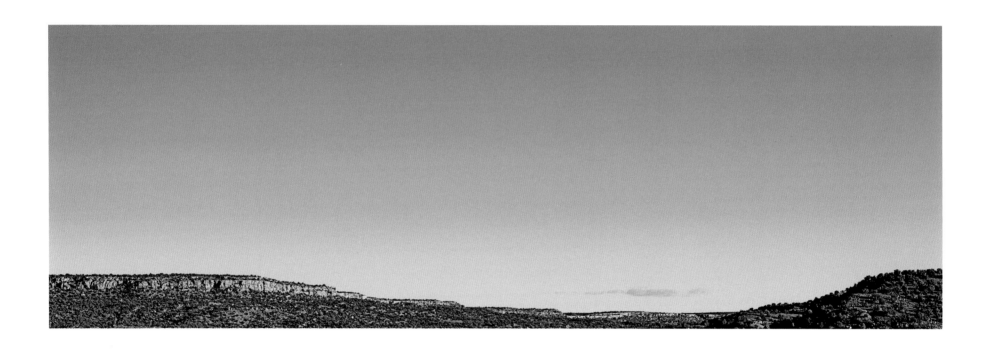

MESAS WEST OF BLANDING.

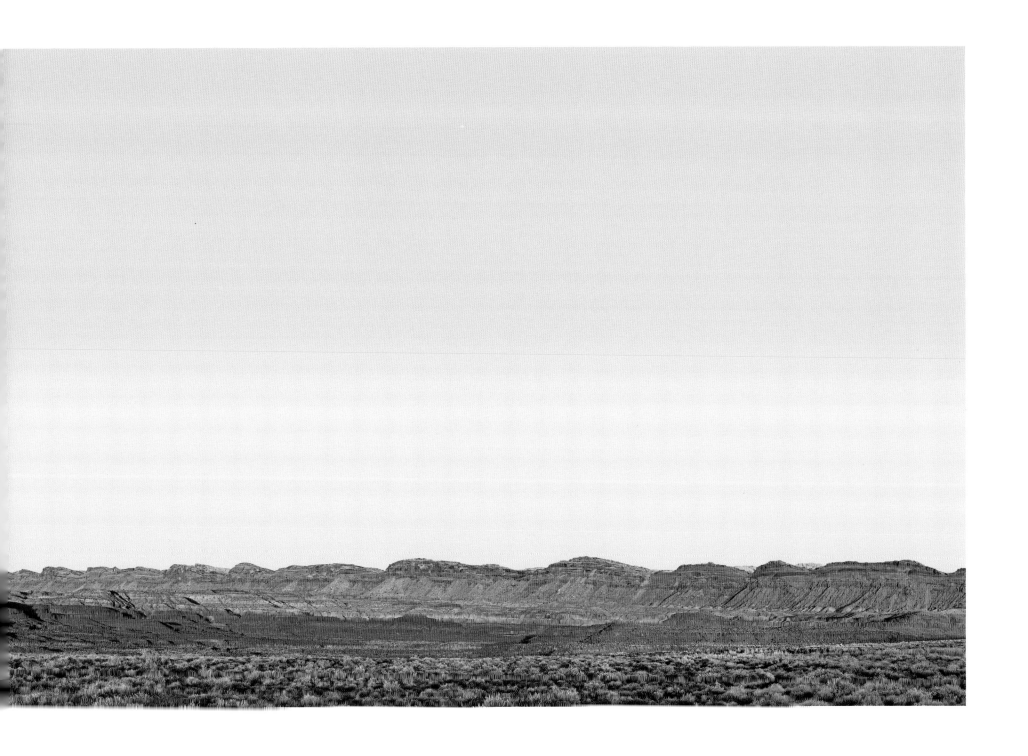

MESAS AND COMB RIDGE, WITH THE ABAJO MOUNTAINS IN THE DISTANCE.

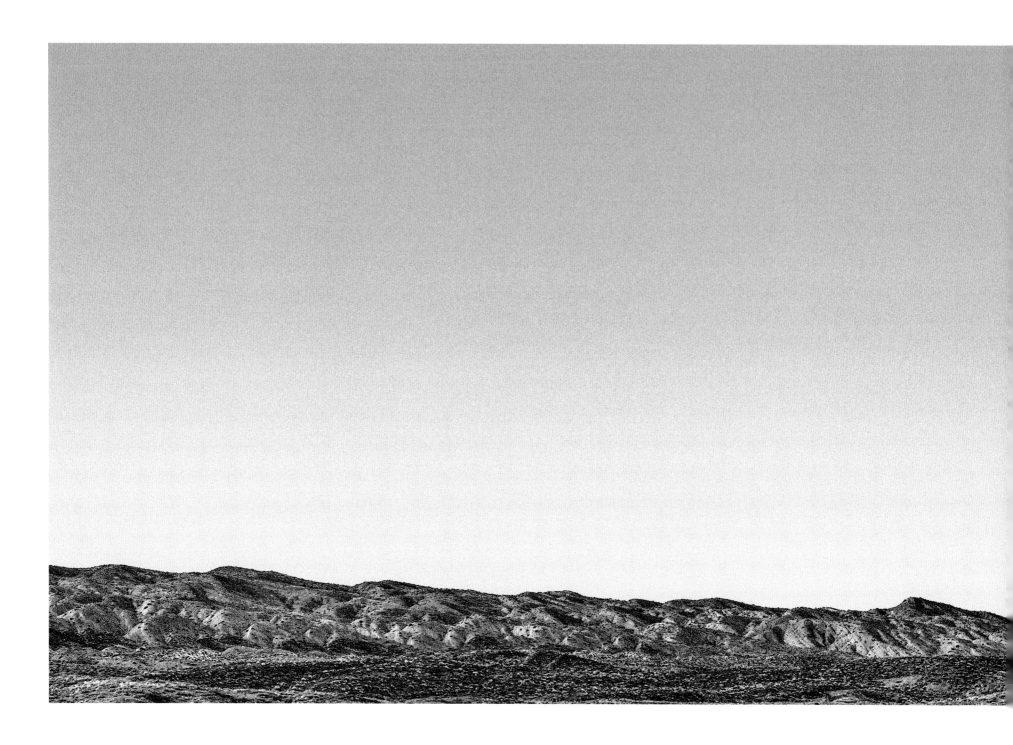

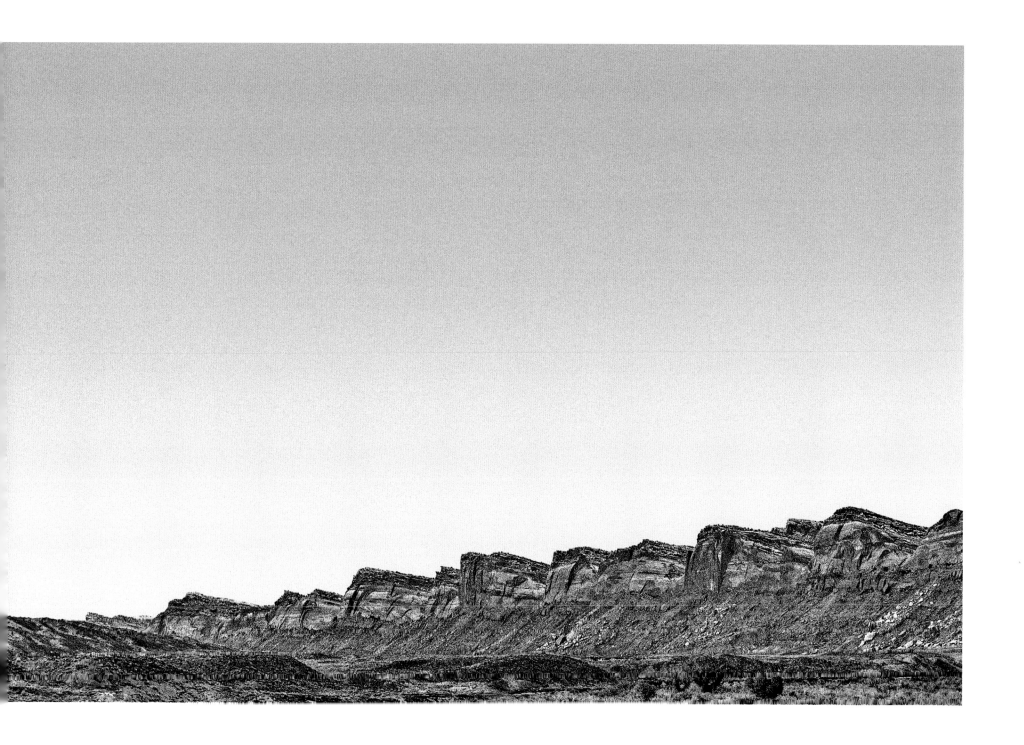

LIME RIDGE (OPPOSITE) AND COMB RIDGE (TOP).

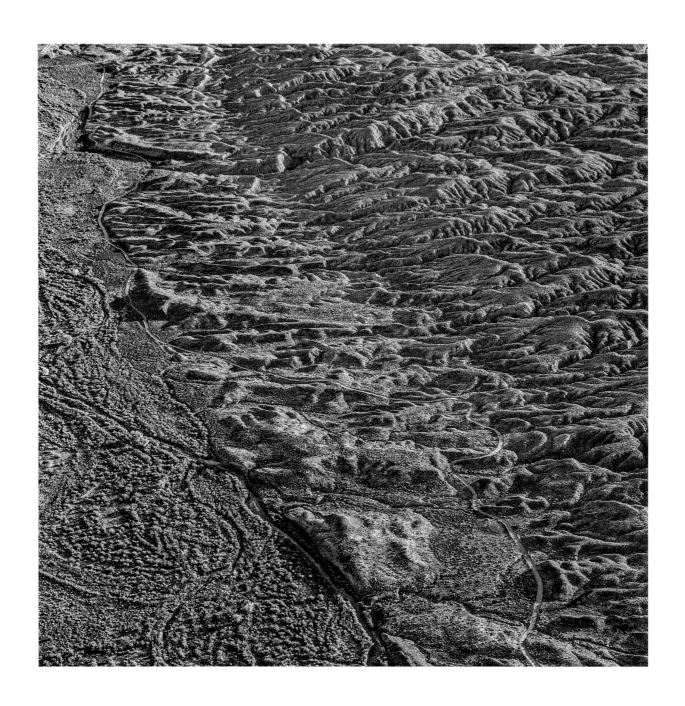

HILLSIDES NEAR COMB RIDGE WEST OF BLUFF (AERIAL IMAGE).

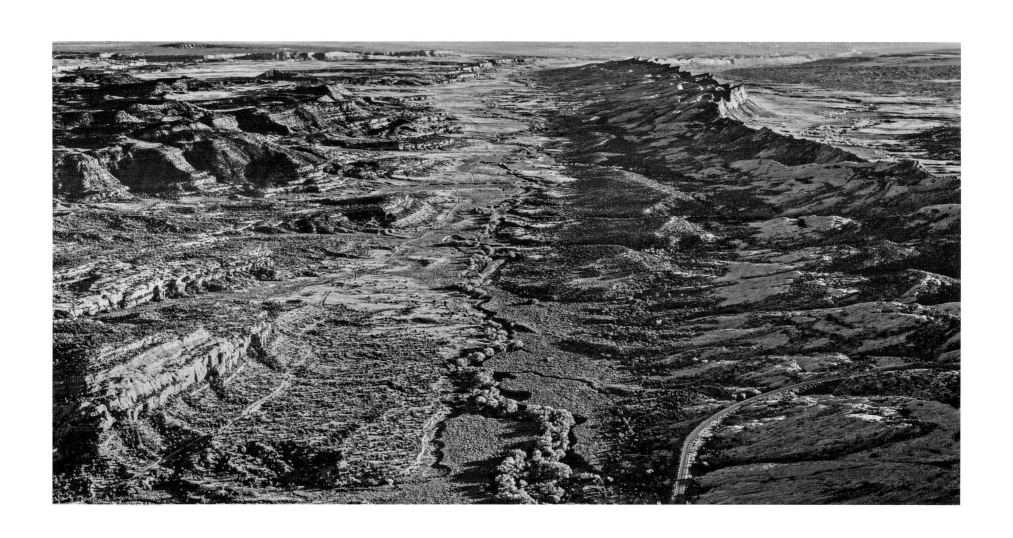

COMB WASH (CENTER) AND COMB RIDGE (RIGHT) (AERIAL IMAGE).

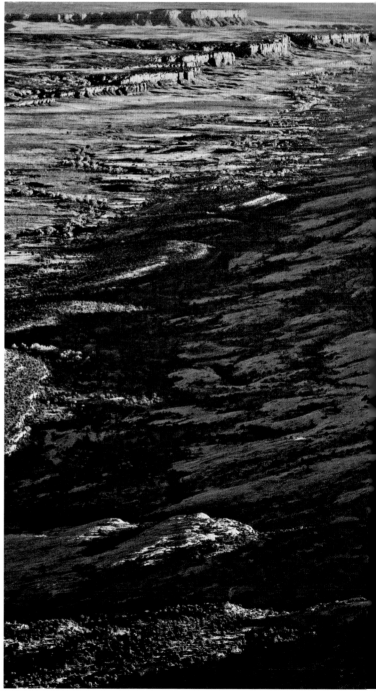

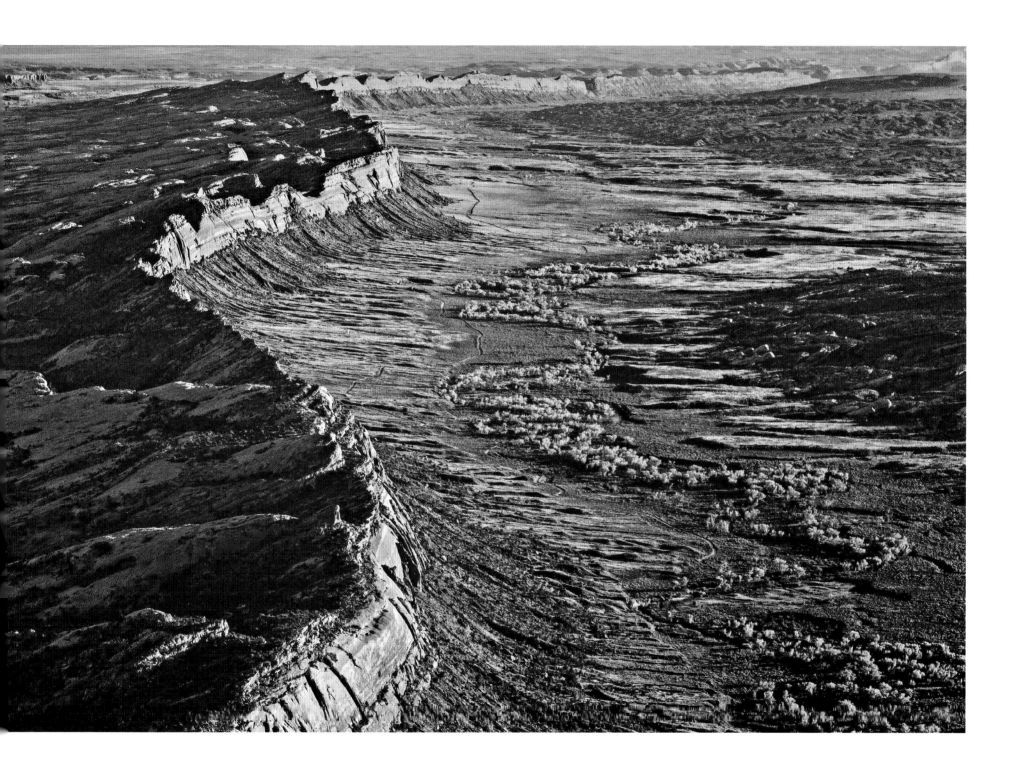

COMB RIDGE (CENTER), BUTLER WASH (LEFT), AND COMB WASH (RIGHT) (AERIAL IMAGE).

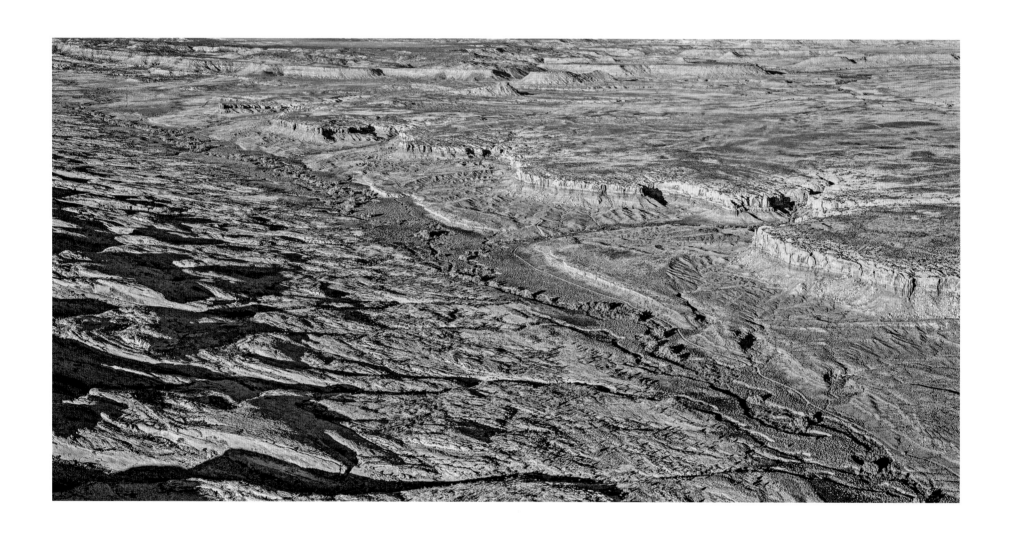

COMB RIDGE (LEFT), BUTLER WASH (CENTER), AND BLUFF BENCH (RIGHT) (AERIAL IMAGE).

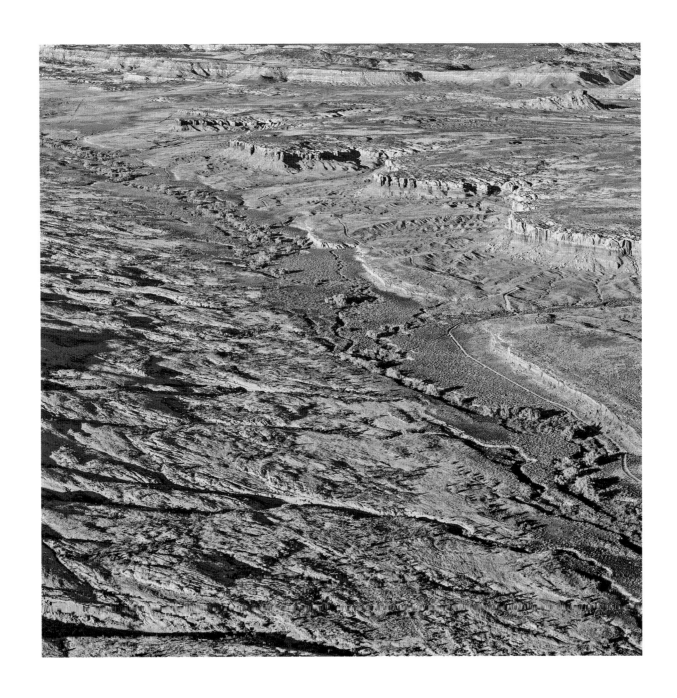

COMB RIDGE (LEFT), BUTLER WASH (CENTER), AND BLUFF BENCH (RIGHT) (AERIAL IMAGE).

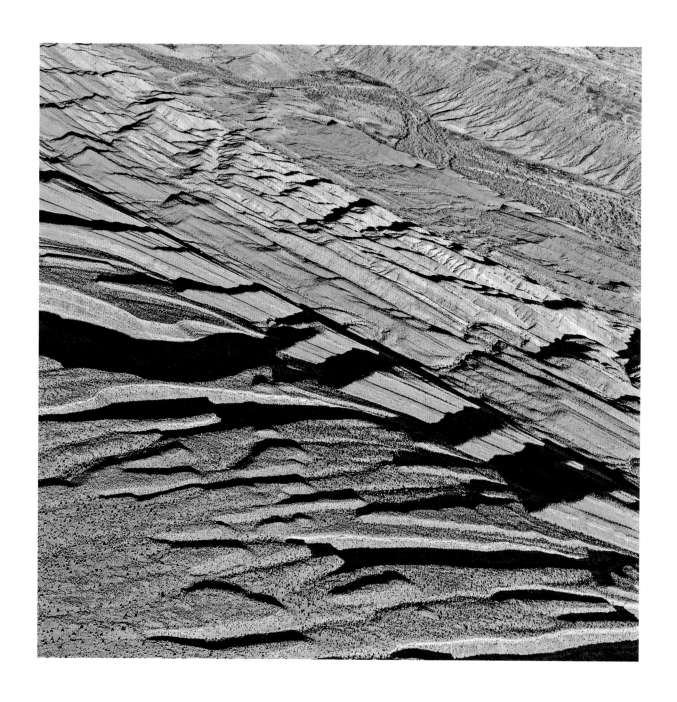

RAPLEE RIDGE (AERIAL IMAGE).

WATER and EROSION

One cannot be pessimistic about the West. This is the native home of hope. When it fully learns that cooperation, not rugged individualism, is the quality that most characterizes and preserves it, then it will have achieved itself and outlived its origins. Then it has a chance to create a society to match its scenery.

—WALLACE STEGNER
WRITER, HISTORIAN, CONSERVATIONIST, AND WINNER OF
THE PULITZER PRIZE AND AMERICAN BOOK AWARD

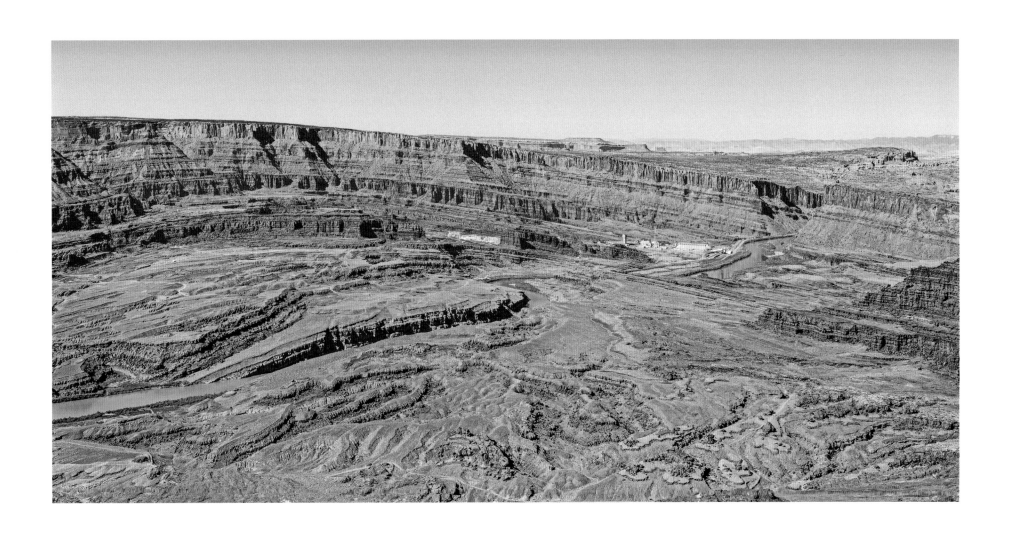

ANTICLINE AND POTASH PROCESSING PLANT ALONG THE COLORADO RIVER FROM ANTICLINE OVERLOOK.

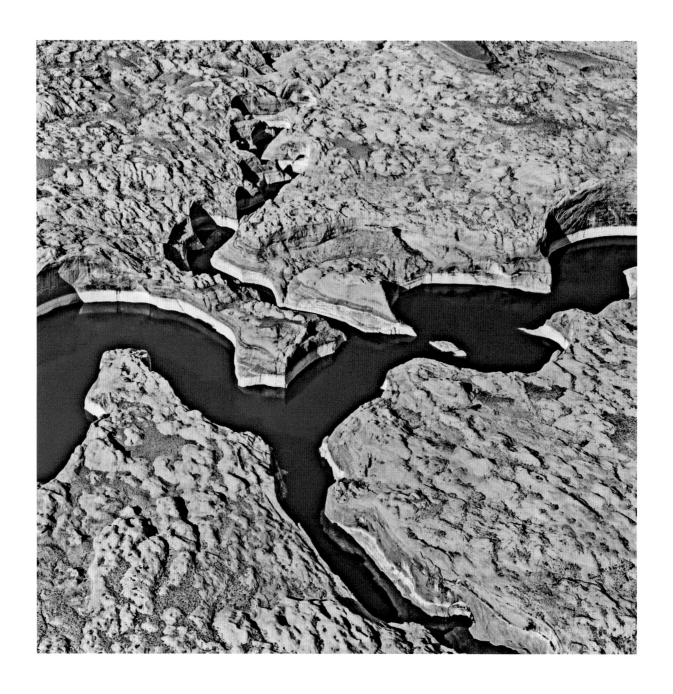

LAKE POWELL FROM THE EASTERN END OF HOLE-IN-THE-ROCK TRAIL (AERIAL IMAGE).

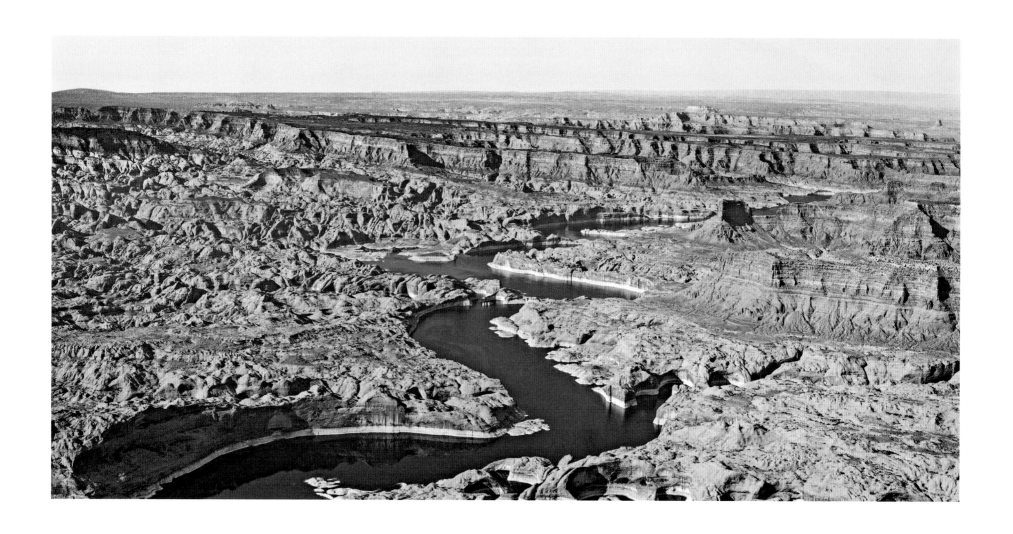

LAKE POWELL LOOKING WEST FROM THE EASTERN END OF HOLE-IN-THE-ROCK TRAIL (AERIAL IMAGE).

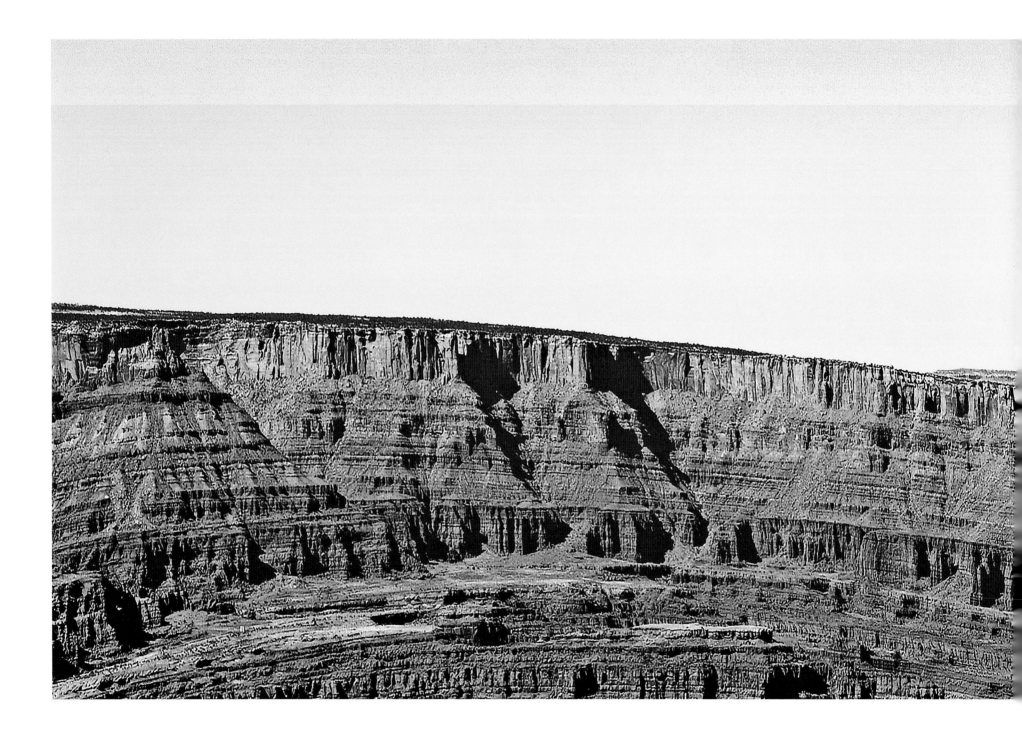

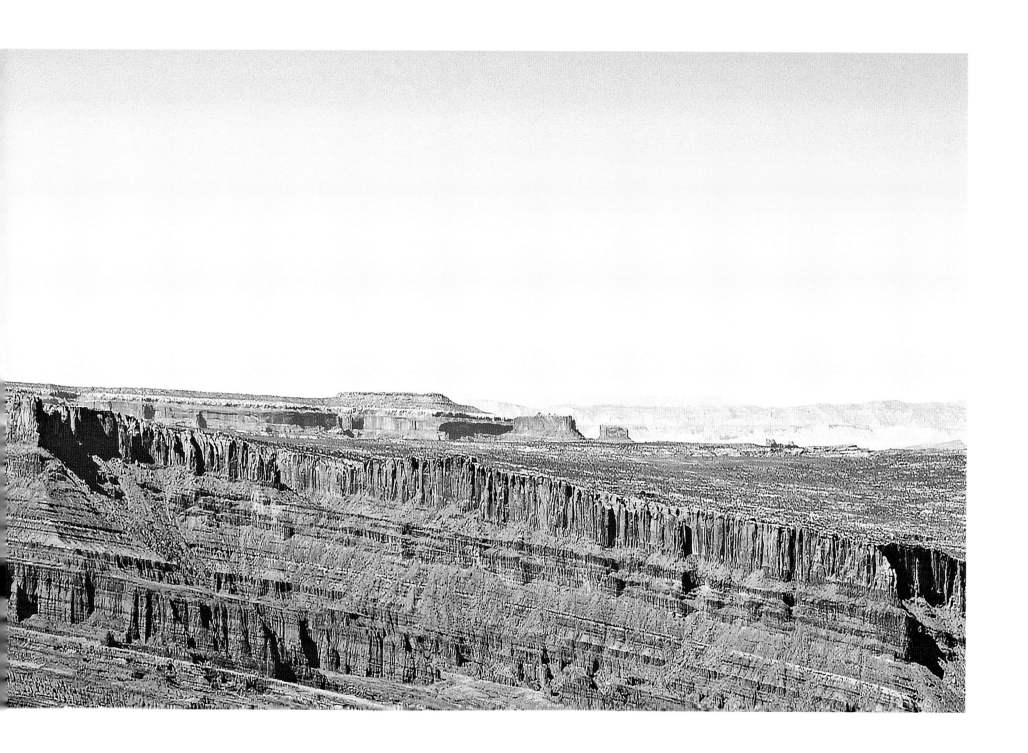

DETAIL OF THE ANTICLINE ALONG THE COLORADO RIVER FROM ANTICLINE OVERLOOK (SEE PAGE 89).

93

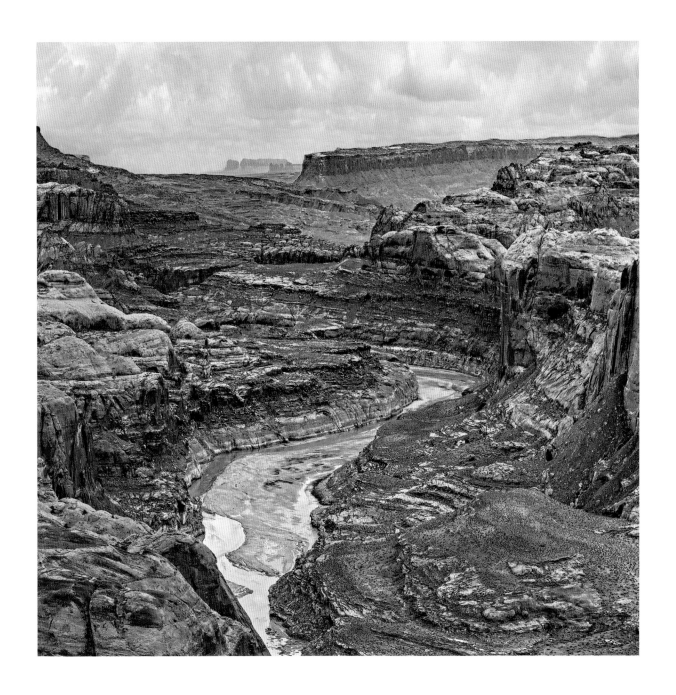

SAN JUAN RIVER FROM HOLE-IN-THE-ROCK TRAIL.

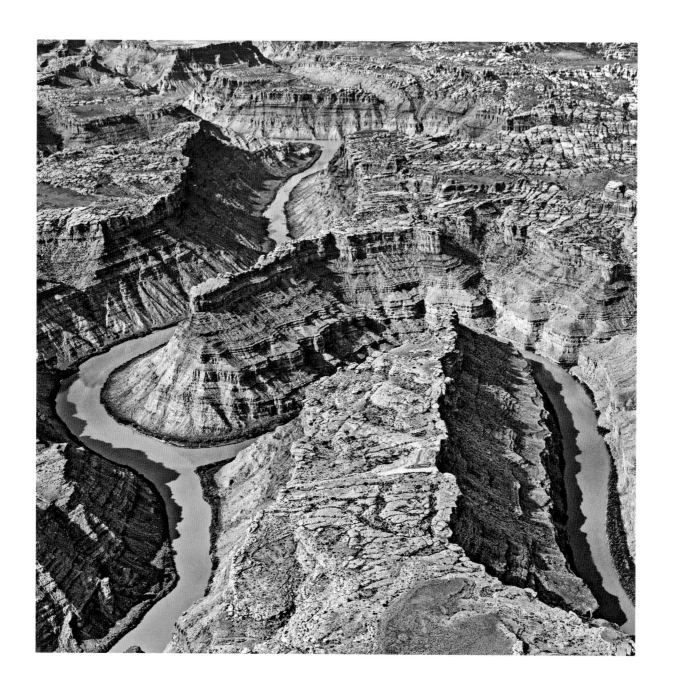

MESAS AT THE CONFLUENCE OF THE GREEN AND COLORADO RIVERS (AERIAL IMAGE).

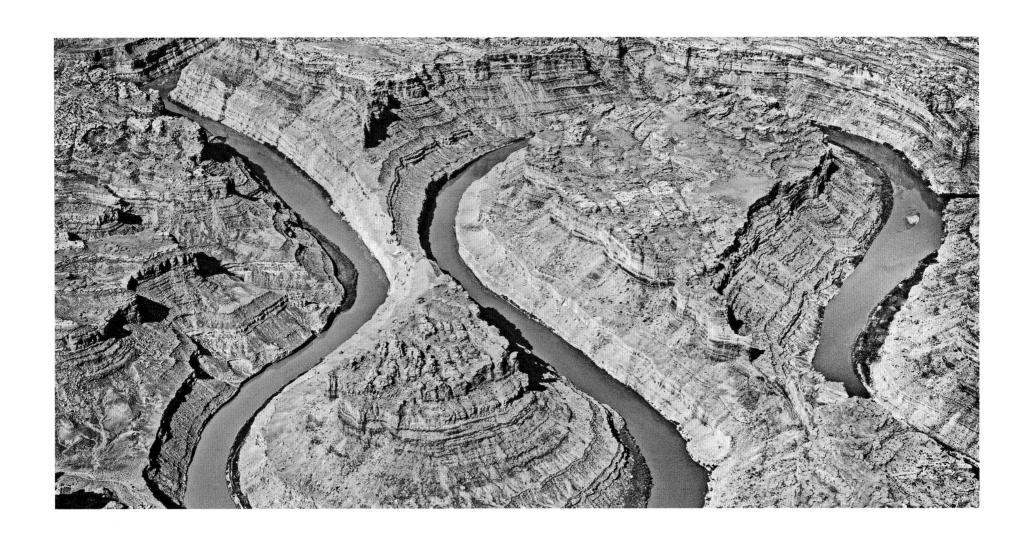

MESAS NEAR THE CONFLUENCE OF THE GREEN AND COLORADO RIVERS (AERIAL IMAGE).

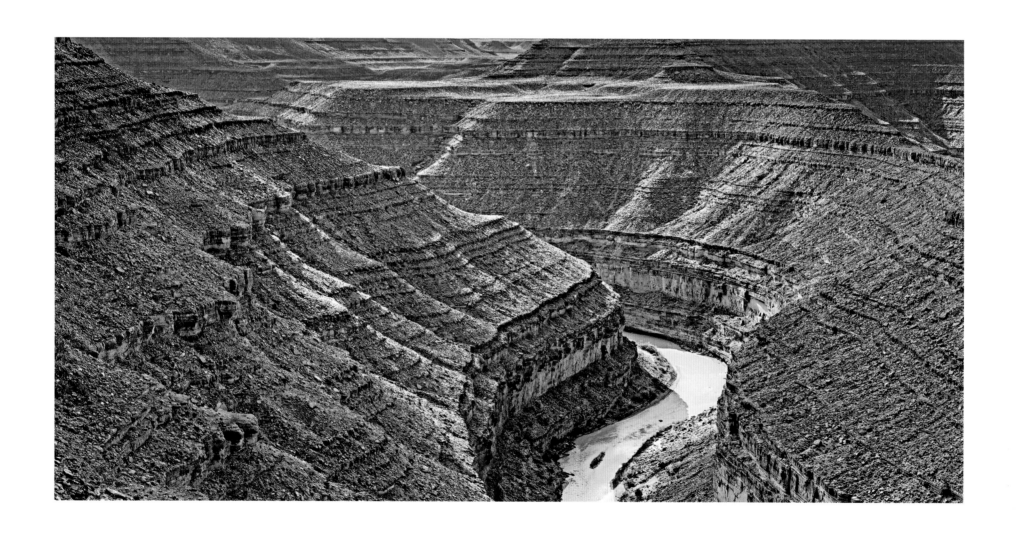

MESAS NEAR GOOSENECKS OF THE SAN JUAN RIVER FROM MULEY POINT.

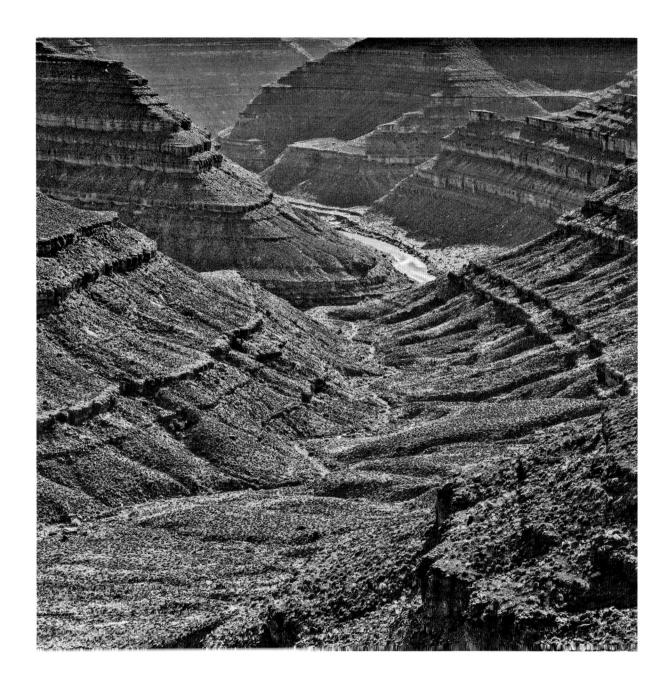

MESAS NEAR GOOSENECKS OF THE SAN JUAN RIVER FROM MULEY POINT.

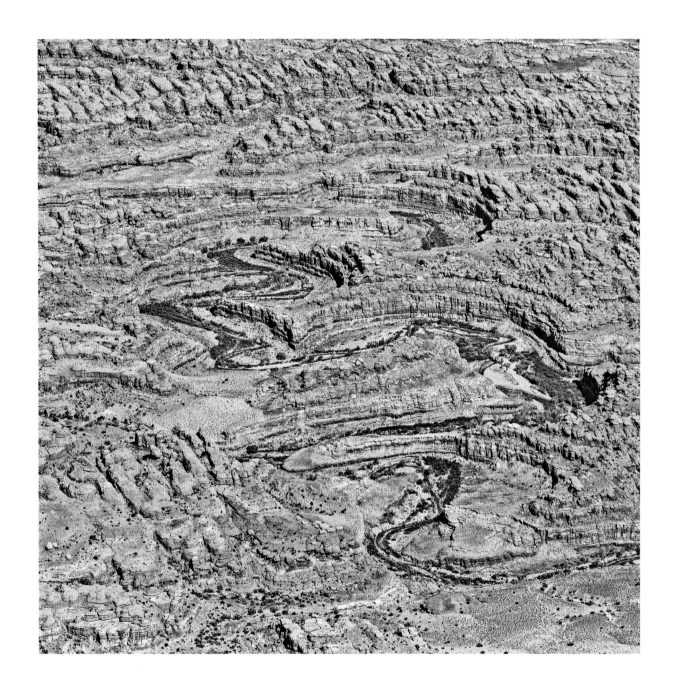

NEAR BIG POCKET NORTH OF SALT CREEK CANYON (AERIAL IMAGE).

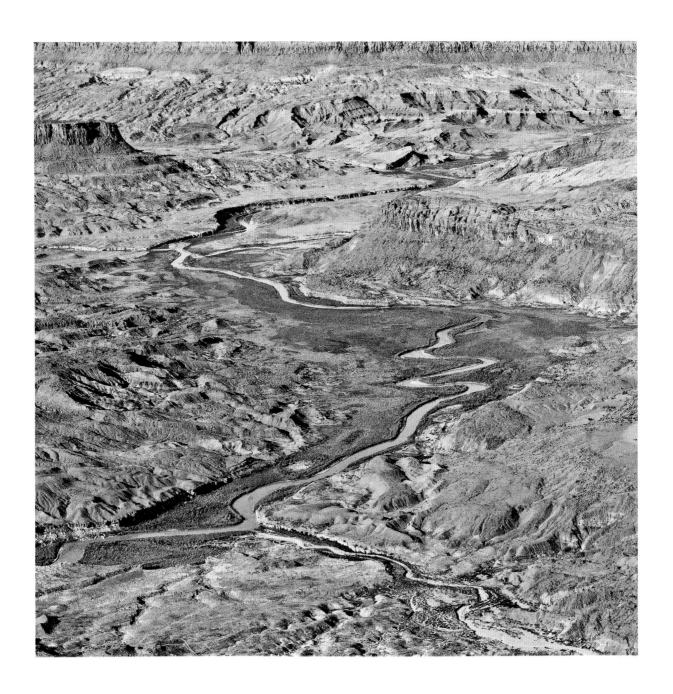

SAN JUAN RIVER NEAR HOLE-IN-THE-ROCK TRAIL (AERIAL IMAGE).

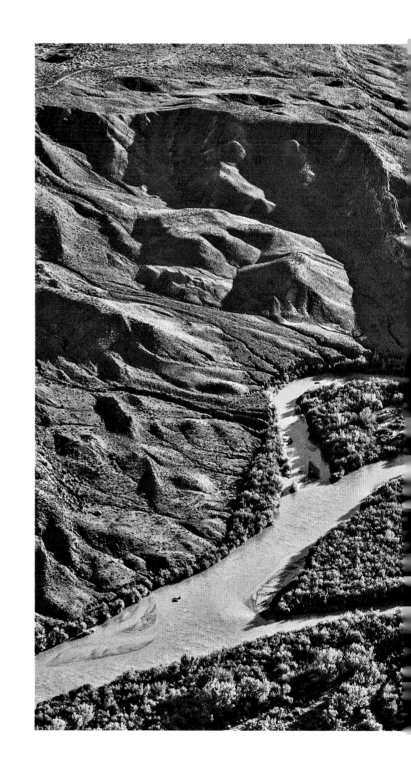

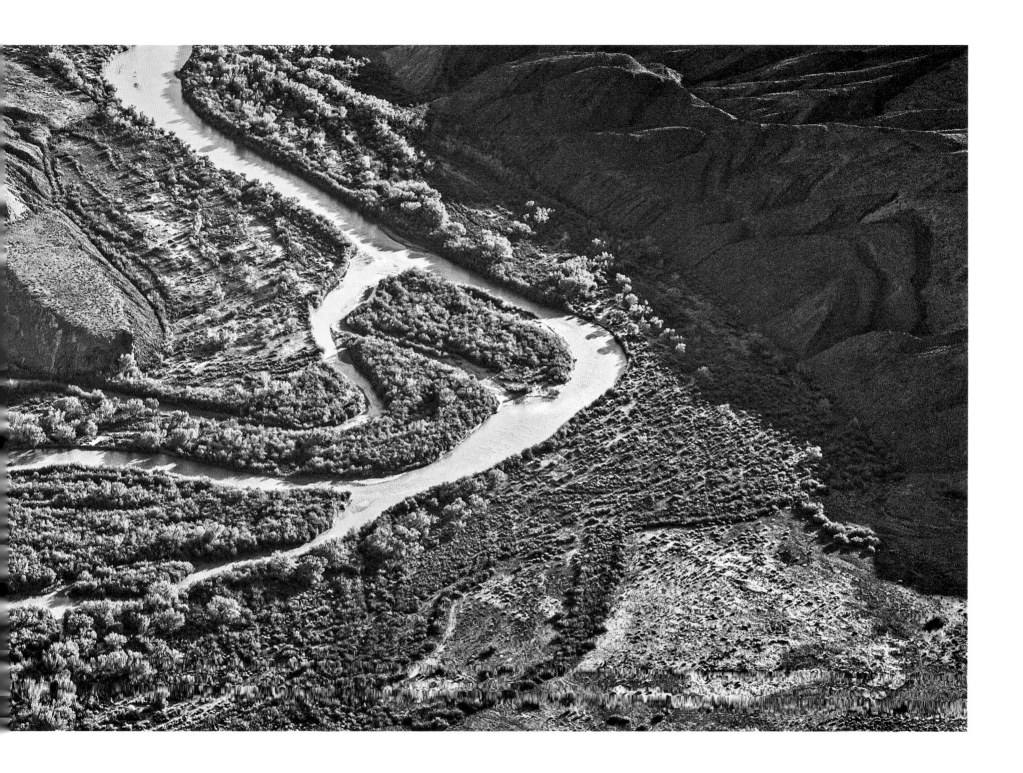

BOSQUE ALONG THE SAN JUAN RIVER NEAR BLUFF (AERIAL IMAGE).

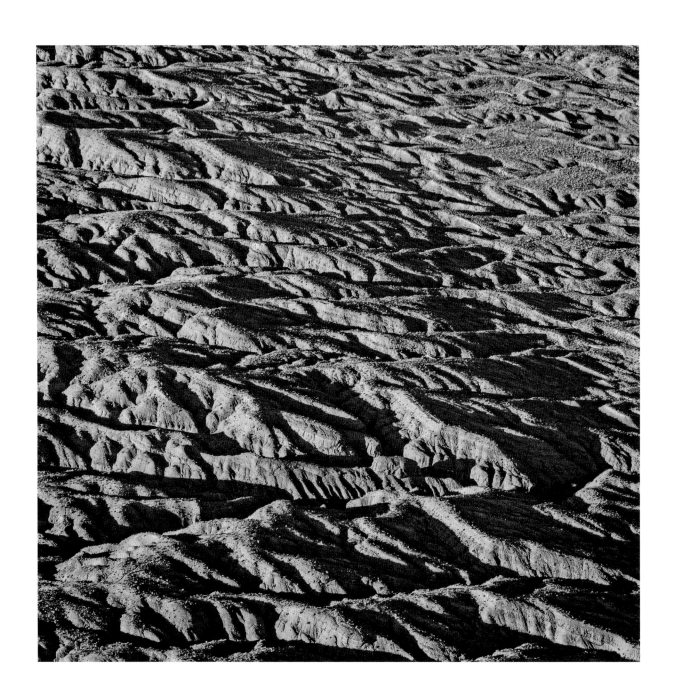

HILLS NEAR LIME RIDGE (AERIAL IMAGE).

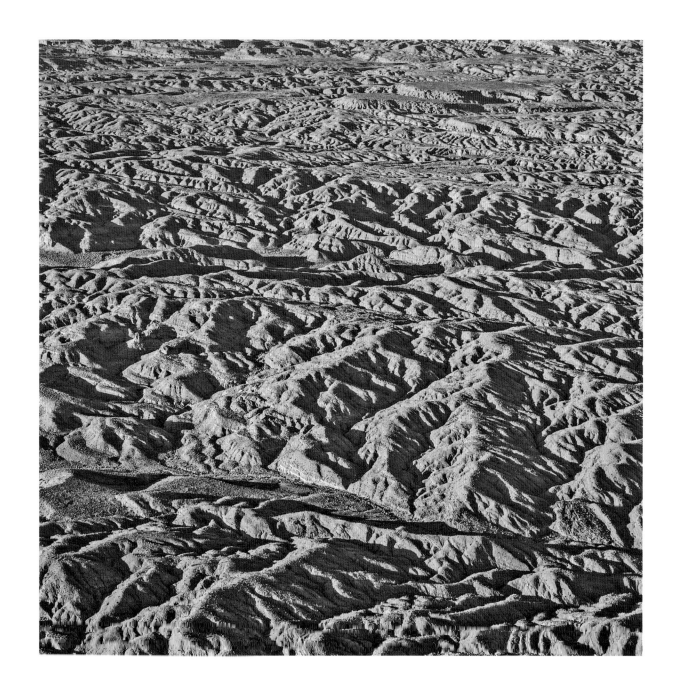

HILLS NEAR LIME RIDGE (AERIAL IMAGE).

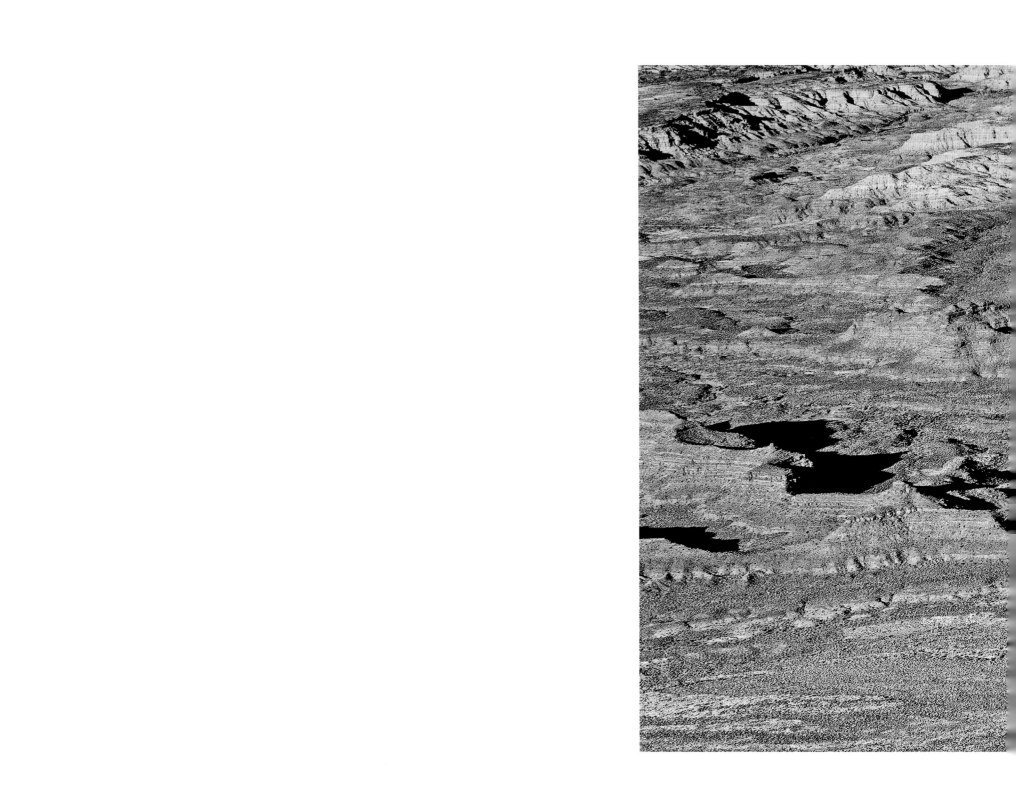

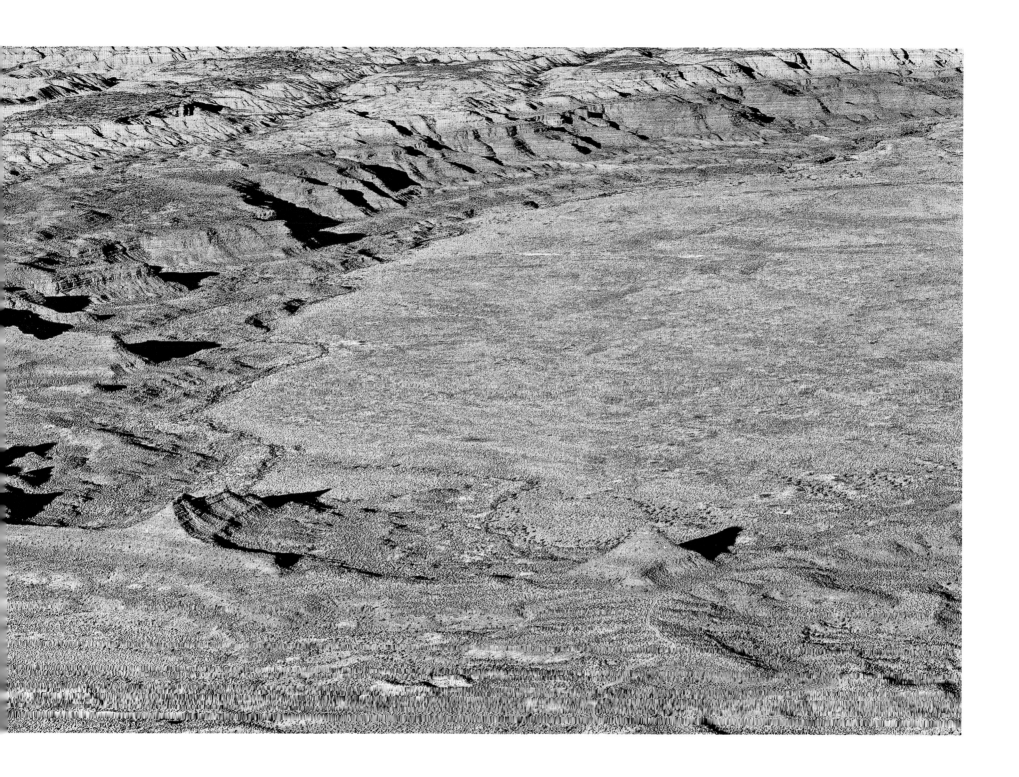

MESAS NEAR LIME RIDGE (AERIAL IMAGE).

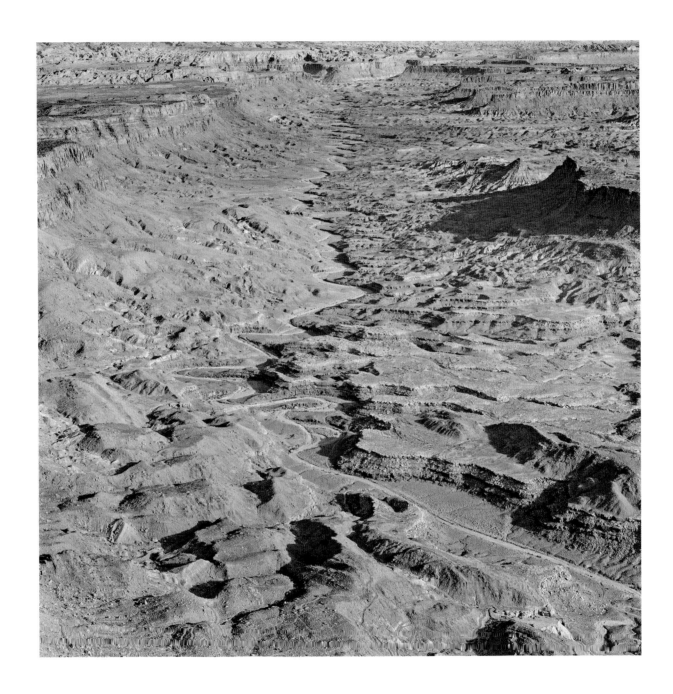

MUDHILLS NEAR RED CANYON (AERIAL IMAGE).

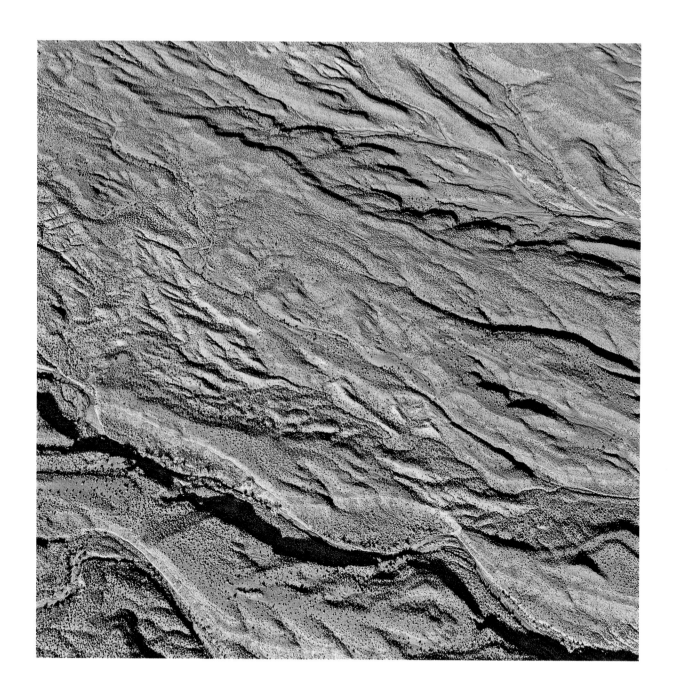

FLOOR OF VALLEY OF THE GODS (AERIAL IMAGES).

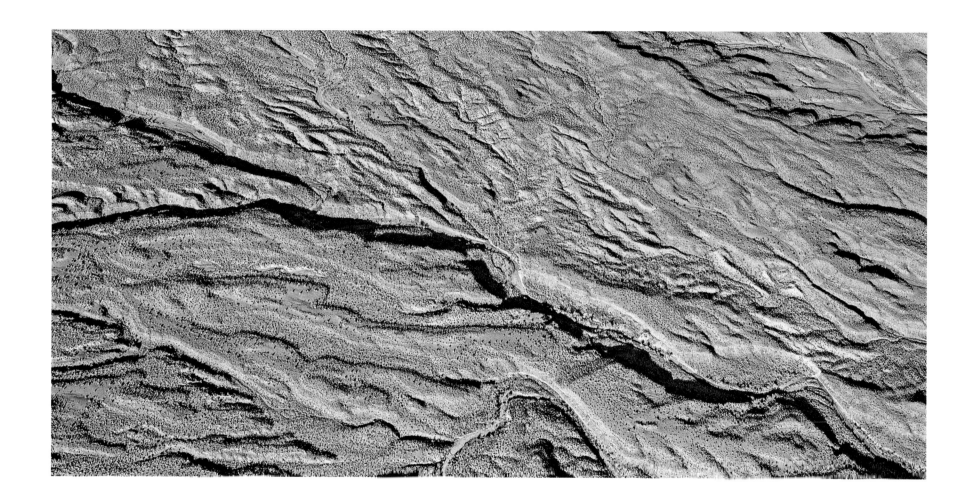

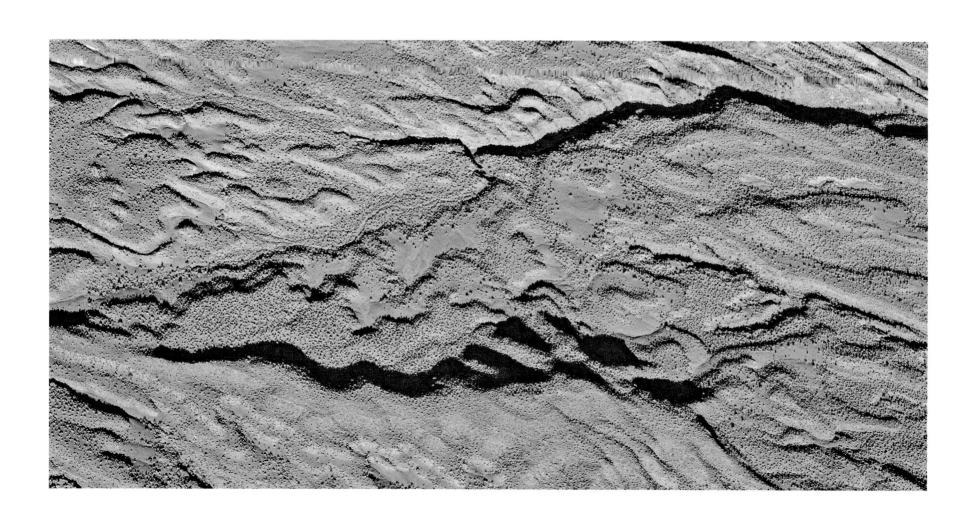

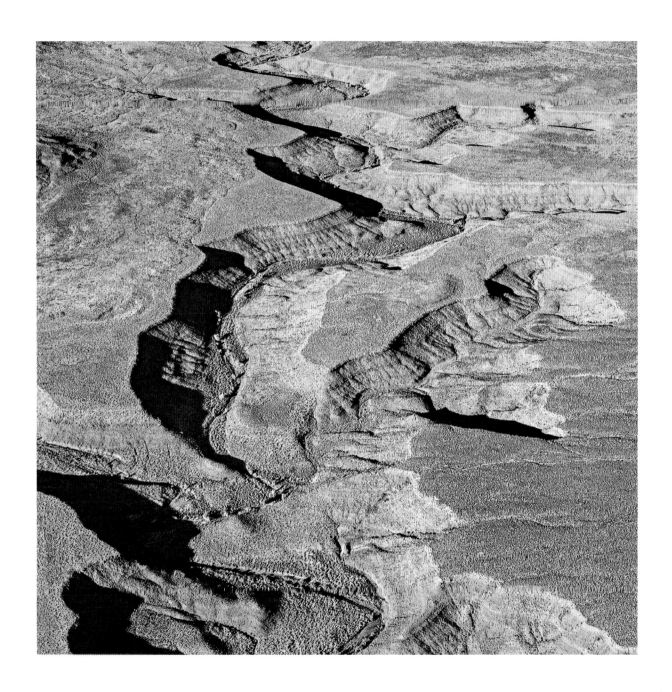

MESAS NEAR VALLEY OF THE GODS (AERIAL IMAGE).

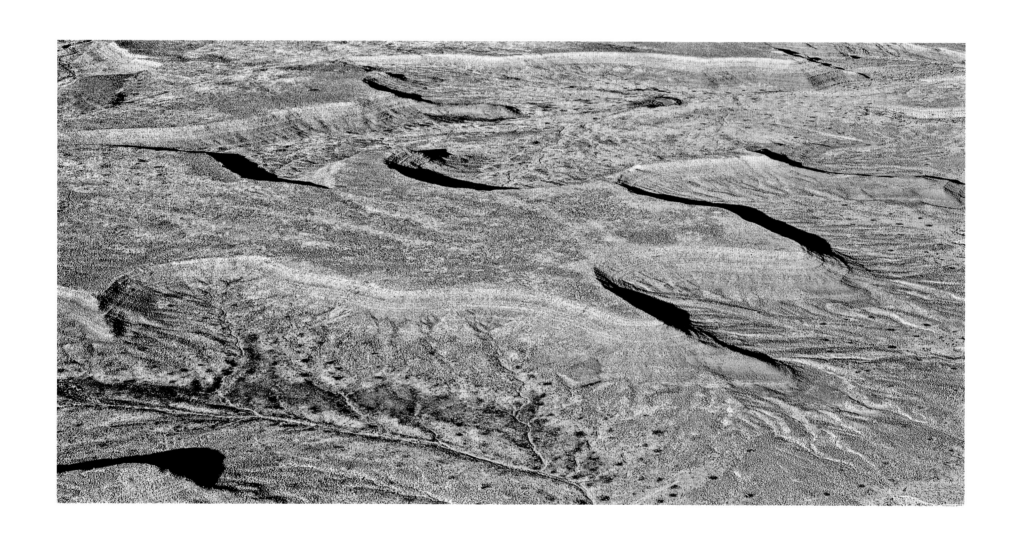

MESAS NEAR LIME RIDGE (AERIAL IMAGE).

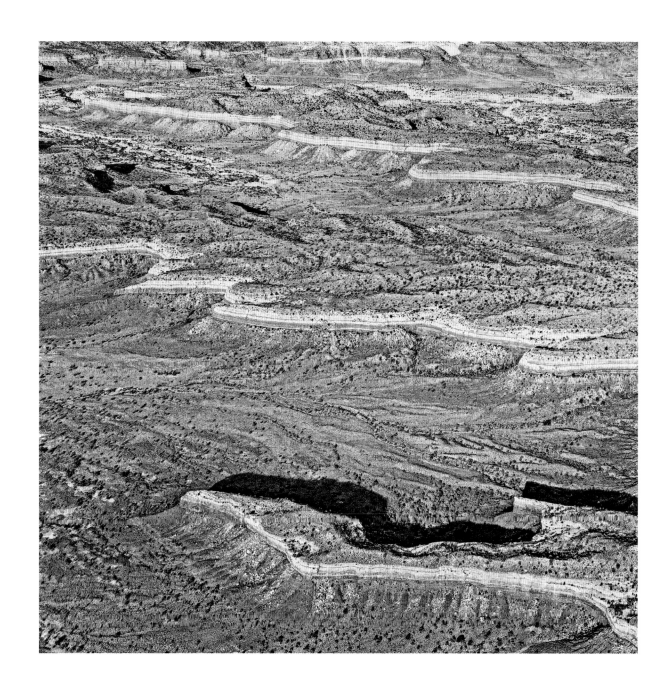

MESAS NEAR WHITE CANYON (AERIAL IMAGE).

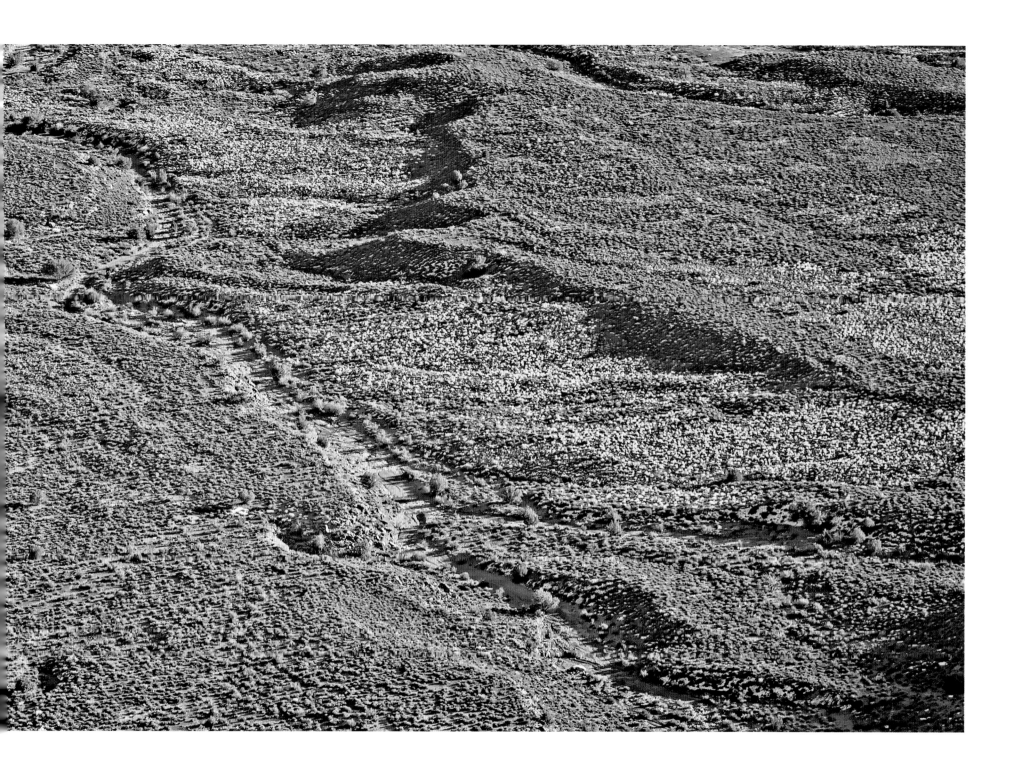

FLOOR OF VALLEY OF THE GODS FROM MOKI DUGWAY ON UT 261.

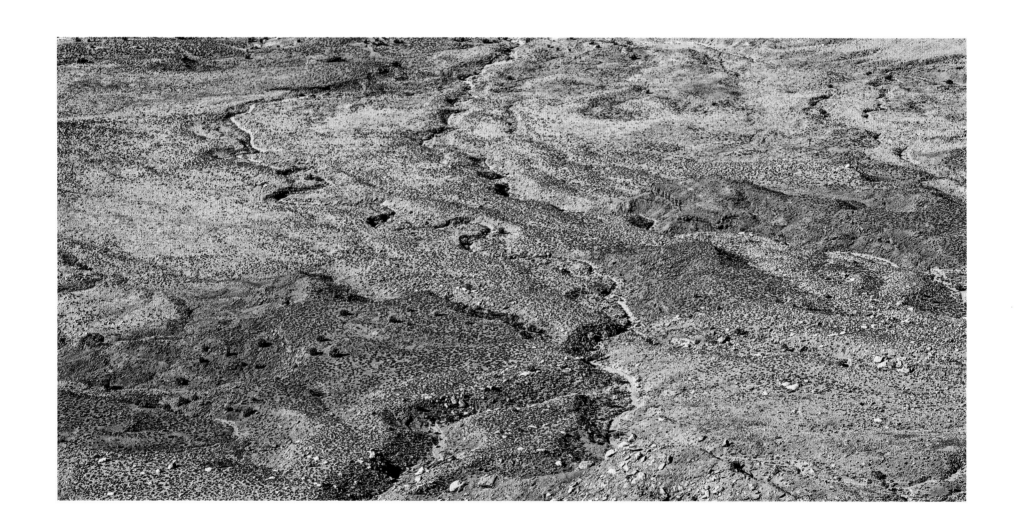

LANDSCAPE FROM NEEDLES OVERLOOK.

LANDSCAPE

Our value system is unique. What you see as a weed, I may see as a medicinal plant.
These are cultural differences. And the part of Bears Ears which was unique was
[that] it was for you and me to better understand each other. It wasn't just about
protecting artifacts. It wasn't just about protecting the rights of indigenous people.
It's a living landscape. It has a pulse. It has a heartbeat. We all see it in different eyes.
But we all have an obligation to protect it.

—SHAUN CHAPOOSE
CHAIRMAN, UTE INDIAN TRIBE BUSINESS COMMITTEE, AND BEARS EARS INTER-TRIBAL COALITION

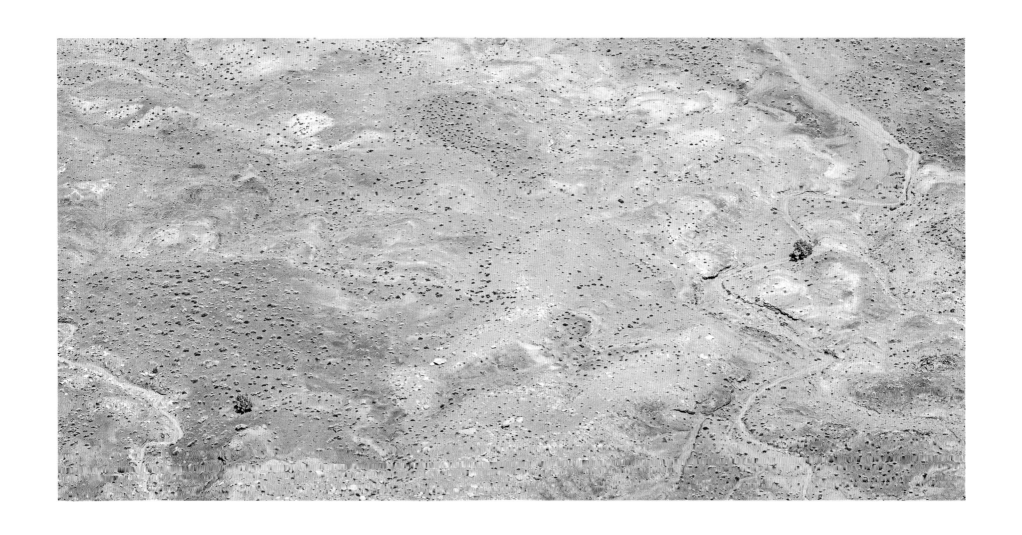

LANDSCAPE FROM NEEDLES OVERLOOK.

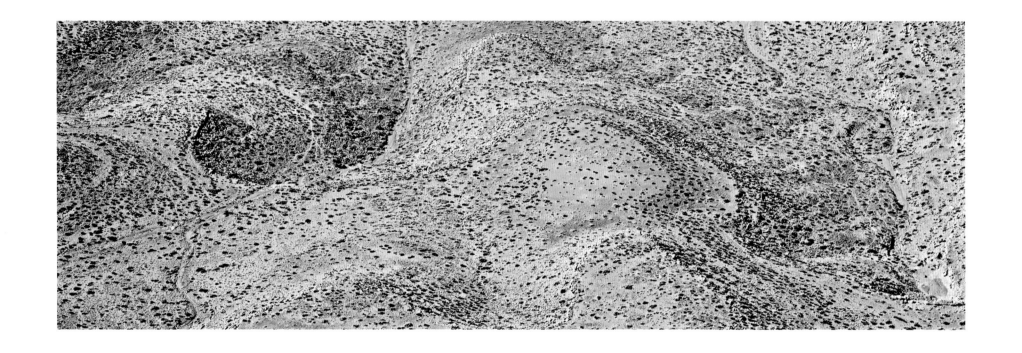

MESA TOPS FROM MULEY POINT.

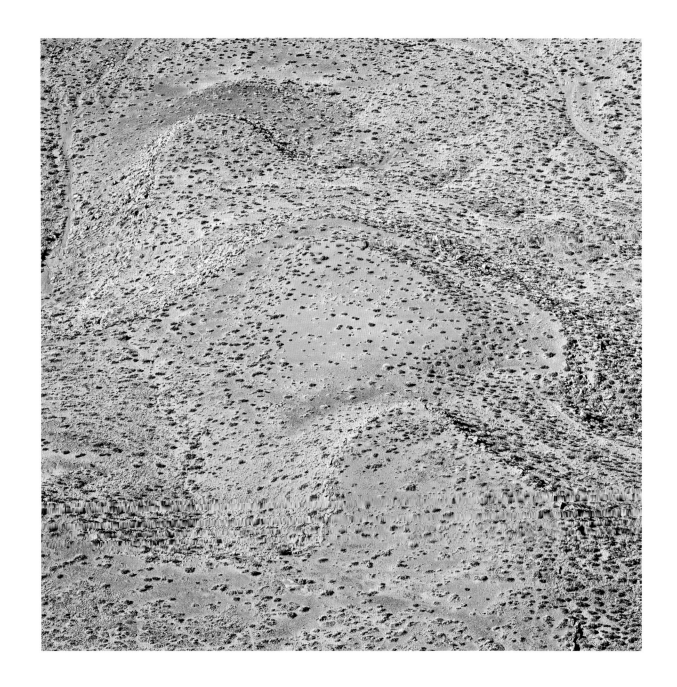

MESA TOPS FROM MULEY POINT.

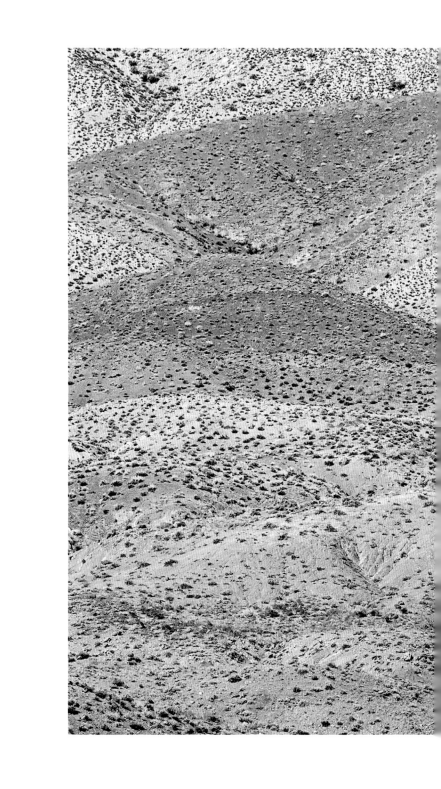

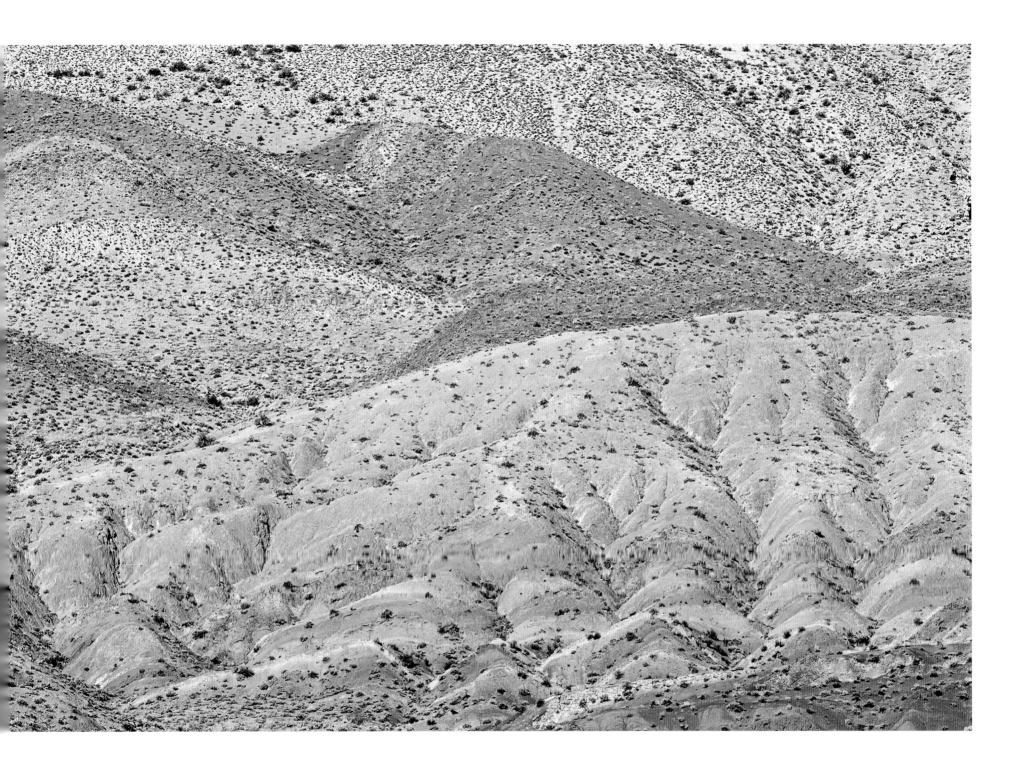

HILLSIDES WEST OF COMB WASH.

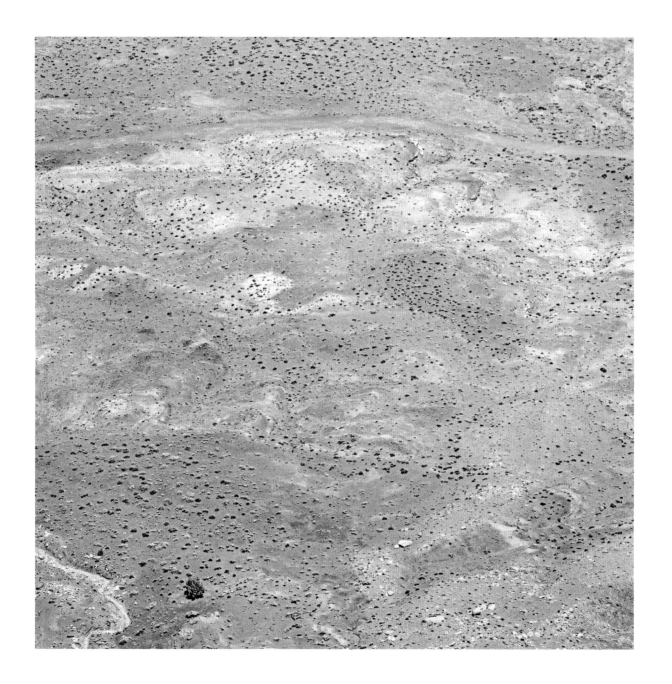

LANDSCAPE FROM NEEDLES OVERLOOK.

126

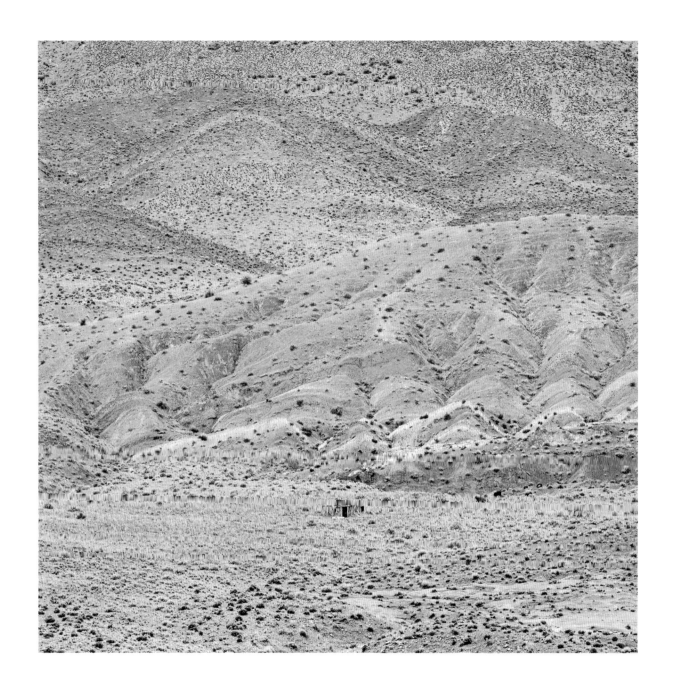

ABANDONED HOGAN WEST OF COMB WASH.

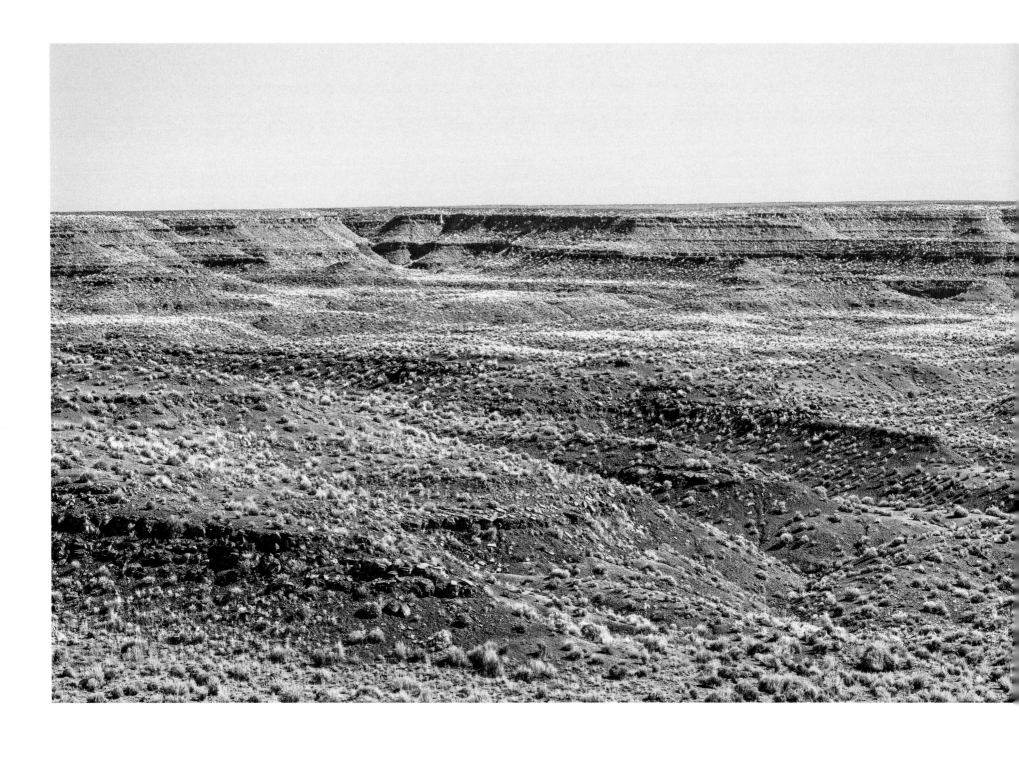

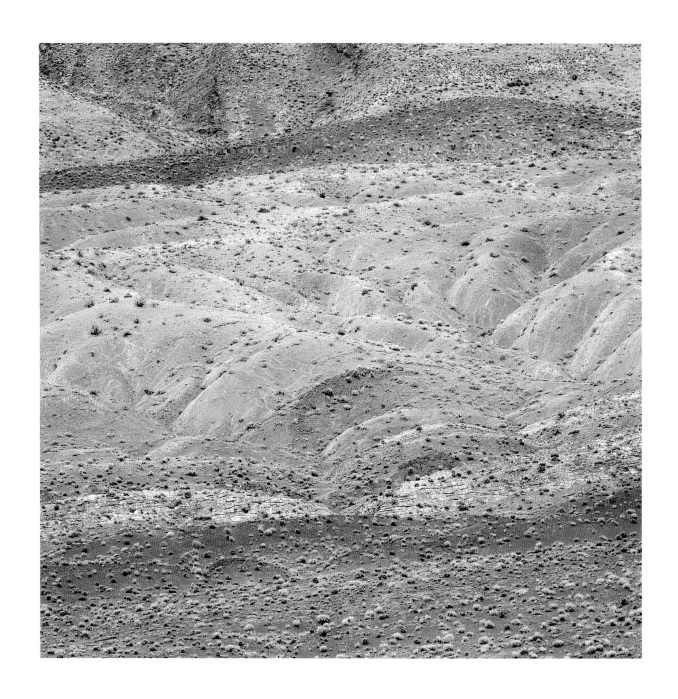

HILLS WEST OF COMB WASH.

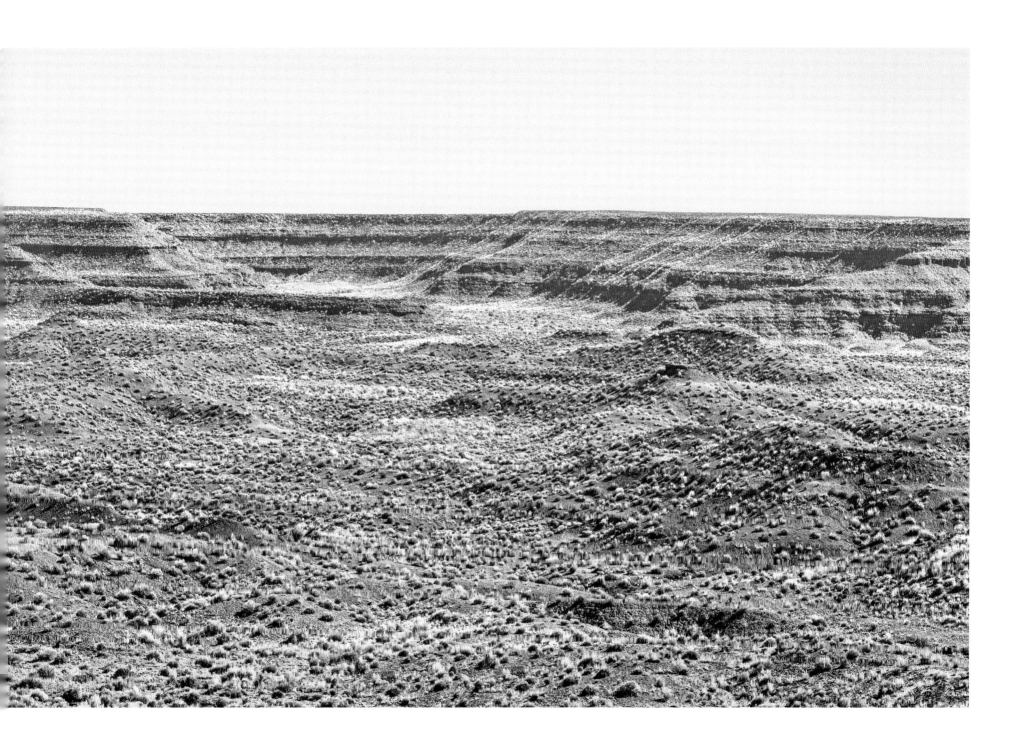

HILLSIDES NORTH OF VALLEY OF THE GODS.

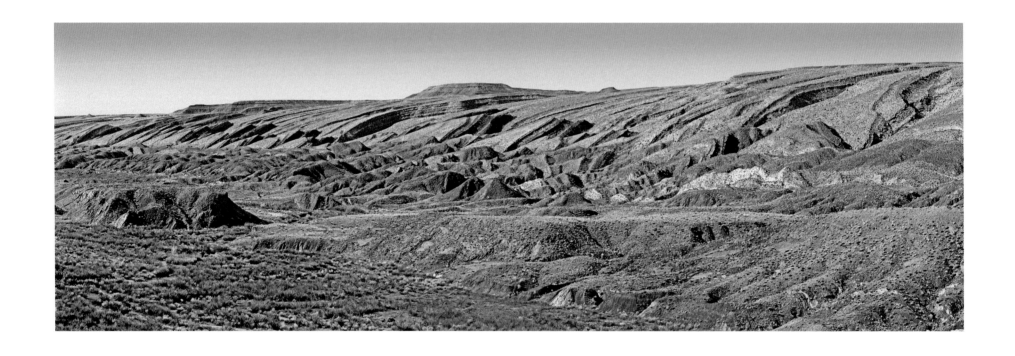

HILLSIDES WEST OF COMB WASH.

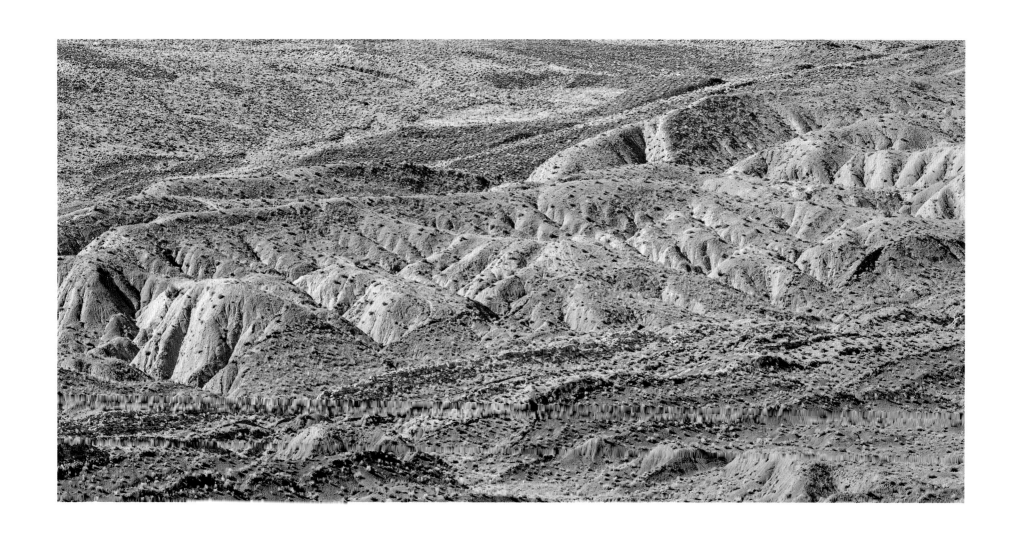

HILLSIDES WEST OF COMB WASH.

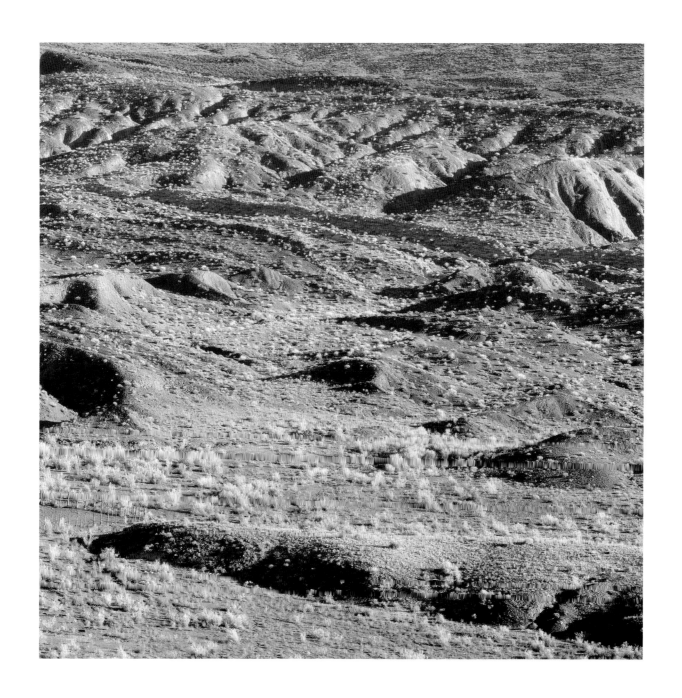

HILLSIDES WEST OF COMB WASH.

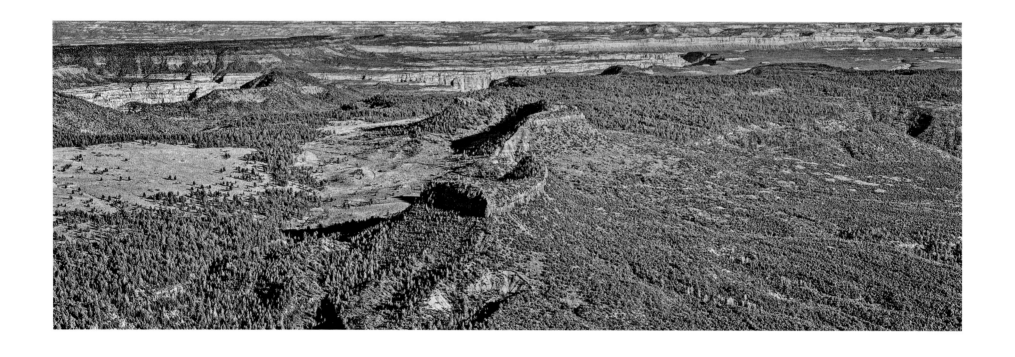

BEARS EARS (TWIN BUTTES, CENTER) LOOKING SOUTHEAST (AERIAL PHOTO).

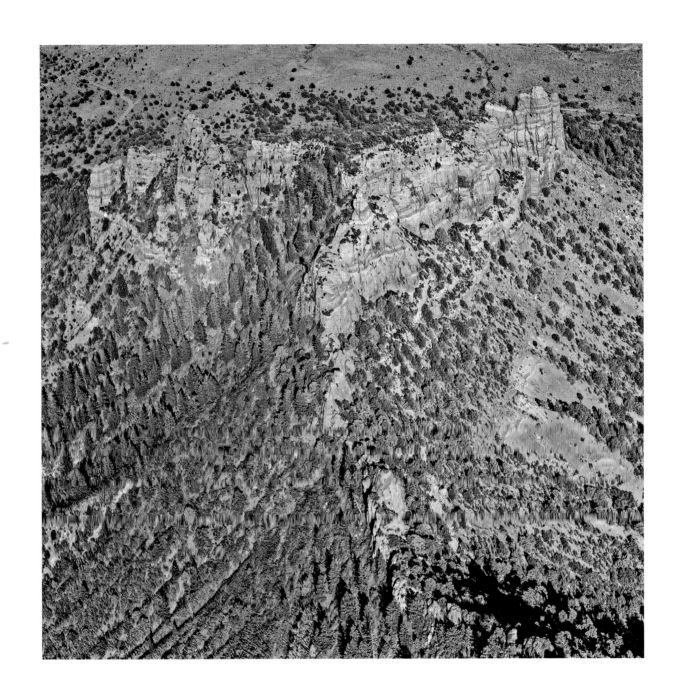

BOUNDARY BUTTE (AERIAL PHOTO).

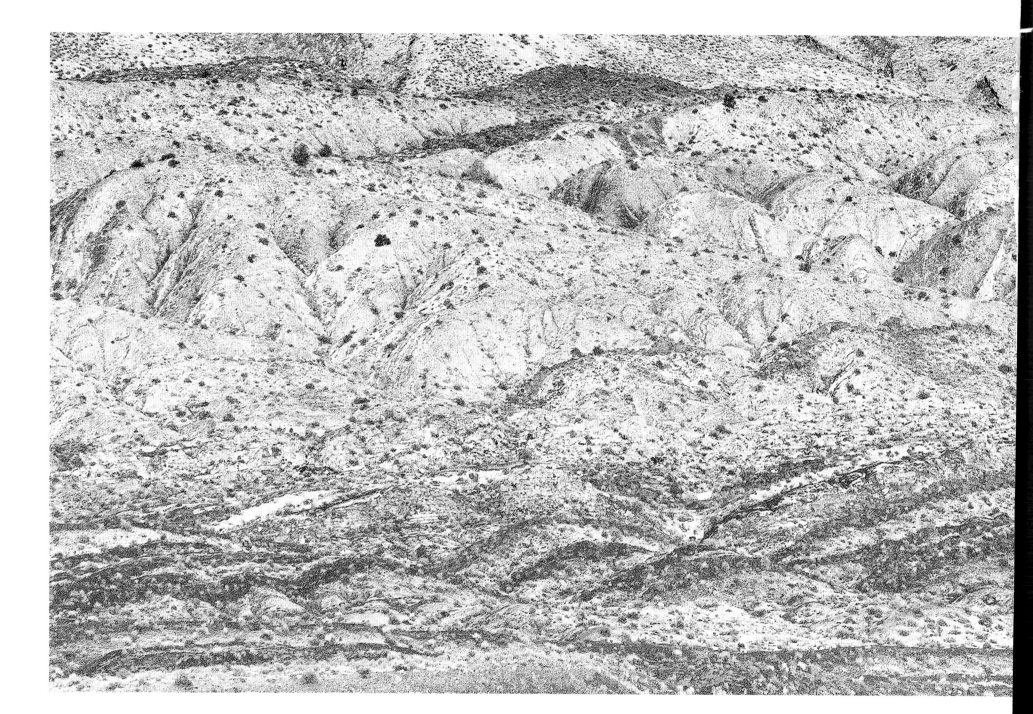

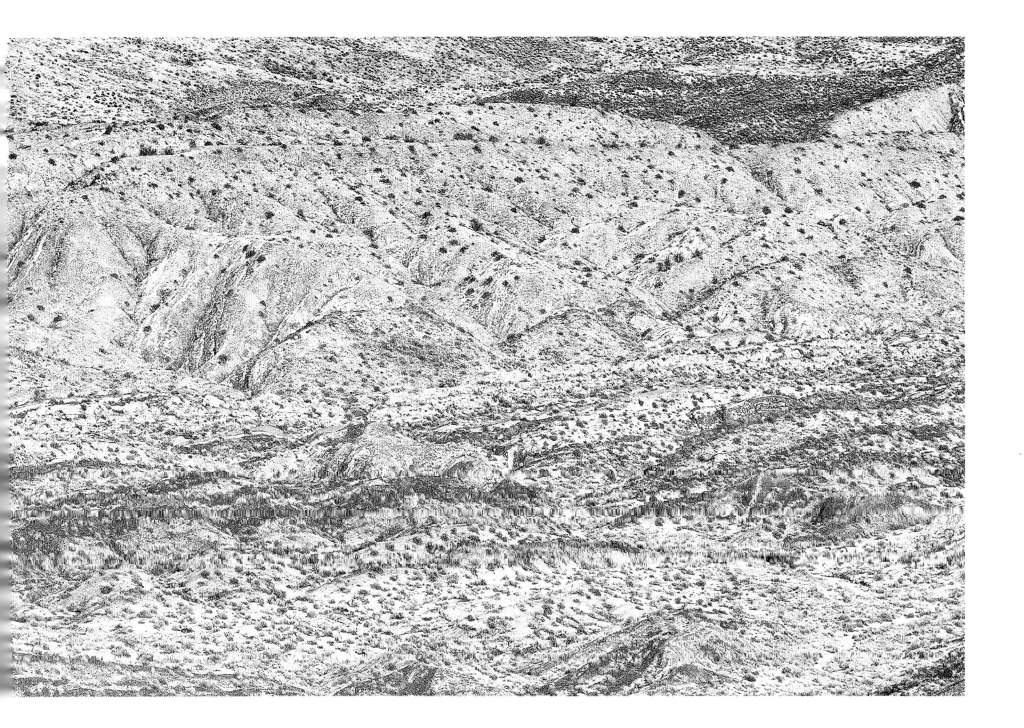

HILLSIDES WEST OF COMB WASH AFTER AN ICE STORM.

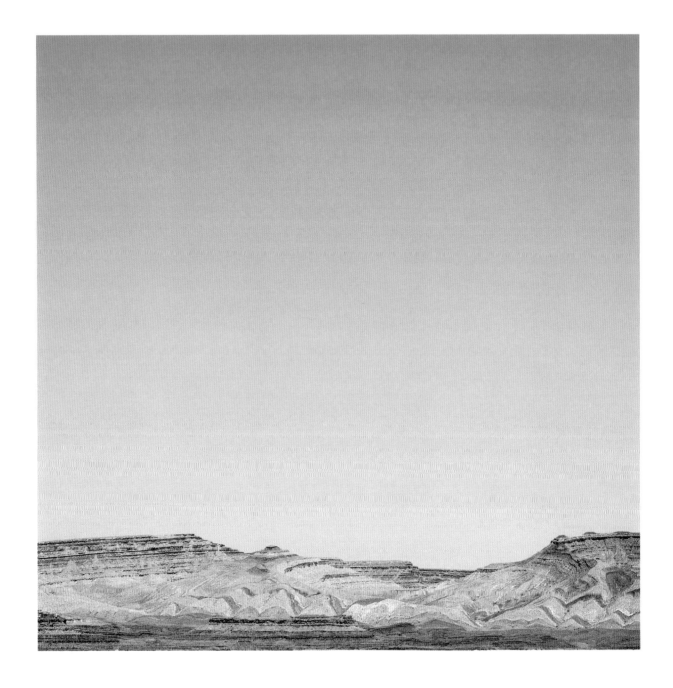

RAPLEE RIDGE.

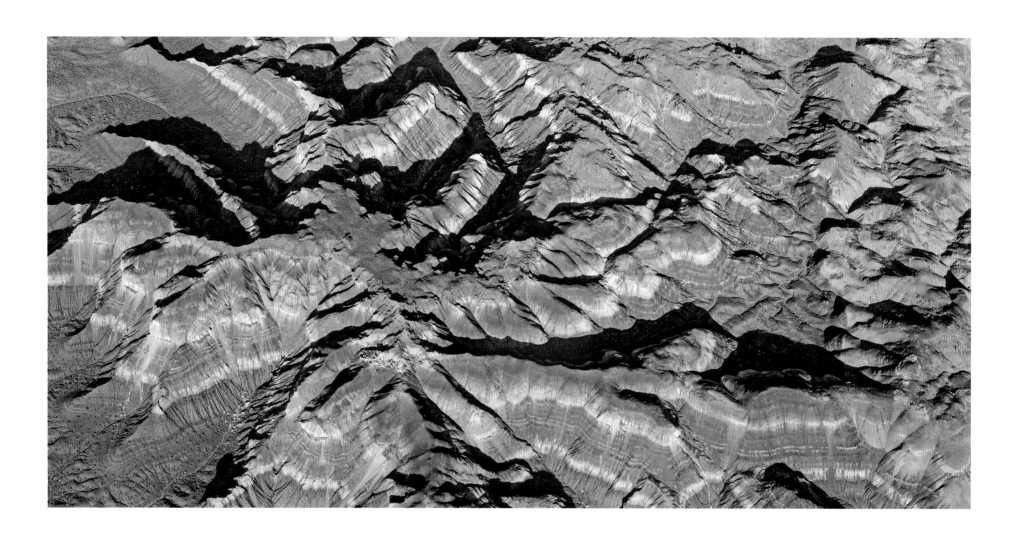

MUDHILLS NEAR CLAY HILLS CROSSING.

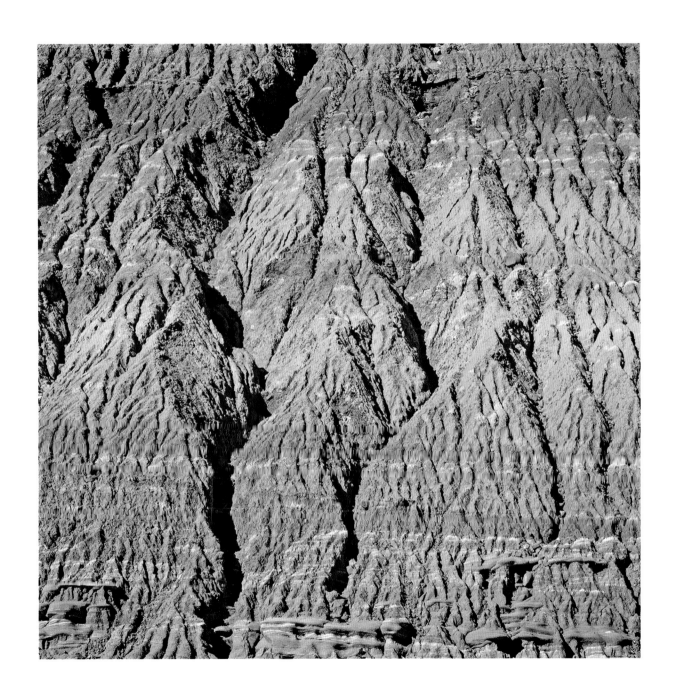

MUDHILLS NEAR CLAY HILLS PASS.

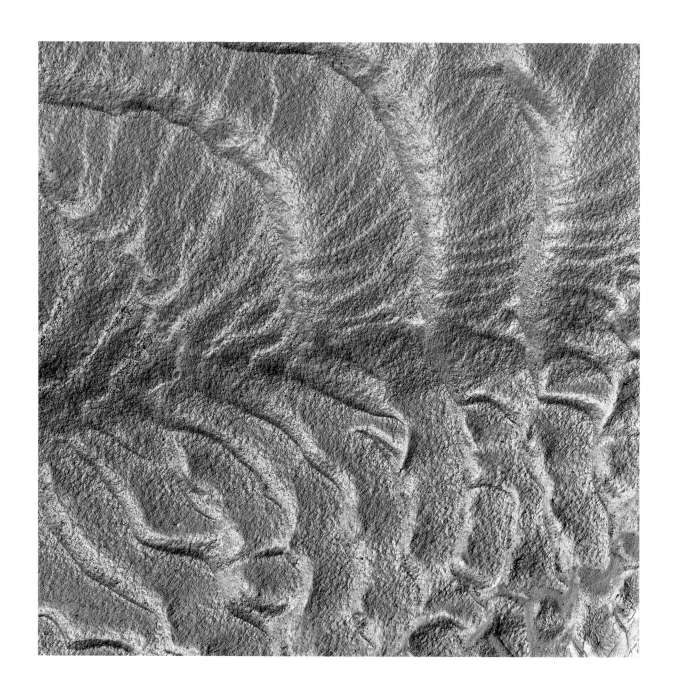

DRYING CREEK BED NEAR RED ROCK CANYON.

142

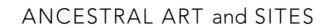

ANCESTRAL ART and SITES

The Bears Ears landscape is a complex of notes and memorials, hand-made testaments of hope and resilience in the American Southwest. Even without the ability to speak for itself, the place called Bears Ears reminds me: I am of this place.

The ancient springs, shelters, shrines, petroglyphs, pictographs, plants, and mineral-gathering places of the Bears Ears area once consecrated even long ago are blessed in perpetuity and must be protected.

—JIM ENOTE
ZUNI AND EXECUTIVE DIRECTOR OF THE A:SHIWI A:WAN MUSEUM AND HERITAGE CENTER

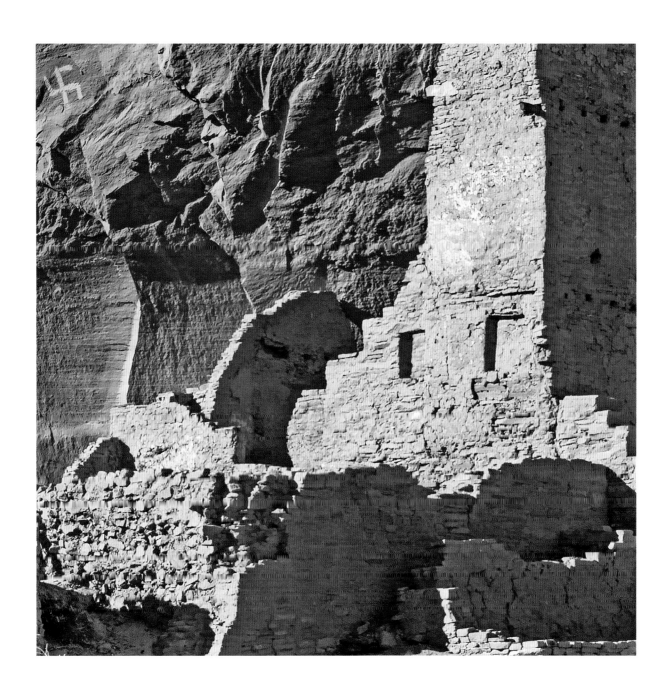

ANCESTRAL PUEBLOAN STRUCTURE.

PICTOGRAPHS (OPPOSITE) ARE SYMBOLS PAINTED ON A ROCK TO CONVEY A MESSAGE OR EVENT.

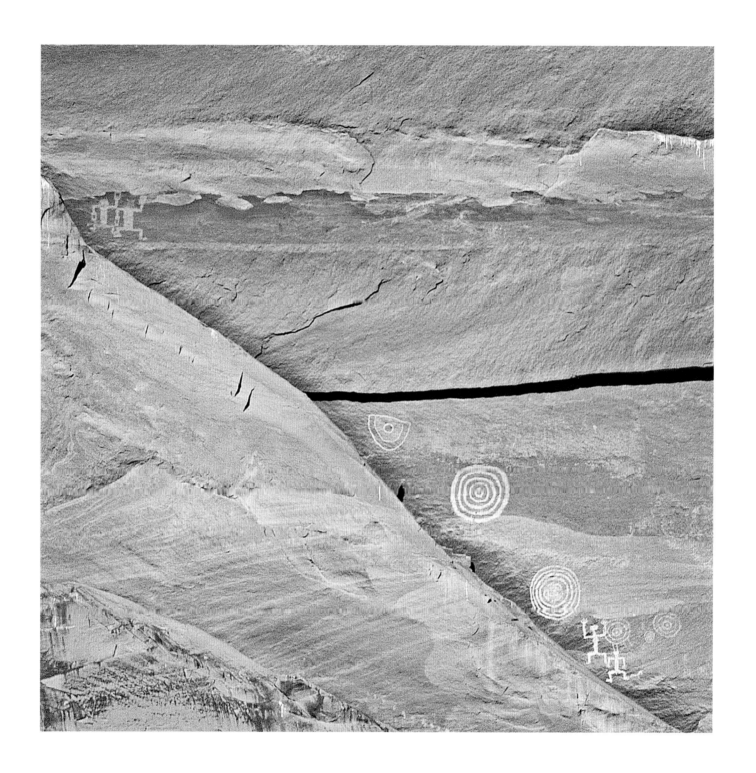

ANCESTRAL PUEBLOAN PICTOGRAPHS.

PETROGLYPHS (OPPOSITE) ARE SYMBOLS SCRATCHED OR CARVED ON A ROCK BY A SMALL STONE TO CONVEY AN EVENT OR MESSAGE.

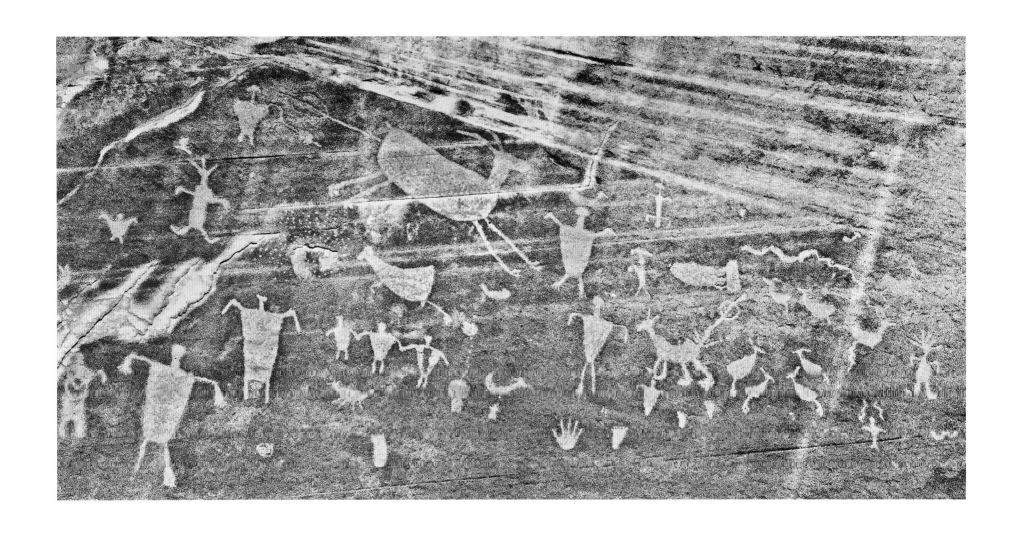

ANCESTRAL PUEBLOAN PETROGLYPHS.

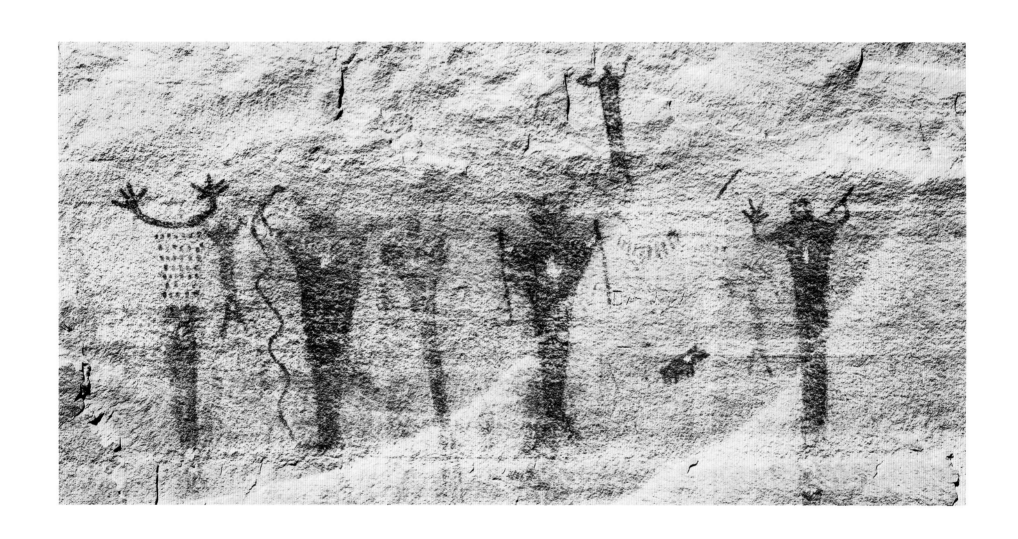

ANCESTRAL PUEBLOAN PICTOGRAPHS.

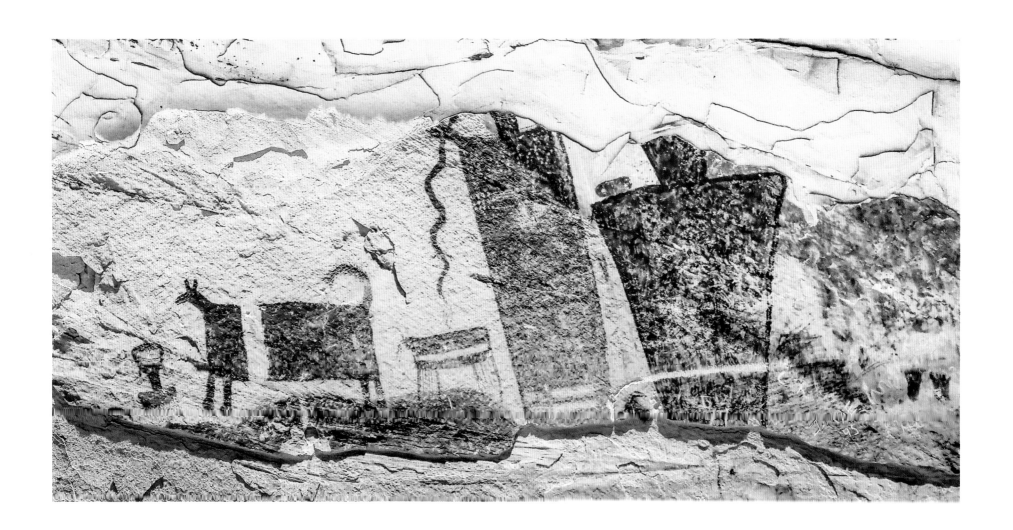

ANCESTRAL PUEBLOAN PICTOGRAPHS.

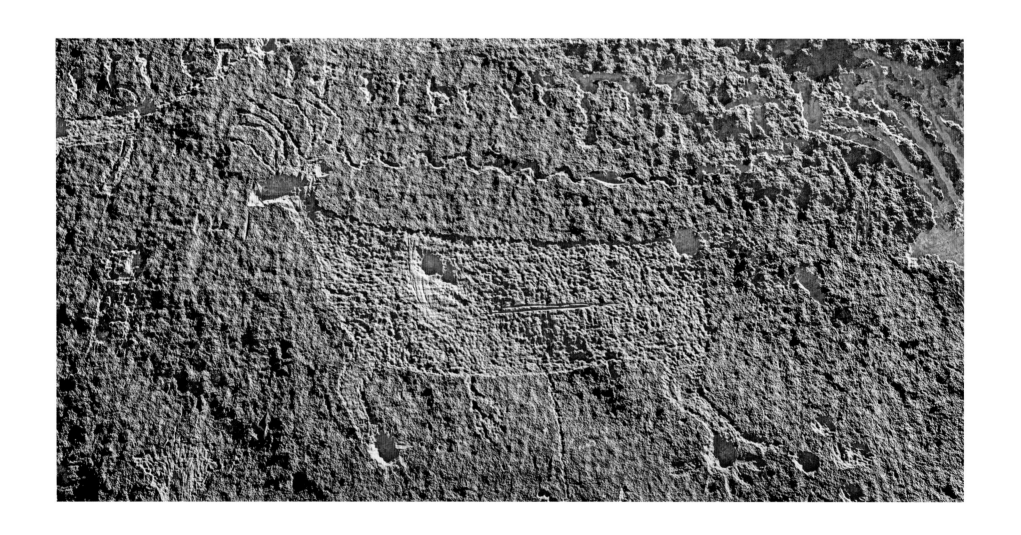

ANCESTRAL PUEBLOAN PETROGLYPHS.

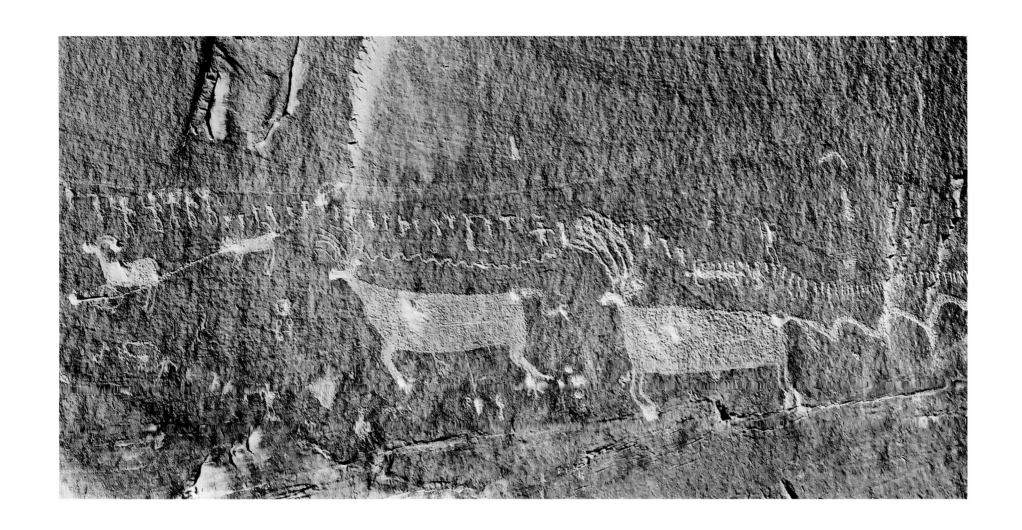

ANCESTRAL PUEBLOAN PETROGLYPHS.

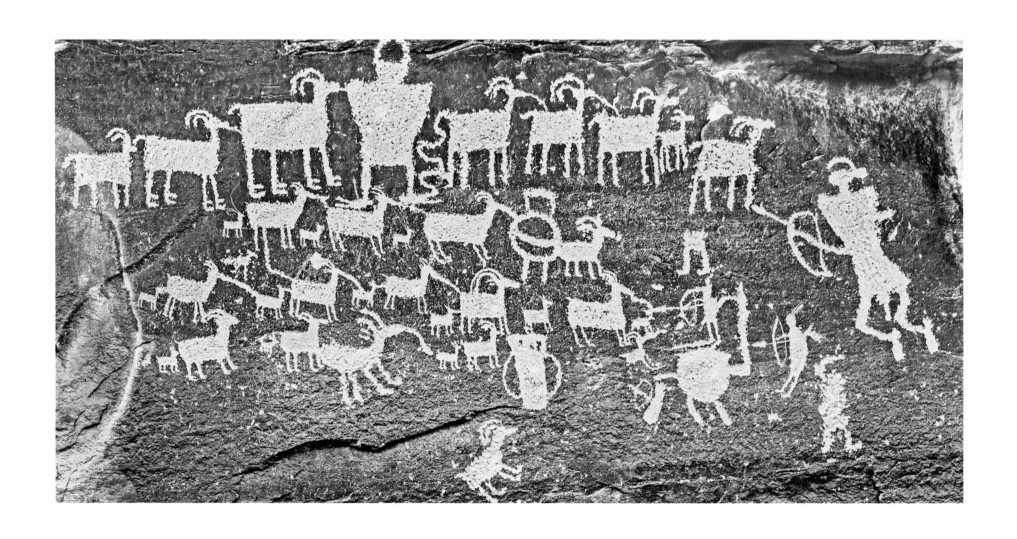

ANCESTRAL PUEBLOAN PETROGLYPHS.

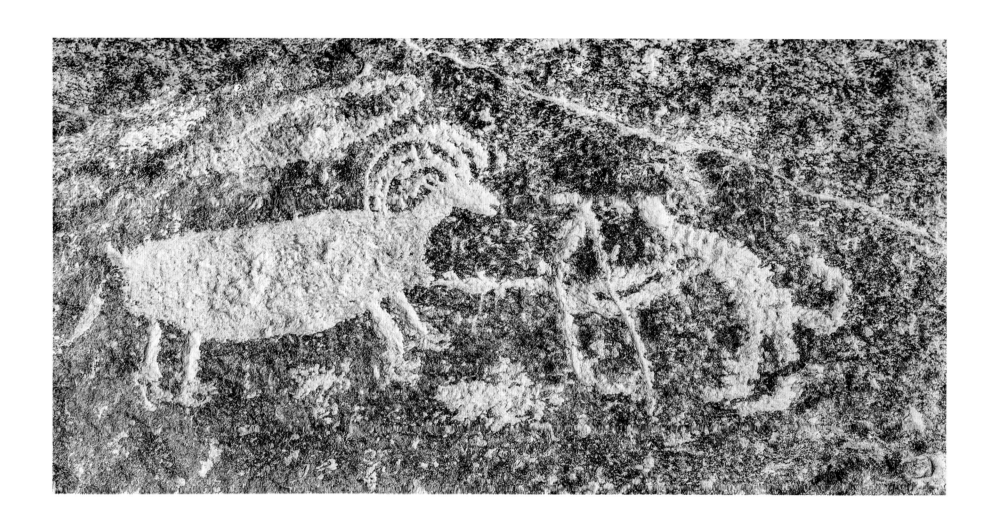

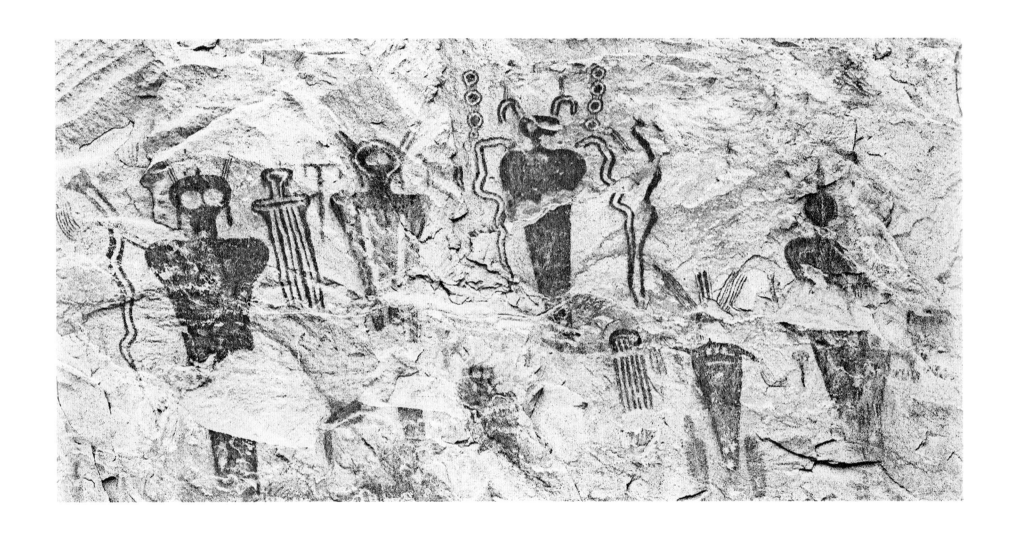

ANCESTRAL PUEBLOAN PICTOGRAPHS.

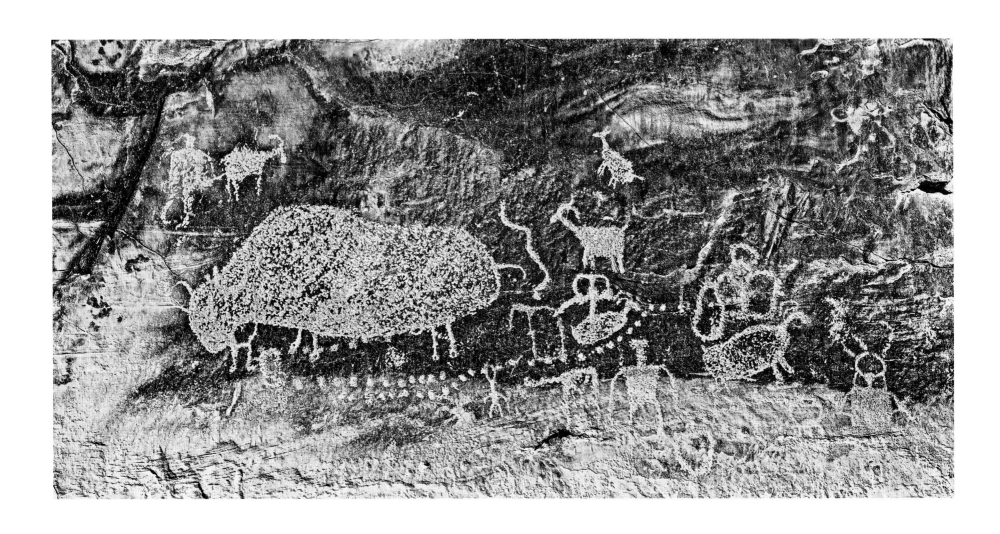

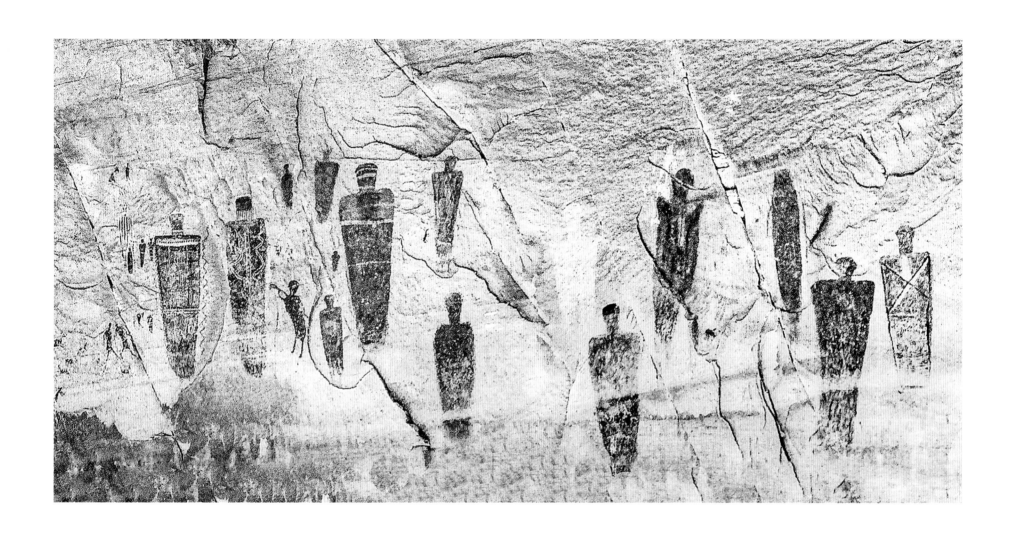

ANCESTRAL PUEBLOAN PICTOGRAPHS.

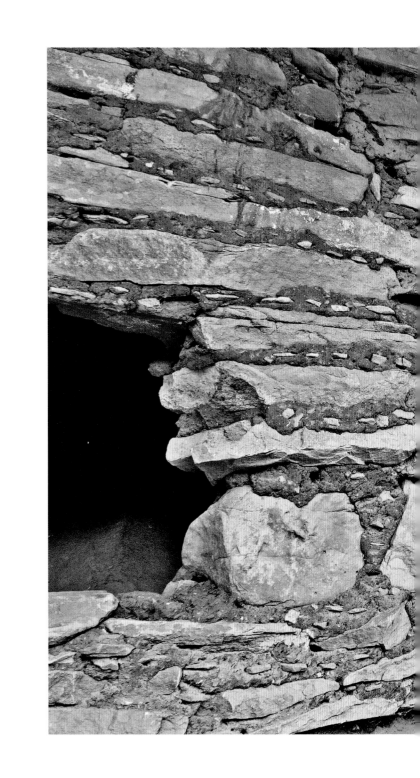

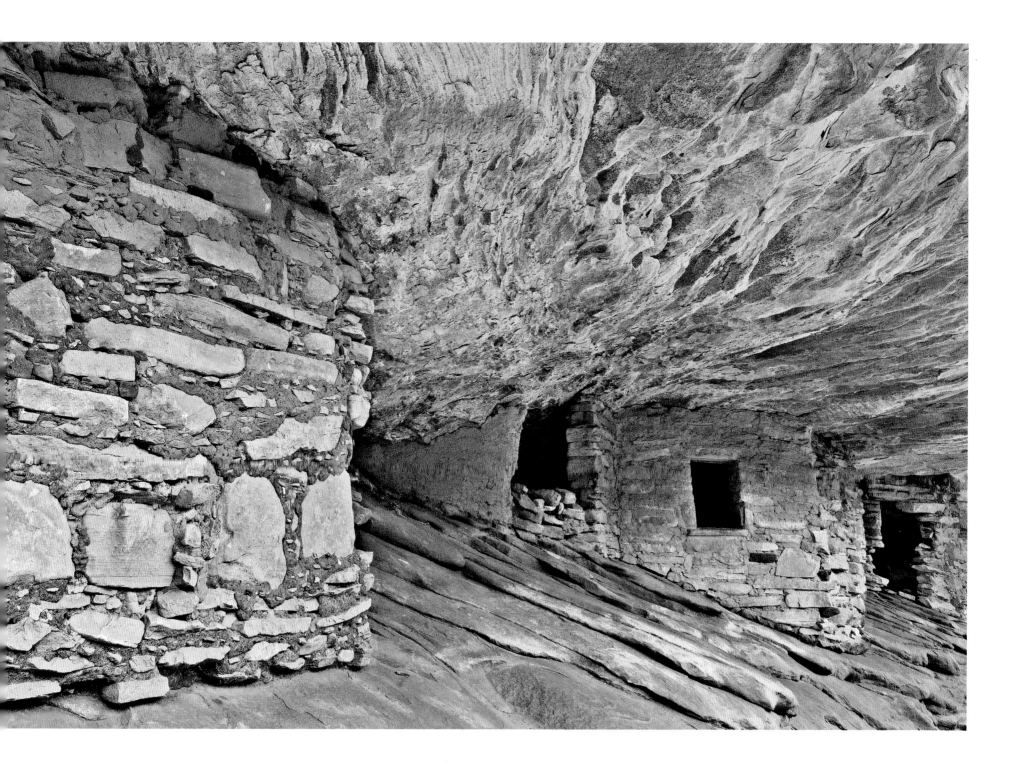

HOUSE ON FIRE RUIN.

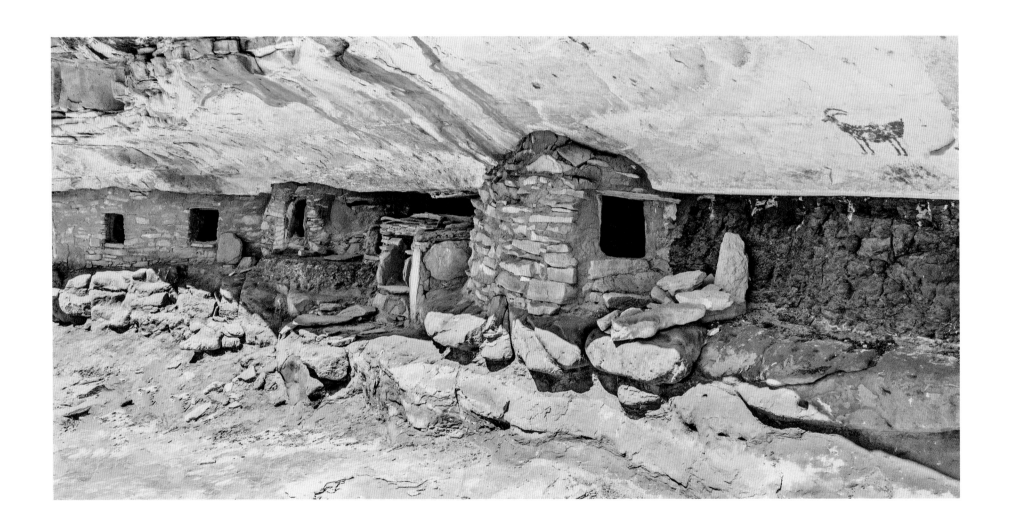

ANCESTRAL PUEBLOAN STRUCTURE.

SANDSTONE

We have and still do cherish these lands. We were physically forced off these lands. Our grandmothers and grandfathers were killed trying to stay in their homes on this land. It is time that we, all American Indians, be recognized as American citizens, as part of the public, with the same rights to speak on behalf of our public lands.

We remain hopeful that a time of healing created by our own renewed involvement for these lands may be upon us. Preserving our shared public lands will require that we come respectfully together and work constructively.

—WILLIE GRAYEYES
BOARD CHAIR, UTAH DINÉ BIKÉYAH

When I explore below the Bears Ears buttes, I understand what this country can do for all of us. Here, we come as close as we ever can to sensing the power of the relationship that Native people have with their homeland. Here, we reconnect with our own relationship to wild country. Here, as the Bears Ears Inter-Tribal Coalition so eloquently tells us, we have a rare chance for restoration and healing.

—MARK UDALL
U.S. SENATOR FROM COLORADO (2009–2015)

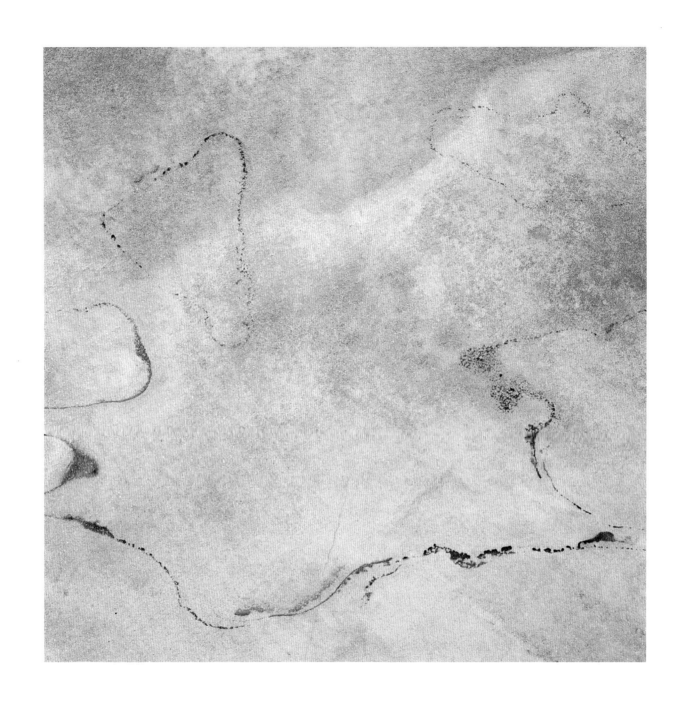

SANDSTONE PATTERN.

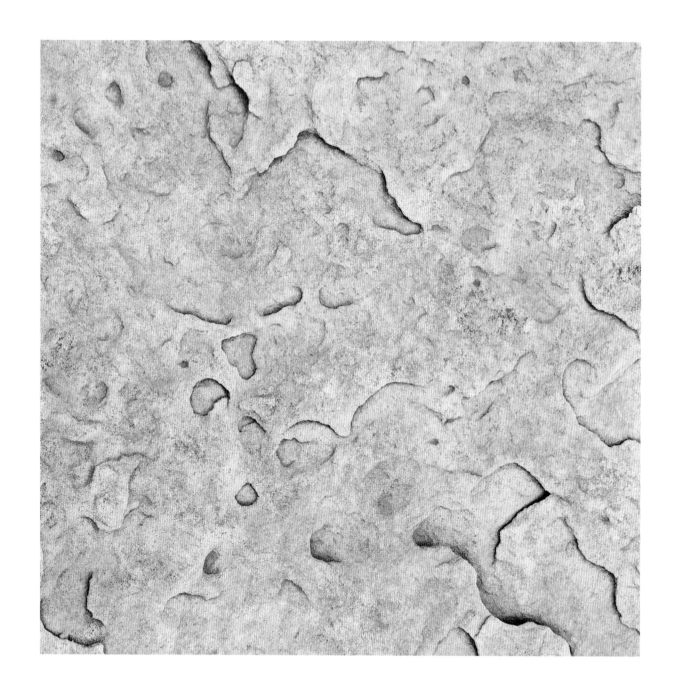

LAYERED SANDSTONE.

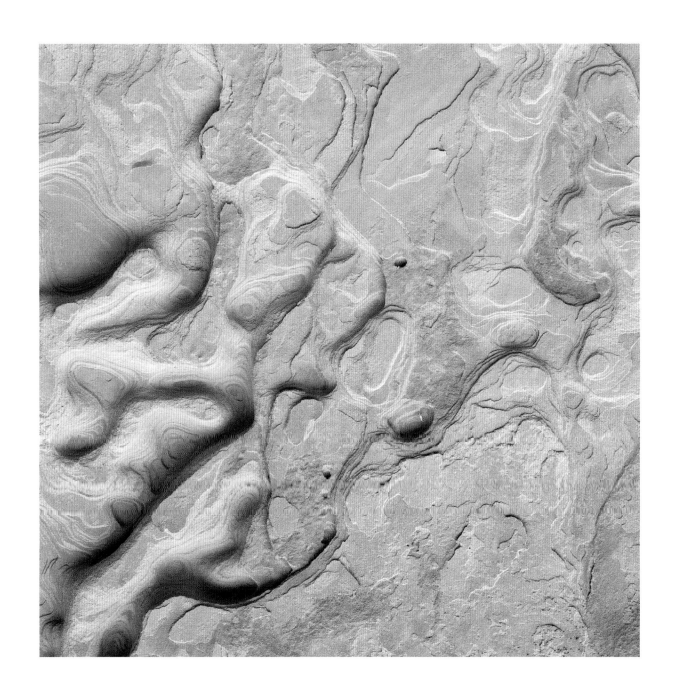

ERODED SANDSTONE.

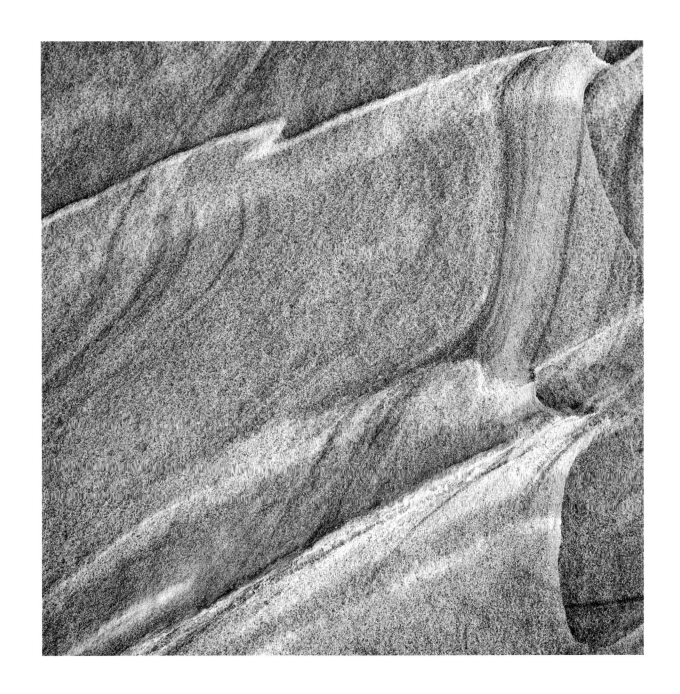

SANDSTONE LAYERS.

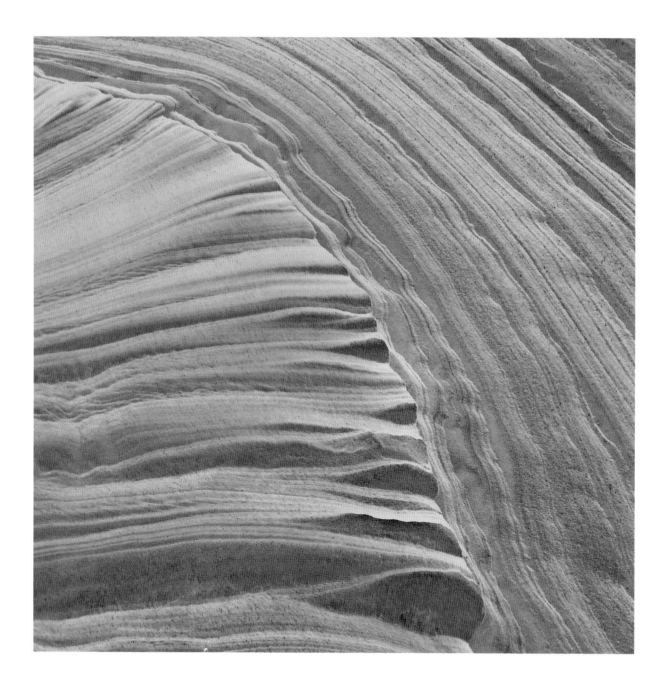

ERODED SANDSTONE.

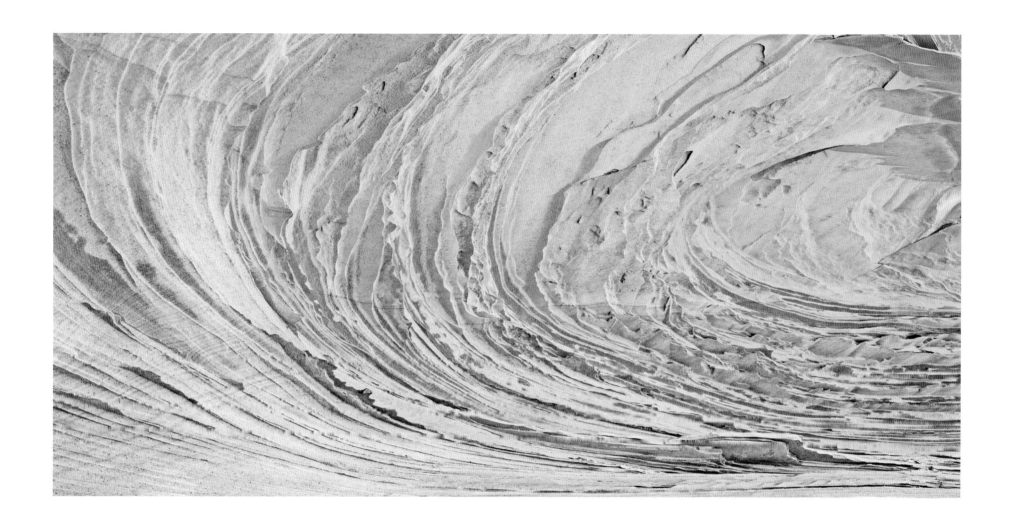

LAYERED SANDSTONE.

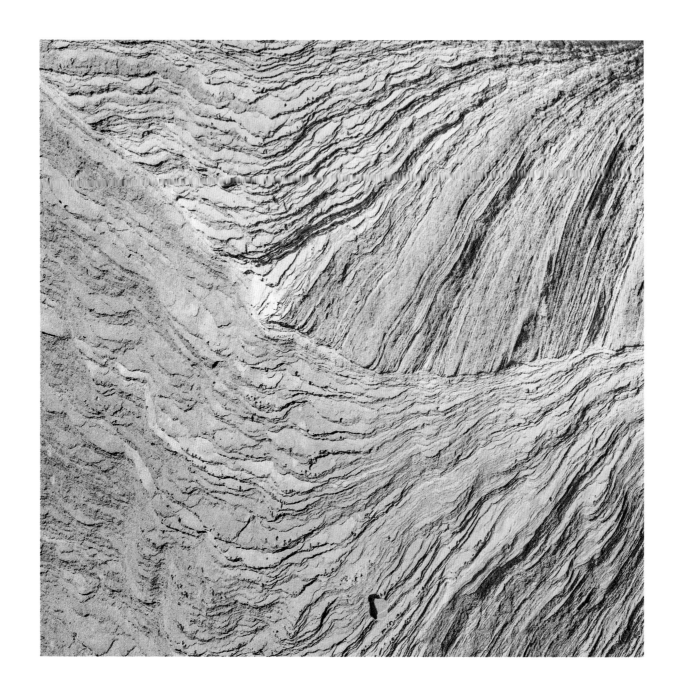

LAYERED SANDSTONE.

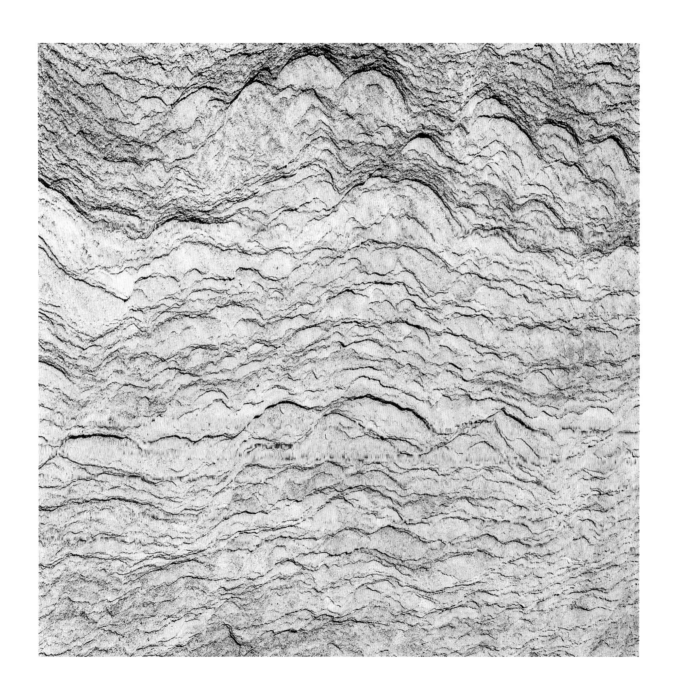

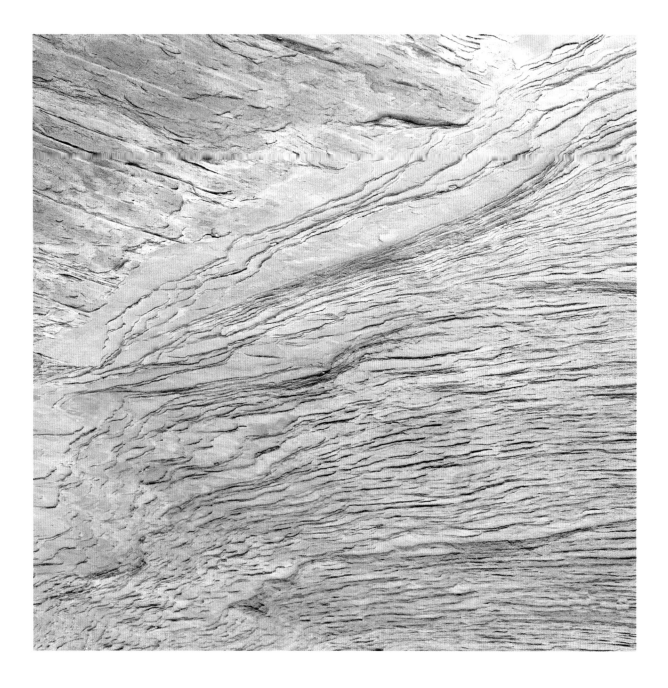

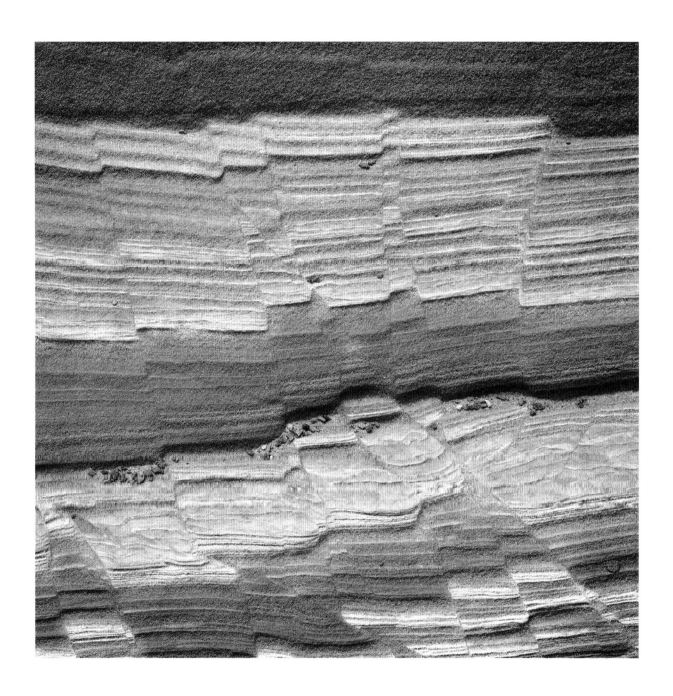

LAYERED SANDSTONE.

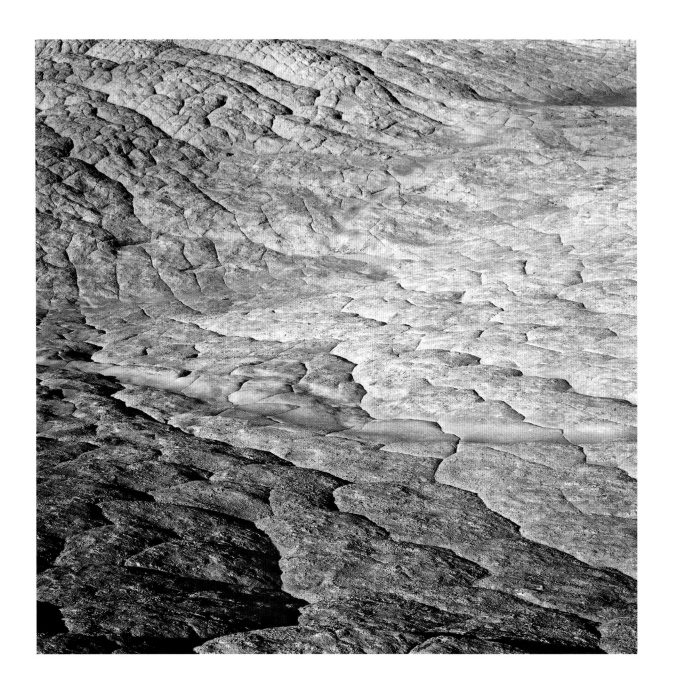

POLYGONAL PATTERN OF LAYERED SANDSTONE.

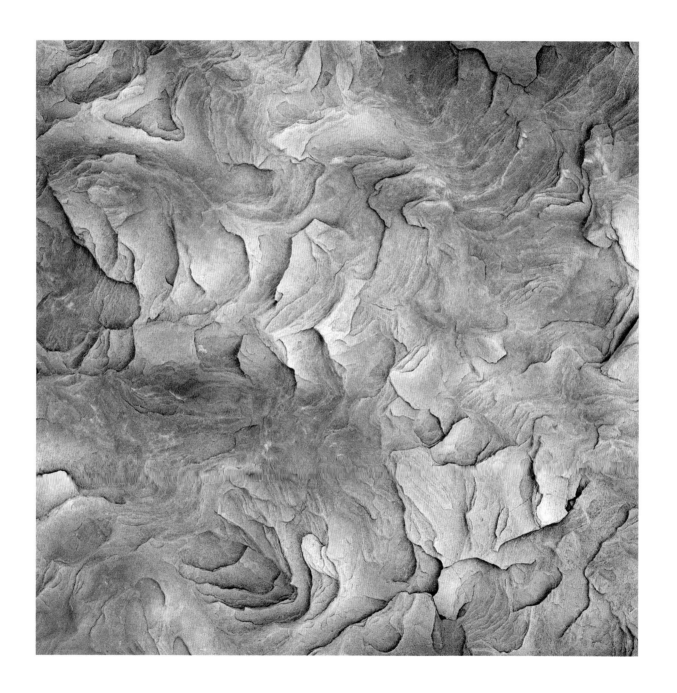

LAYERED SANDSTONE.

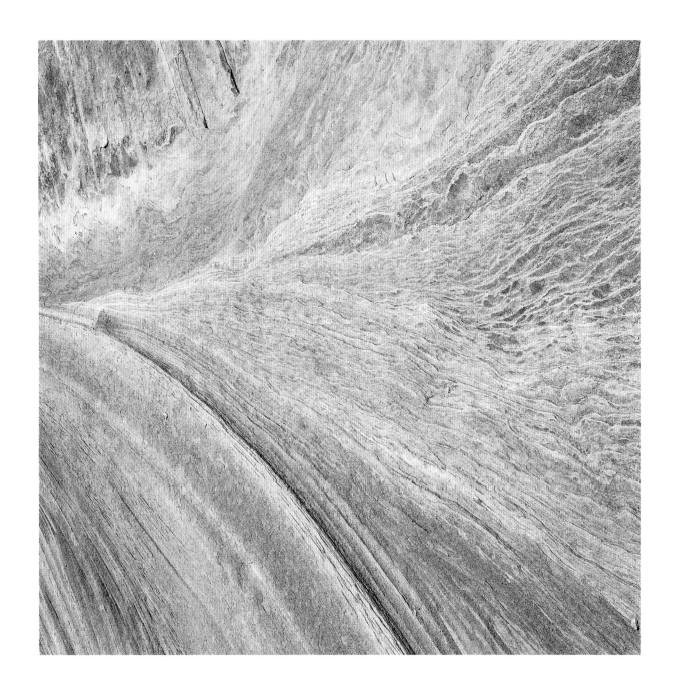

LAYERED SANDSTONE.

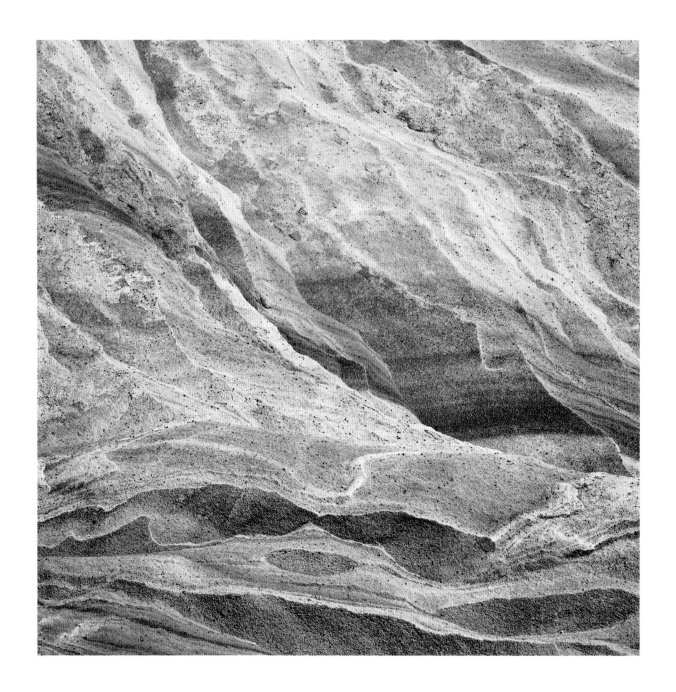

LAYERED SANDSTONE.

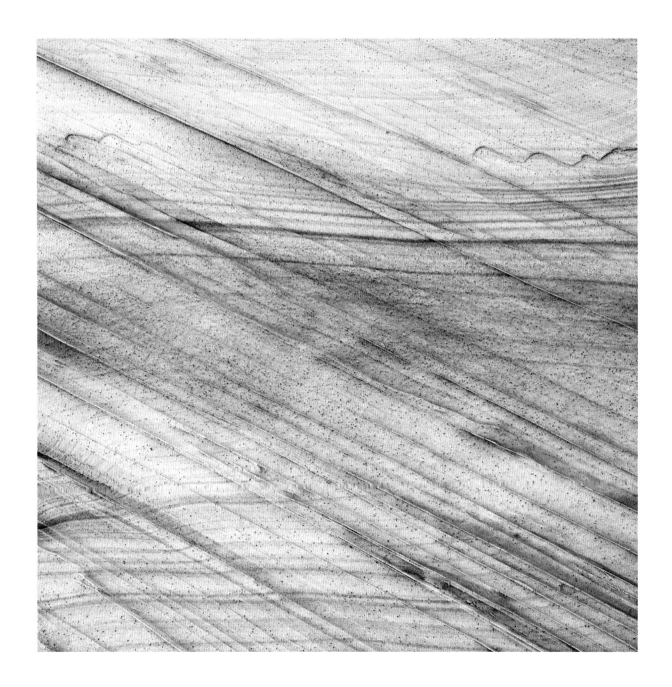

LAYERED SANDSTONE.

179

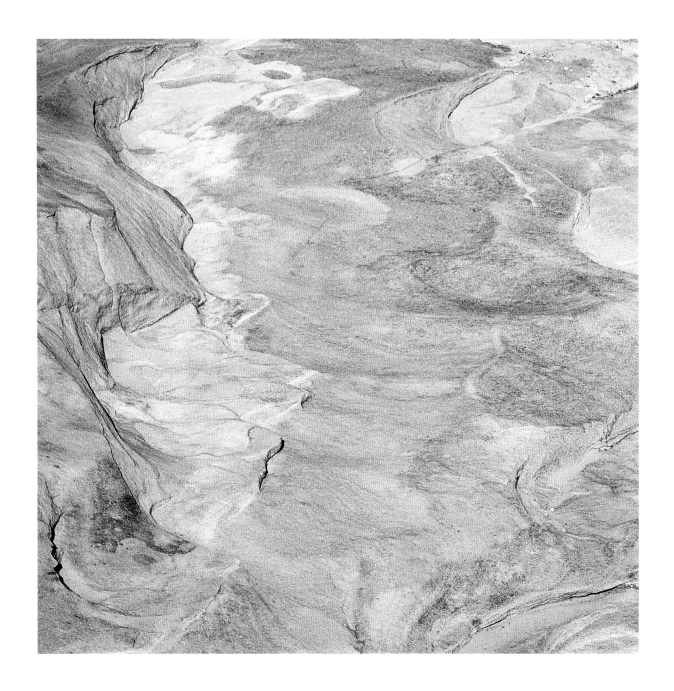

ERODED SANDSTONE.

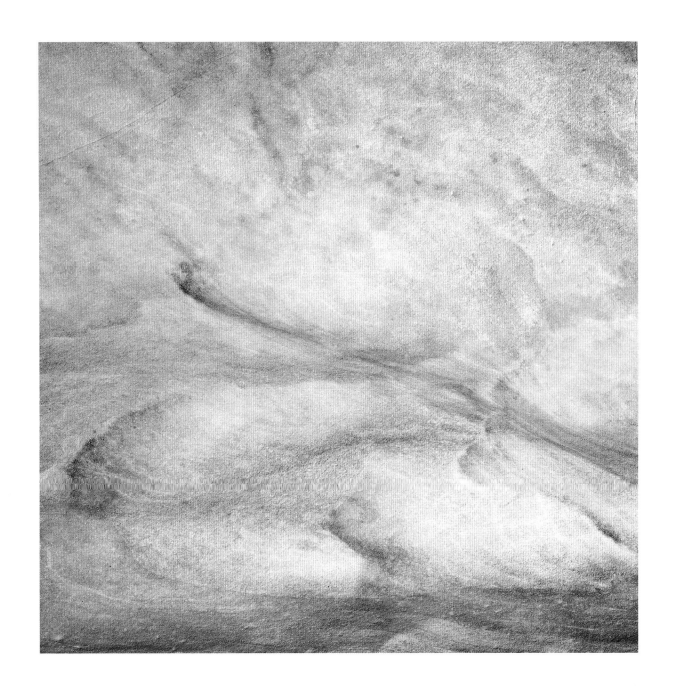

ERODED SANDSTONE.

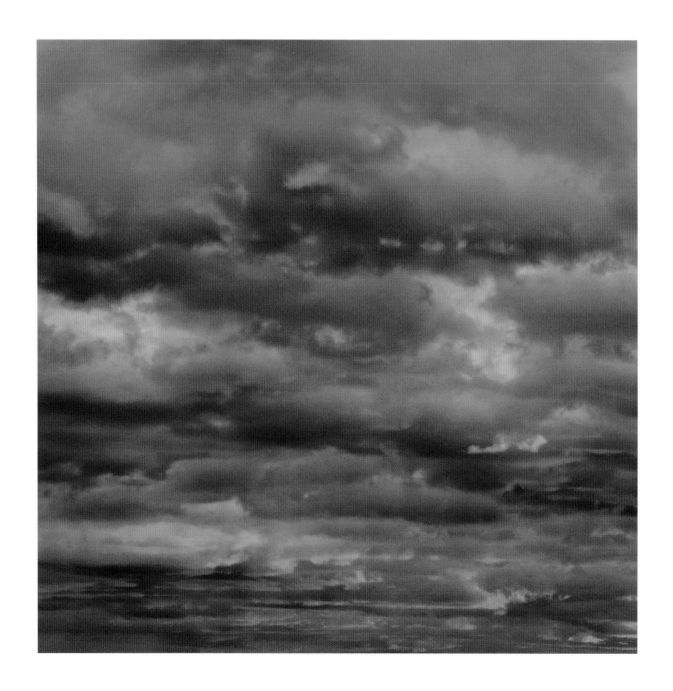

CLOUDS SOUTH OF MONTICELLO.

182

AT SUNSET

We need places like this. A lot of [visitors] don't understand it when they go to this place that has a lot of solitude. Somewhere along the line they may have lost something, the true essence of being human. But your inner human still has it; subconsciously, you still have it. So when they come out here, they feel a feeling that they've never had before. It's a good feeling. I think when they go back to the city they yearn to be back again.

We wear shoes now. But back then, when our feet touched the earth, there was the connection there. So every now and then I'll go there and take my shoes off and just put my toes in the sand. A lot of people, when they go to the beach they'll run their feet through the sand and that's when that connection [comes] back. It's an awesome feeling, and we can do that out here. If [visitors] learn about things like that, and we teach them to connect back to the earth for themselves, I think it will help them understand more about who they are and where they want to be and where they want to go.

—ALFRED LOMAHQUAHU
VICE CHAIRMAN, HOPI TRIBE, AND CO-CHAIR, BEARS EARS INTER-TRIBAL COALITION

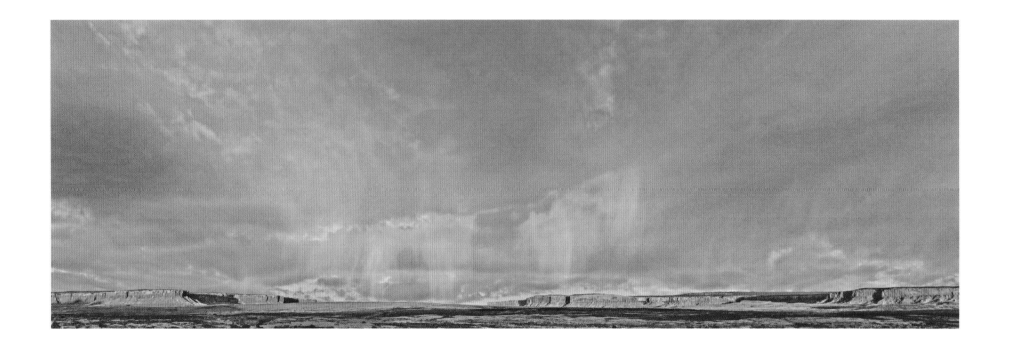

MONSOON RAIN WEST OF BLUFF.

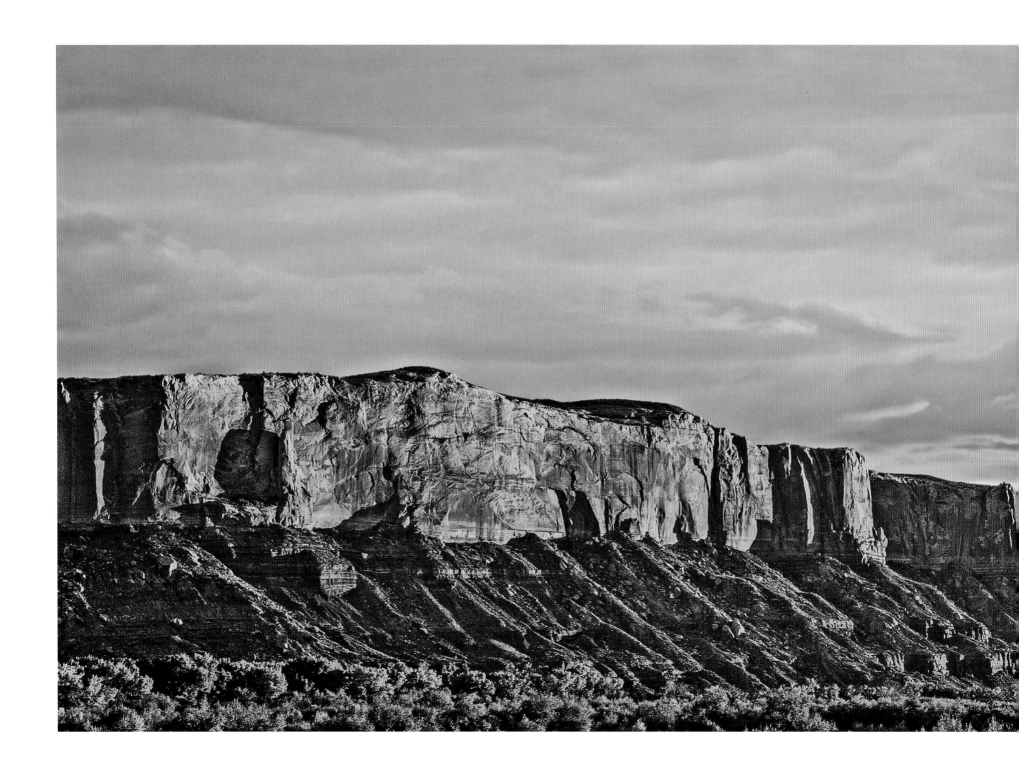

MESA ADJACENT TO THE SAN JUAN RIVER NEAR BLUFF.

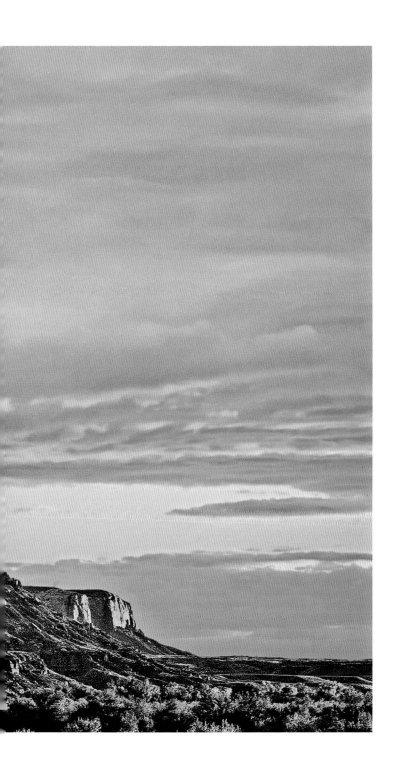

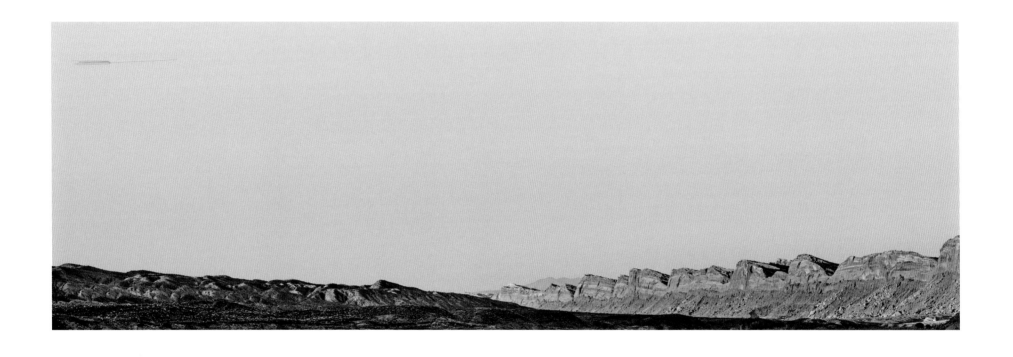

COMB RIDGE (RIGHT).

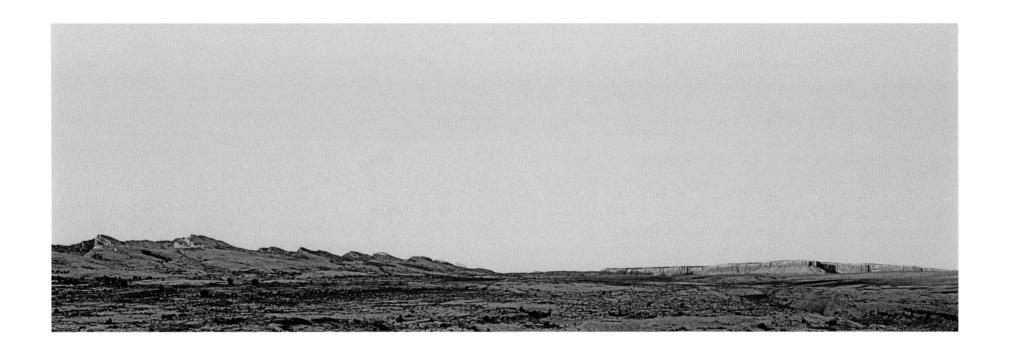

COMB RIDGE (LEFT) AND TANK MESA (RIGHT).

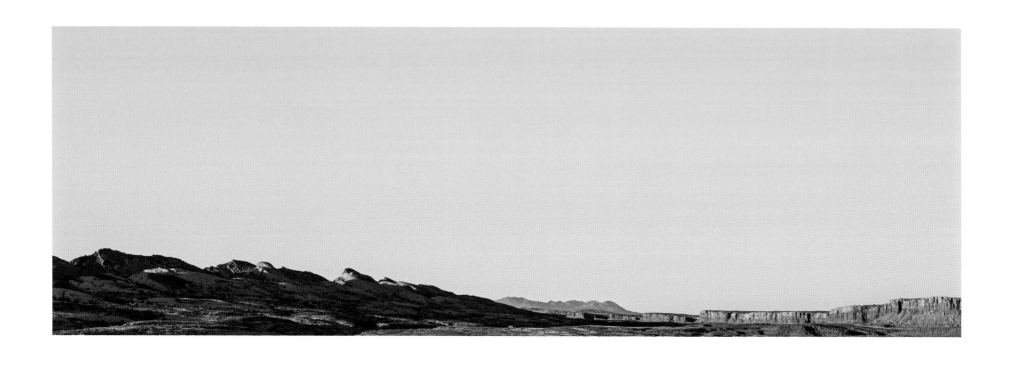

COMB RIDGE (LEFT) AND BLUFF BENCH (RIGHT) WITH THE ABAJO MOUNTAINS (CENTER) IN THE DISTANCE.

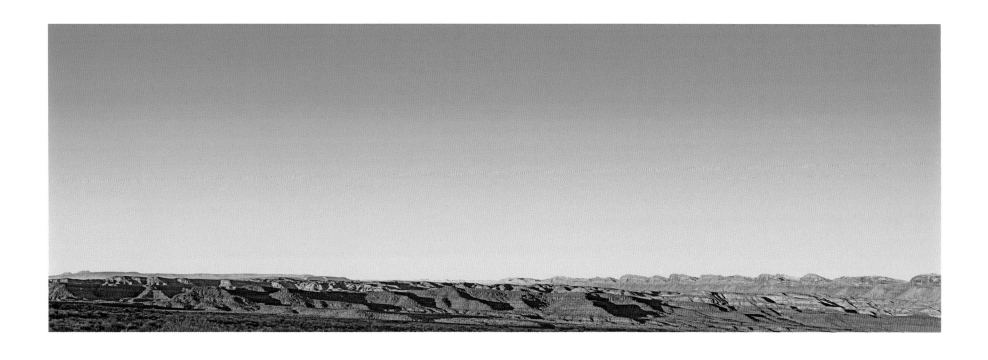

MESAS AND COMB RIDGE (CENTER-RIGHT).

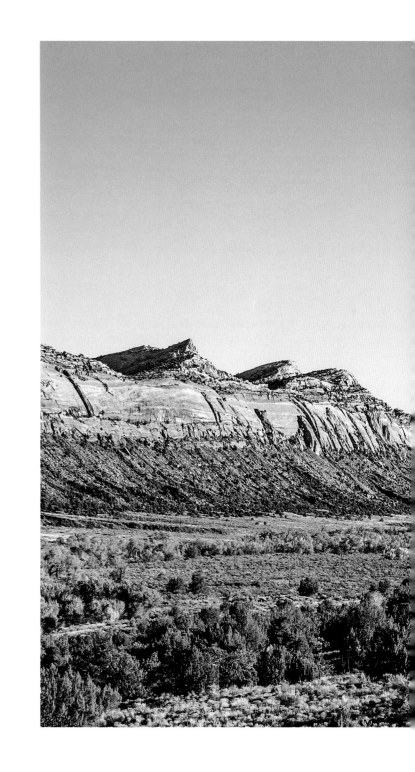

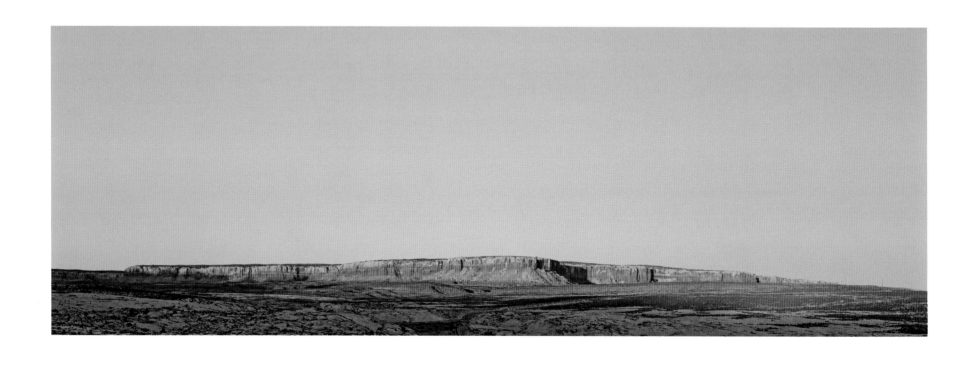

BLUFF BENCH.

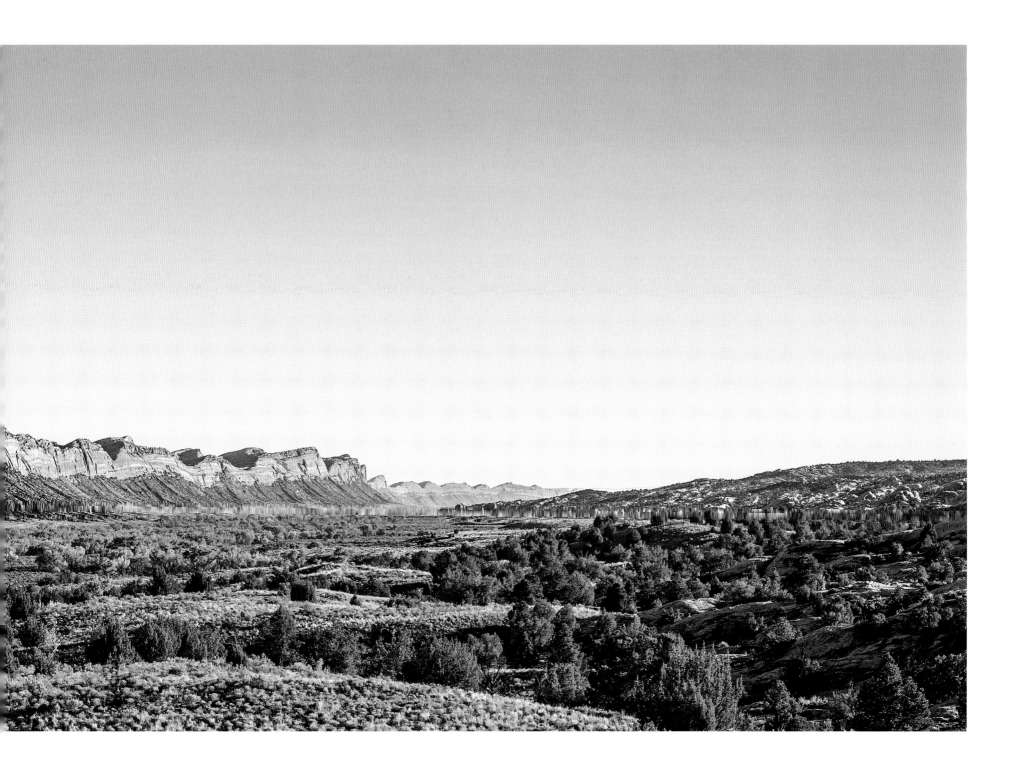

COMB RIDGE.

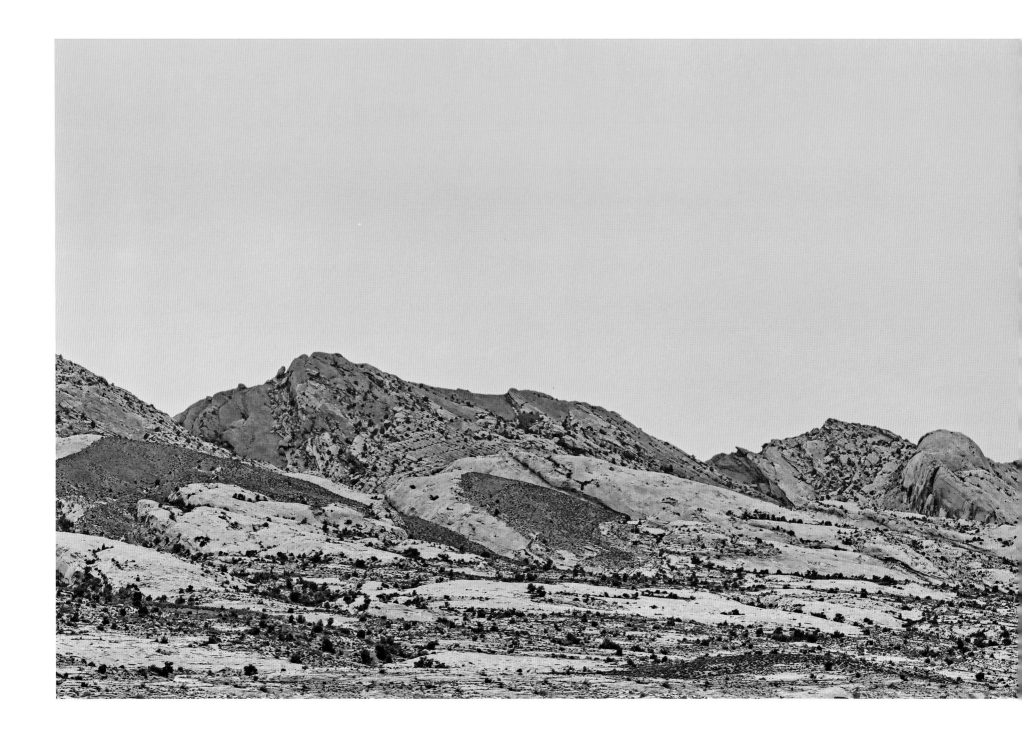

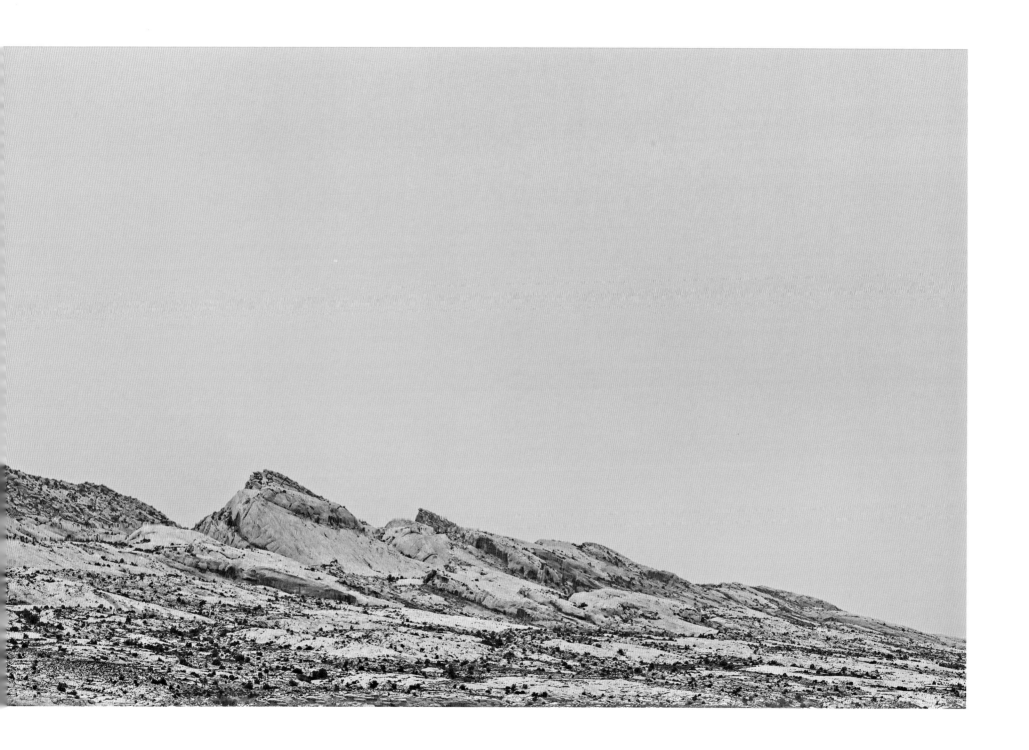

COMB RIDGE AFTER A FOREST FIRE.

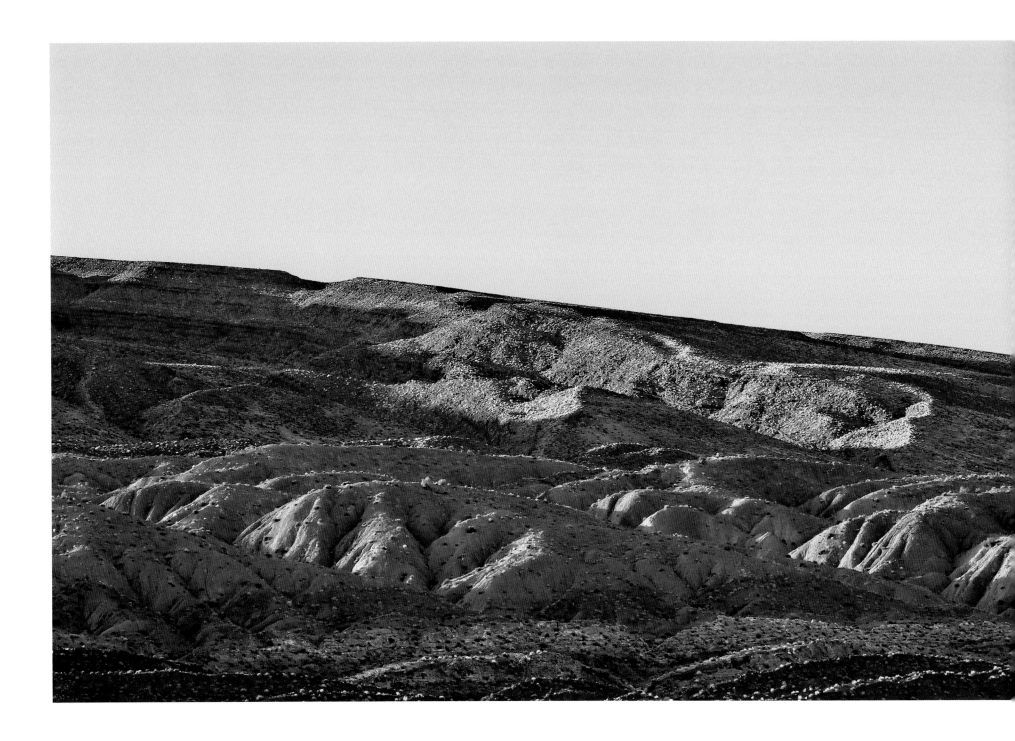

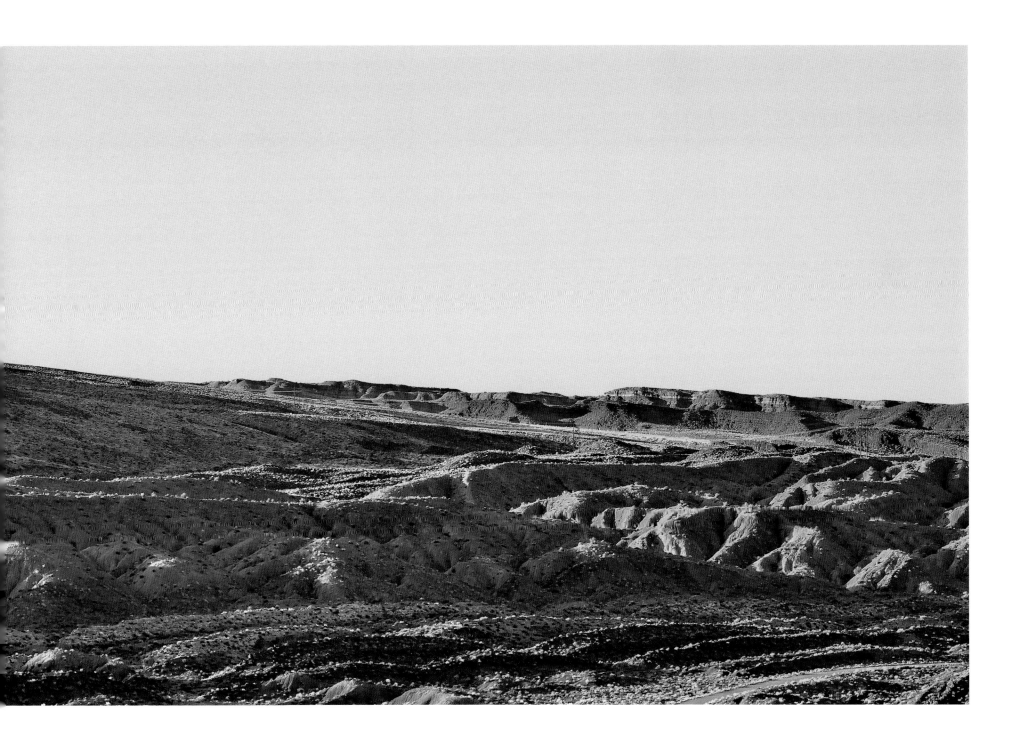

HILLSIDES WEST OF COMB WASH.

197

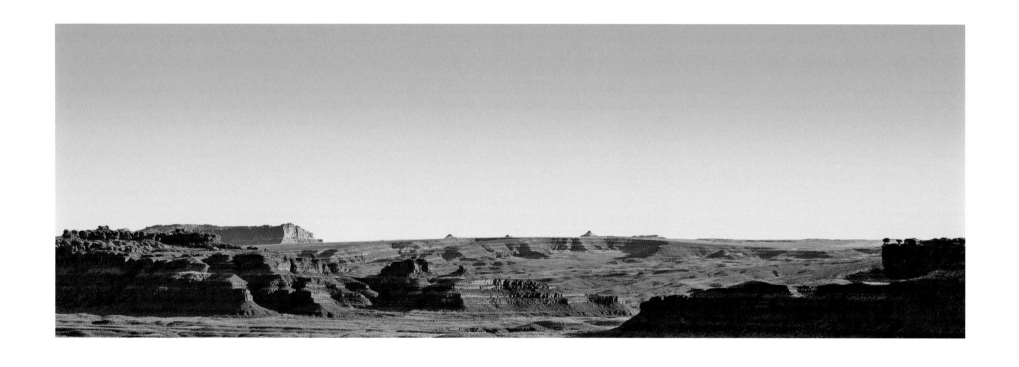

MESAS AND SPIRES IN VALLEY OF THE GODS.

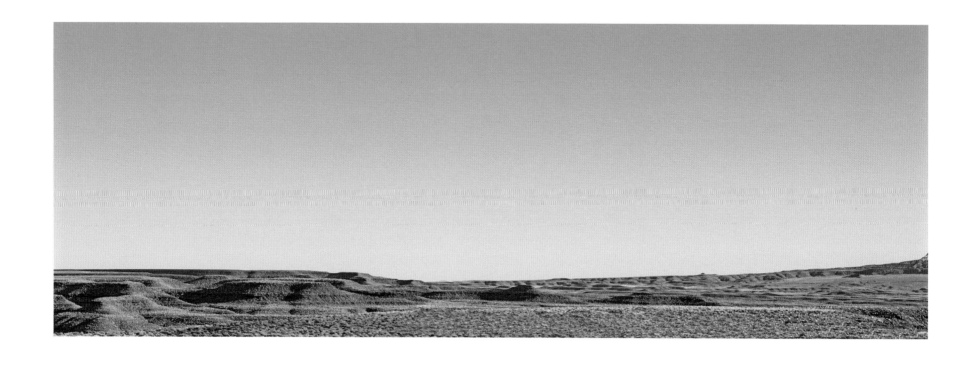

MESAS NORTH OF VALLEY OF THE GODS.

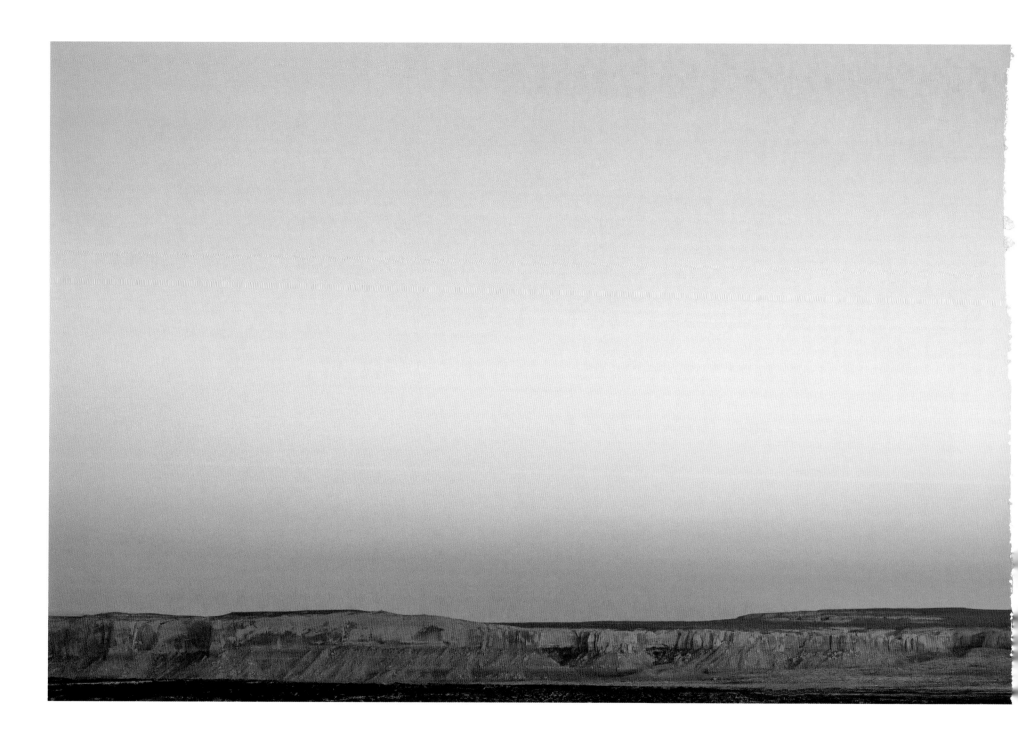

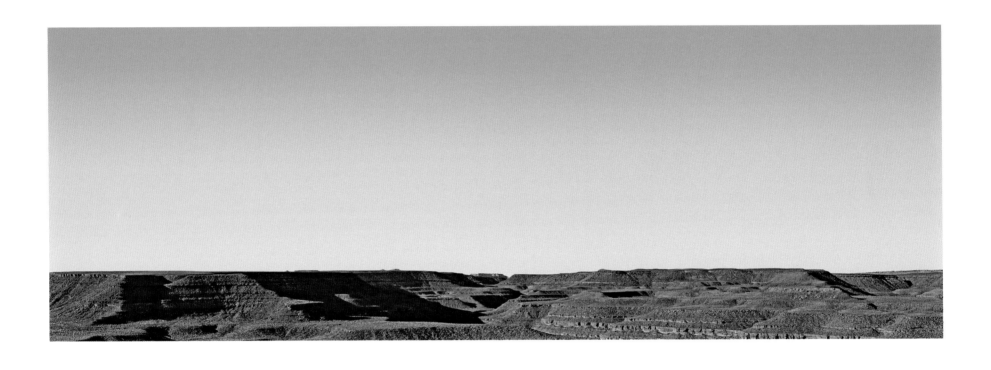

MESAS NEAR GOOSENECKS OF THE SAN JUAN RIVER.

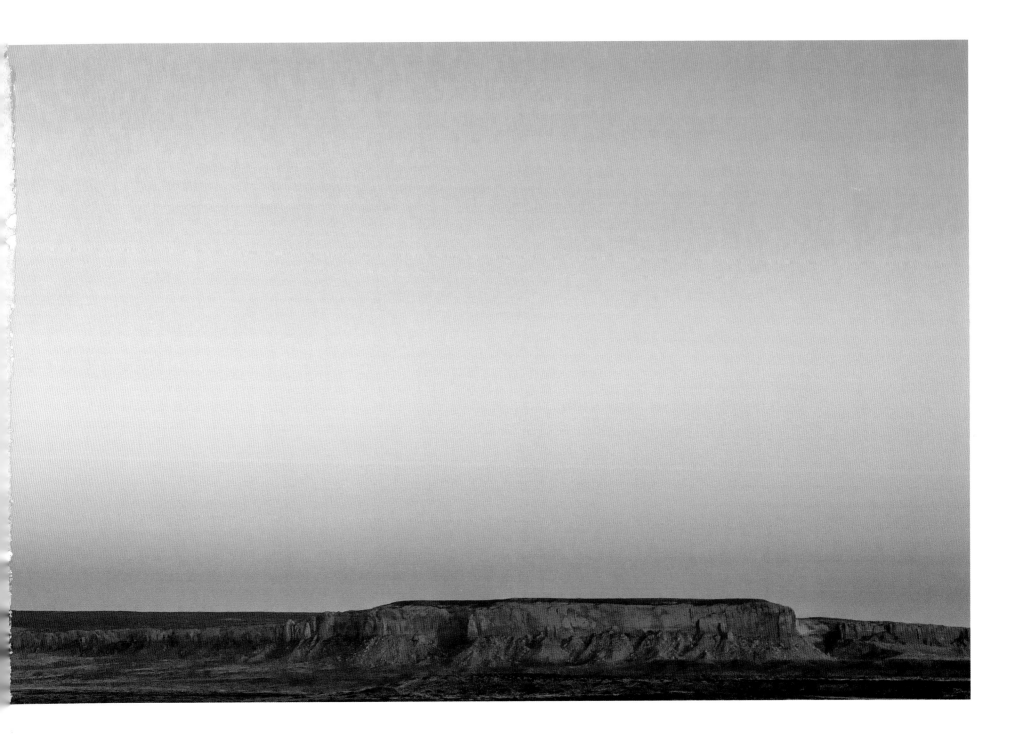

MESAS WEST OF BLUFF.

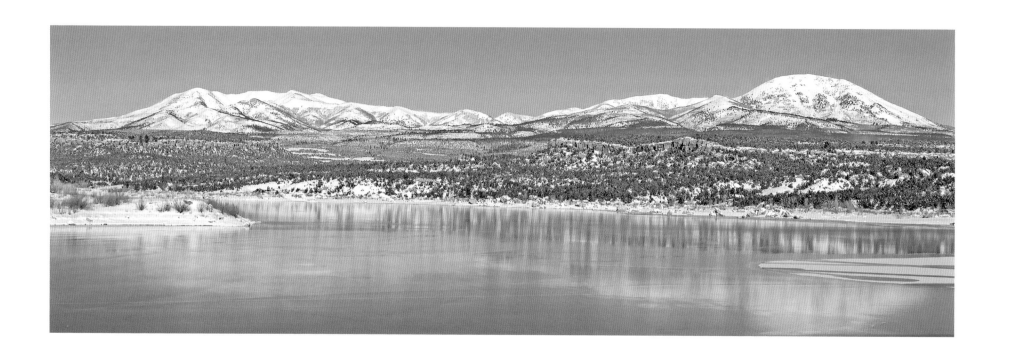

THE ABAJO MOUNTAINS ABOVE RECAPTURE RESERVOIR.

You outline all your ancestors, your history, your grandparents, and by their clans you can tell where they are from, and then you say where you're from. When I say the clans of my ancestors and who my grandparents and my parents are, it is almost like they come to me. They come forth, and it's like, by saying those words in Navajo, it's almost like a hug or an embrace. . . . It grounds me wherever I am, and it makes me feel like I am not by myself. I know I'm not by myself by saying those words in Navajo. By saying them, it makes me think of the land and of all of those stories of the land.

—LUCI TAPAHONSO
UNIVERSITY OF ARIZONA AND NAVAJO NATION POET LAUREATE (2014–2015)

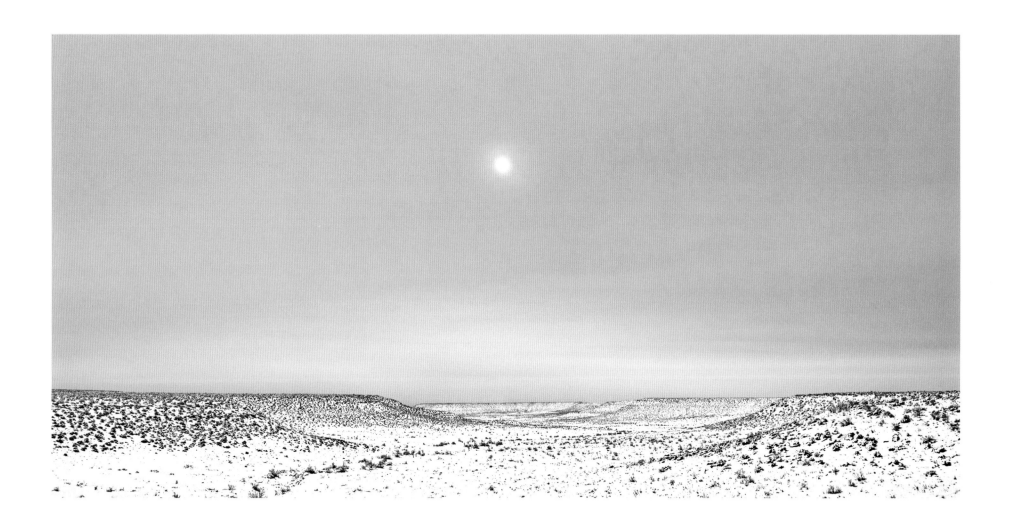

MESAS ON LIME RIDGE.

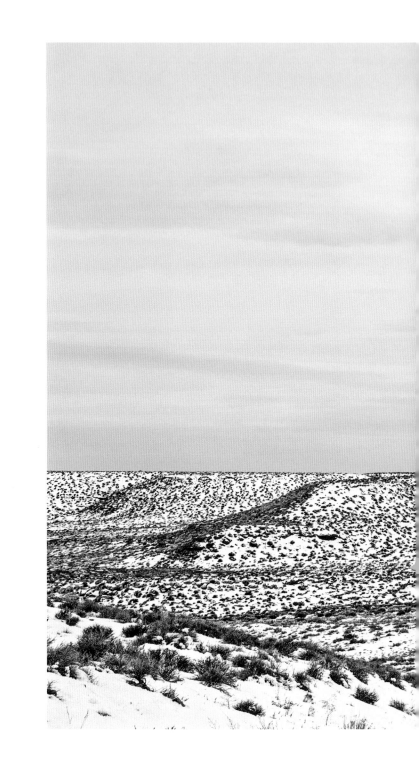

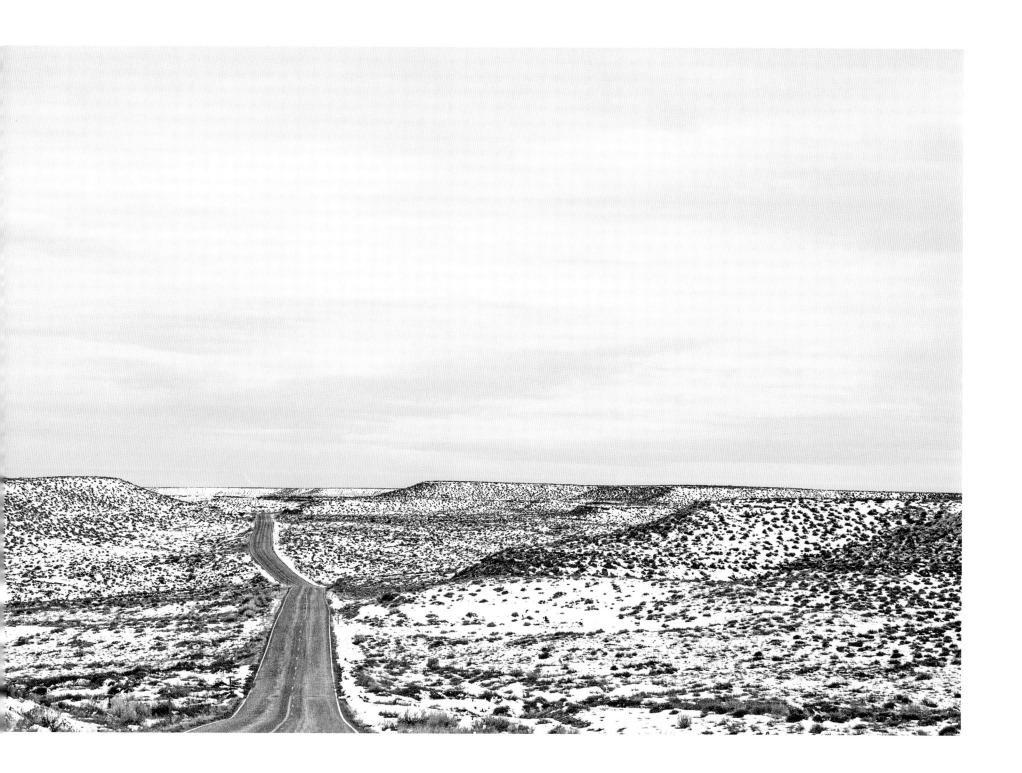

MESAS ALONG UT 316 LEADING TOWARD GOOSENECKS OF THE SAN JUAN RIVER.

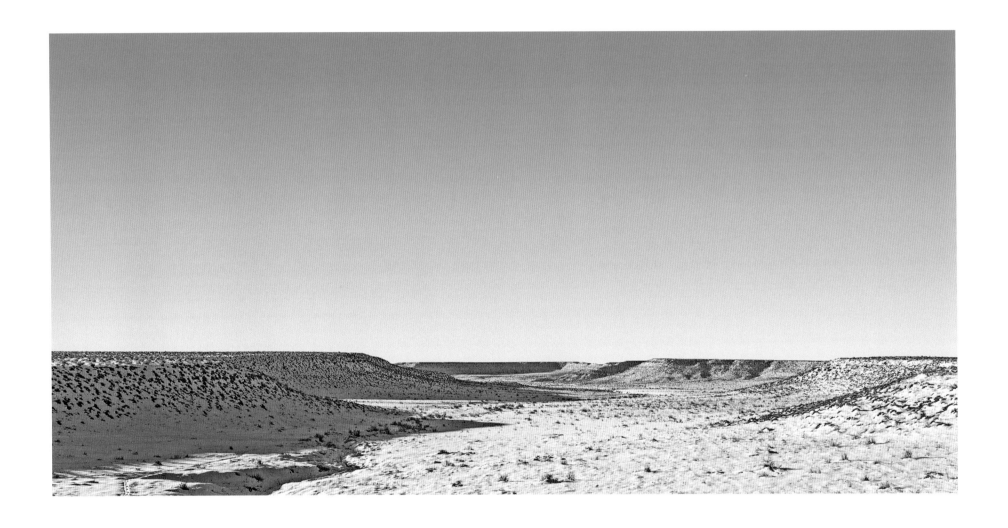

MESAS ON LIME RIDGE.

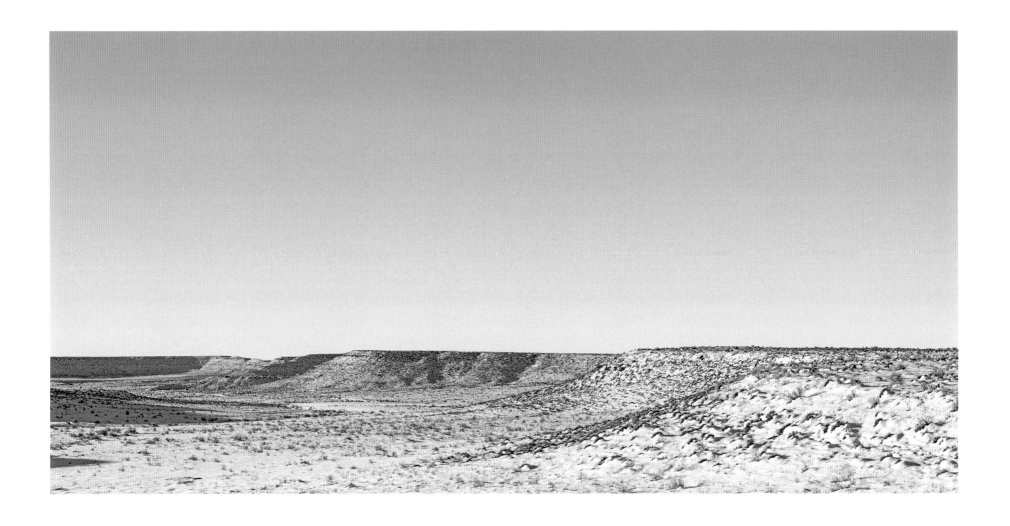

MESAS ON LIME RIDGE.

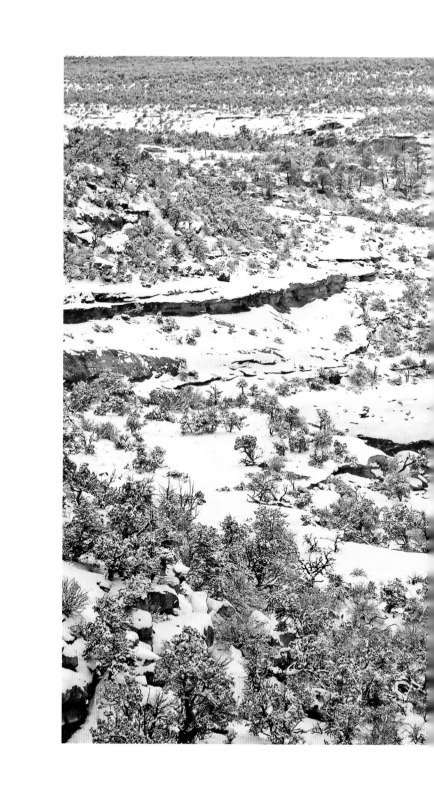

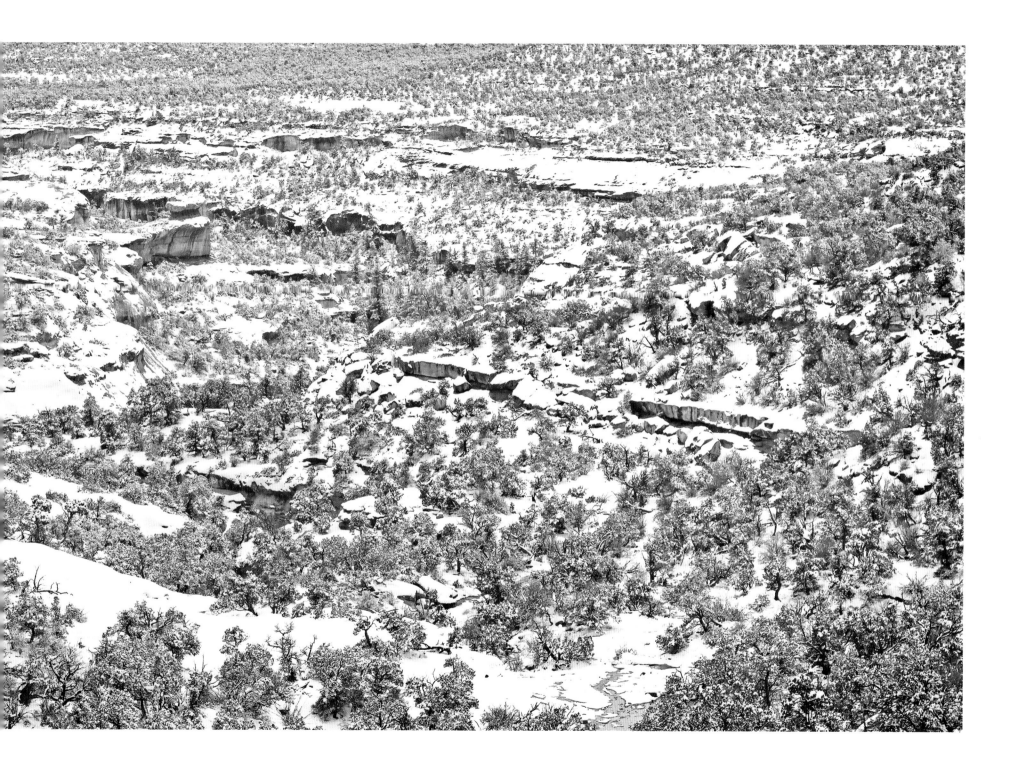

CANYONS AND THE SOUTH FORK OF FISH CREEK NEAR SALVATION KNOLL.

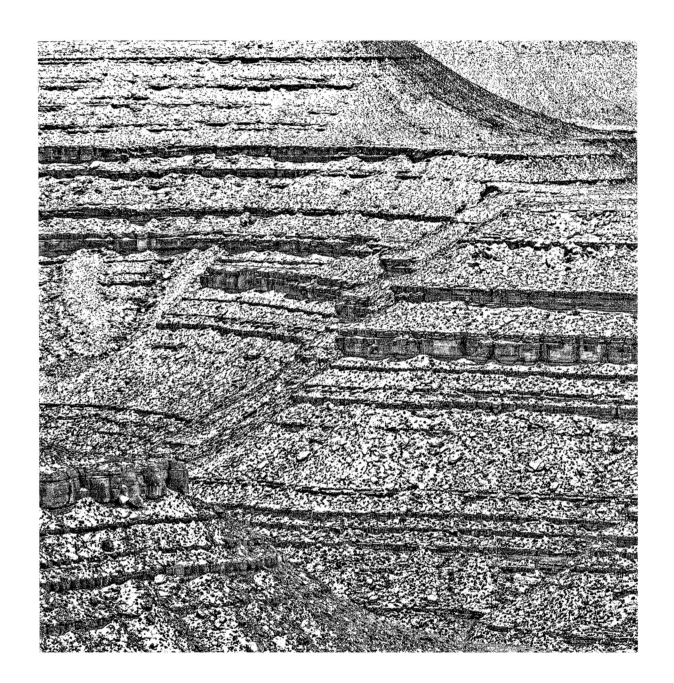

MESAS NEAR GOOSENECKS OF THE SAN JUAN RIVER.

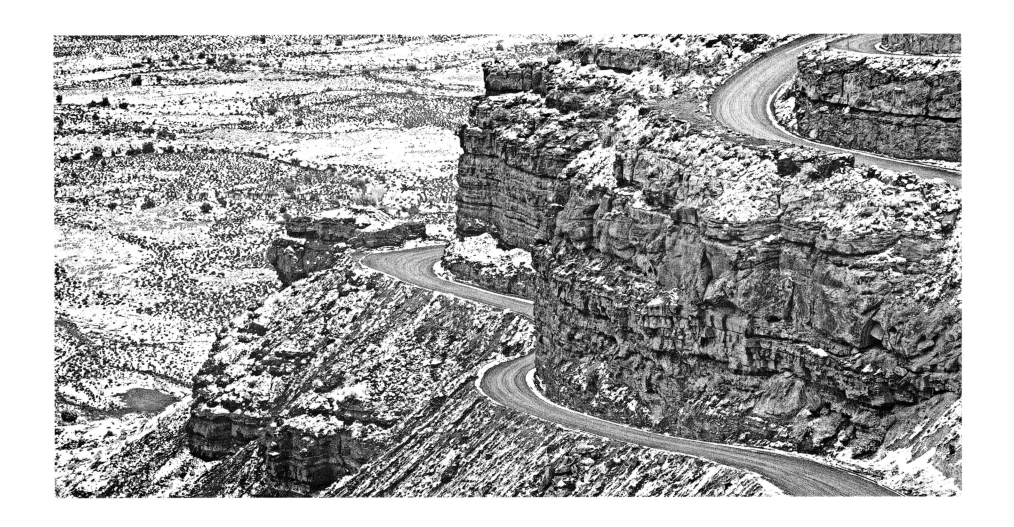

MOKI DUGWAY ON UT 261 IN SNOW.

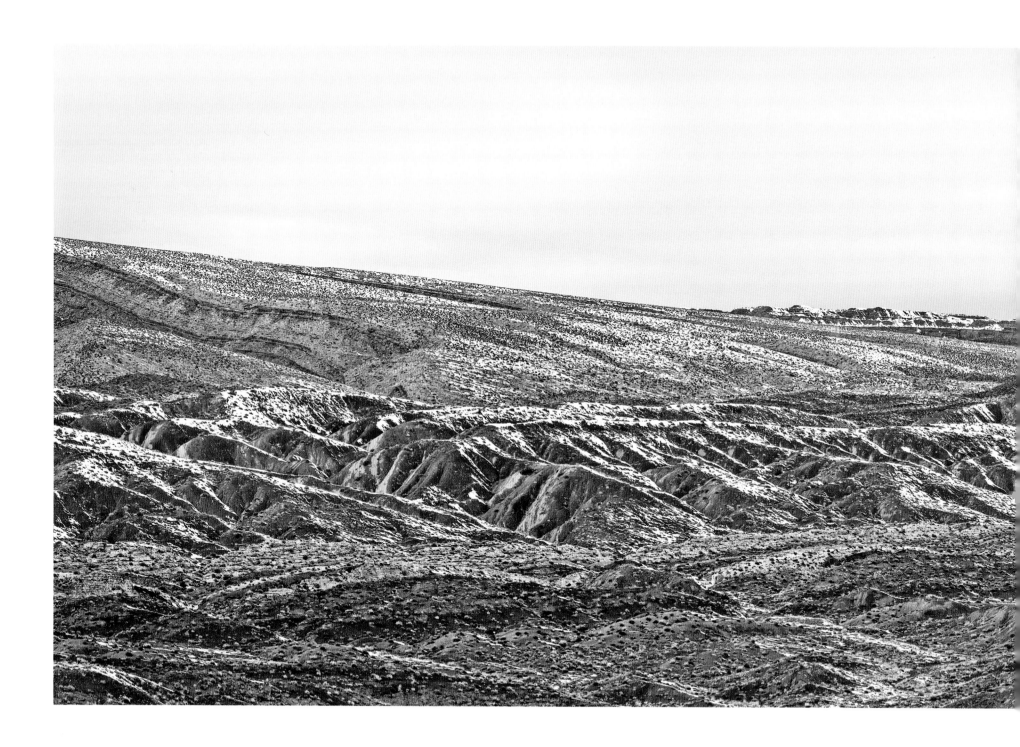

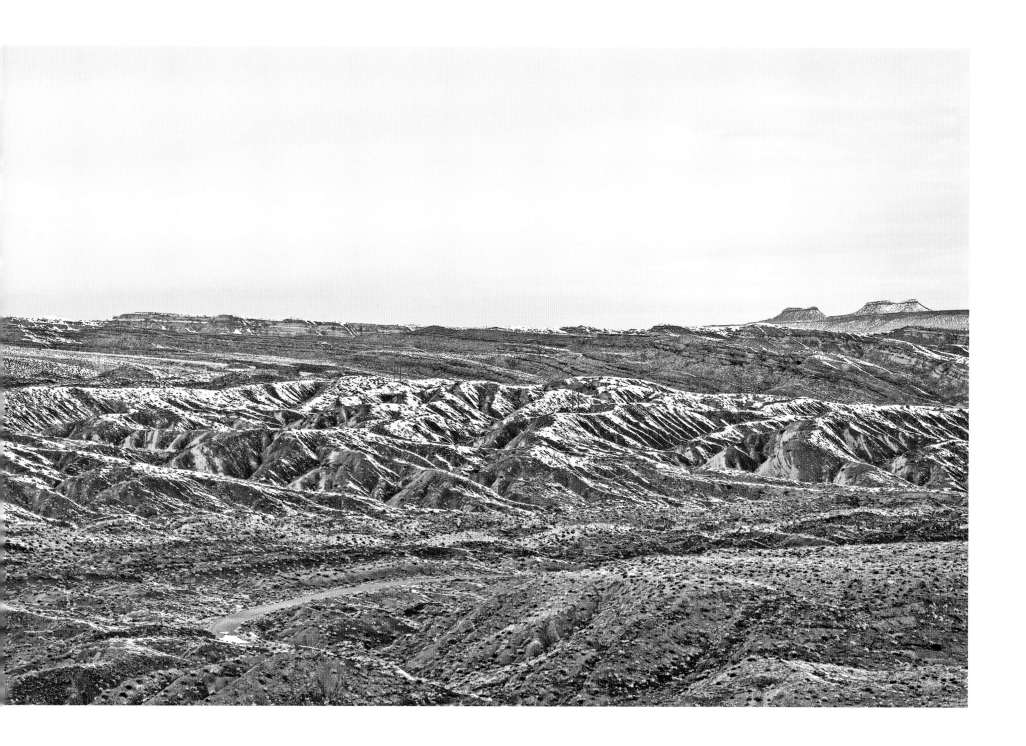

HILLSIDES WEST OF COMB WASH, WITH BEARS EARS (TWIN BUTTES, FAR RIGHT) IN THE DISTANCE.

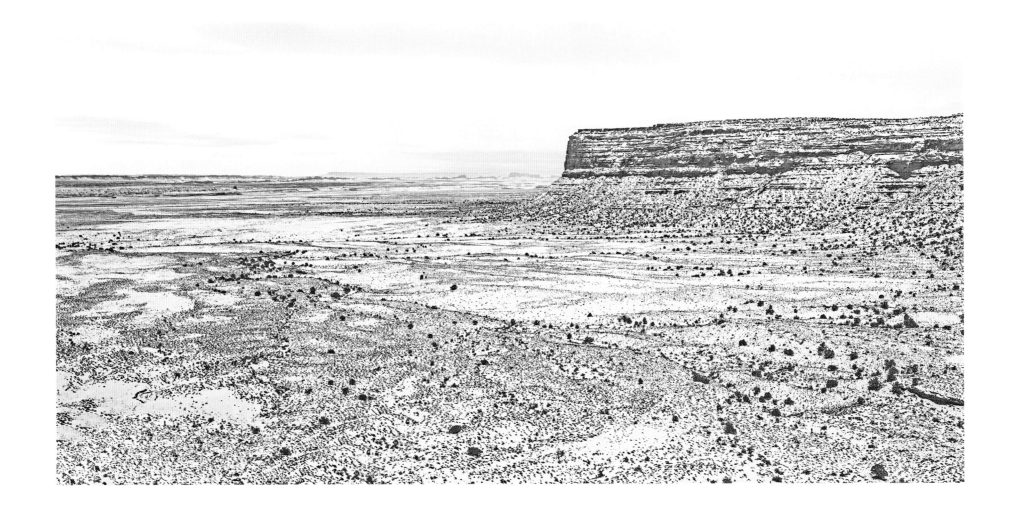

CEDAR MESA (RIGHT) AND VALLEY OF THE GODS FROM MOKI DUGWAY ON UT 261.

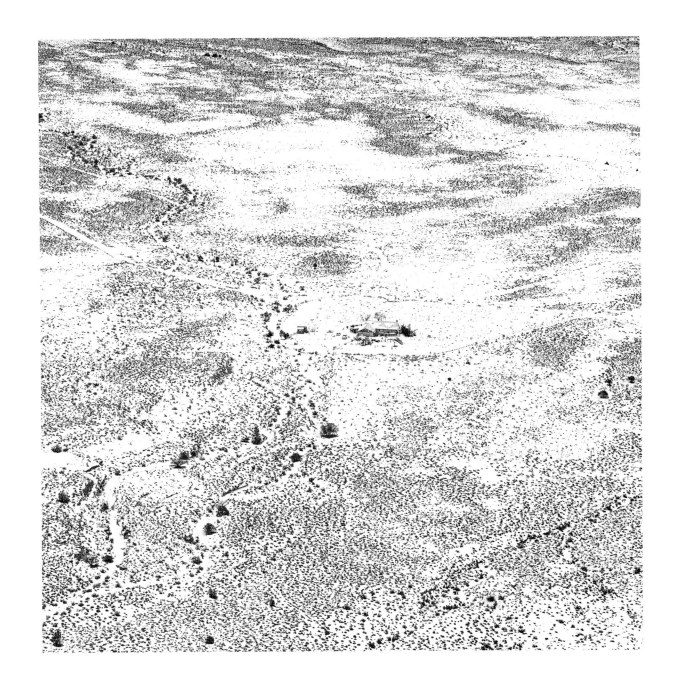

VALLEY OF THE GODS BED AND BREAKFAST (CENTER) FROM MOKI DUGWAY ON UT 261.

Here is your country. Cherish these natural wonders, cherish the natural resources, cherish the history and romance as a sacred heritage, for your children and your children's children. Do not let selfish men or greedy interests skin your country of its beauty, its riches or its romance.

—THEODORE ROOSEVELT
26TH PRESIDENT OF THE UNITED STATES OF AMERICA

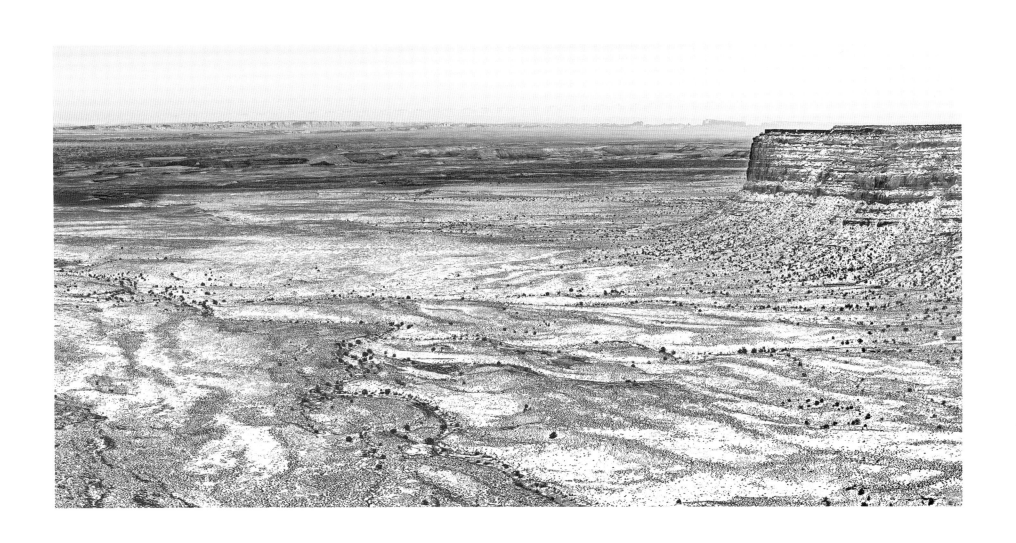

CEDAR MESA (RIGHT) AND VALLEY OF THE GODS FROM MOKI DUGWAY ON UT 261.

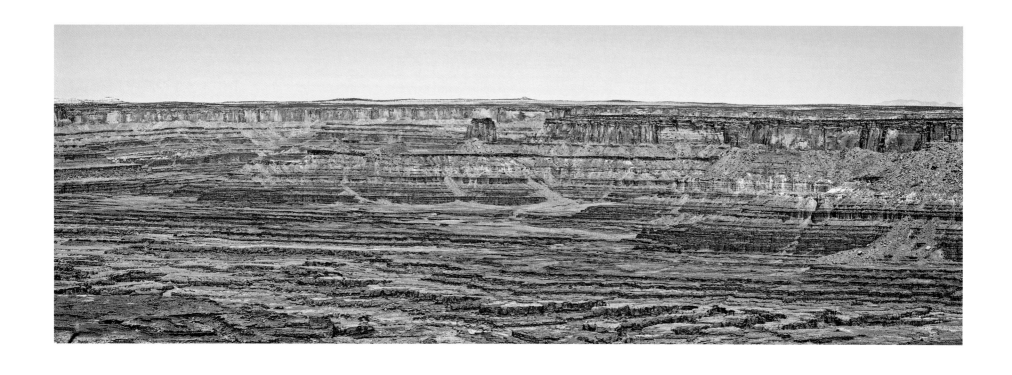

LAYERED LANDSCAPE OF LOCKHART BASIN FROM NEEDLES OVERLOOK.

A Photographer's Reflection:
A History of the Colorado Plateau

Stephen E. Strom

Standing on a slick rock promontory at Needles Overlook, I close my eyes. The rising sun slowly heats my back, while the remainder of my body still shivers in the penetrating morning cold. The sweet-pungent fragrance of a nearby juniper invites deep breathing. The slow beating of wings overhead breaks the silence, and my eyes open, curious. Hawk or raven? Before the urge to know and classify can take control of my scientist mind, the intense blue of an early spring sky overwhelms, and I yield instead to the primitive sense that the indigo sky at zenith must be an opening to the darkness and infinity of the universe beyond. As I scan downward, indigo yields to more pastel shades, until the blue is interrupted with startling suddenness. Below the sharp horizon line, my senses are overwhelmed by a labyrinth of canyons, hoodoos, hogbacks, uncountable layers of sandstone, sensuous slick rock, and, almost lost among the interplay of sculptural forms, light reflected from filaments of water in Indian Creek and the surface of the Colorado River in the distance.

The complexity and interwoven patterns of the landscape compel investigation. As I turn slowly, the more distant territory blends into syncopations of dark and light, mountains beyond, while, nearby, nature's carvings assume more dramatic forms in the chiaroscuro lighting. Looking sunward, light glances off the tops of mesas and reveals through scattering and shadow the subtler textures of the desert: small rocks, sand, and low-lying plants hugging the desert soil.

I feel an ecstatic connection to this land. In the profound and prayerful words of the Navajo people who know Canyon Country well: beauty before me; beauty behind me; beauty below me; beauty above me. Or from Mormon prophet Brigham Young: Nature is the glass reflecting God. The land humbles, evoking a sense of the vastness of space and passage of time. Ecstasy, humility, and walking in the beauty of creation should be sufficient. And, for a long moment, it is.

Yet humans are by nature curious and seek understanding beyond their senses and their faith. And so I ask: How did the land before me take form? What forces shaped this place? How am I connected to the universe beyond the indigo dome? How did I come to be? The answers, as much as we know them, add deeper layers of beauty to the land and lead to an understanding of the seemingly miraculous series of events that led to my standing on the promontory.

EARTH TAKES FORM—BIRTH OF A PLANET

My journey to a rock outcrop in Utah started in a trillion-mile-wide, slowly rotating cloud comprised of a tenuous mix of gas and tiny grains of dust. Shielded from heating light from stars in the Milky Way, the gas and dust cooled to a temperature not far above absolute zero—the state where matter ceases to move—but just high enough that the motion of gas molecules and dust grains can produce a feeble pressure barely sufficient to resist the pull of gravity.

Within a few hundred thousand years or so, a young, hot, gaseous sun took form in the cloud's center. A disk comprised of gas and dust grains spun around the sun like a record surrounding a spindle. The grains, now squeezed together within the confines of a thin disk, began to collide and, in the process, stick to one another. Within a million years, successive collisions between dust grains led to the growth of larger and larger bodies. In the inner disk, they grew to sizes comparable to Mars and Earth, while in the outer disk they formed larger, more massive bodies whose gravitational pull allowed them to draw in material from the surrounding disk and form huge, gaseous giant planets. In the cold, outermost regions of the disk, collisions between dust grains took place less frequently, and the resulting bodies were small: mile-size dusty balls of ice and dust, today's comets. Within 5,000,000 years or so, our solar system was beginning to take form. Relatively small, rocky planets closest to the sun—Mercury, Venus, Earth, and Mars; further out, the gas giants—Jupiter, Saturn, Uranus, and Neptune; and beyond the orbit of Neptune a swarm of comets. Thanks to the peculiar architecture of this, our solar system, the strong gravitational pull of Jupiter aborted the birth of a planet between the orbits of Mars and Jupiter. Today, tens of thousands of these planetary embryos—asteroids—orbit the sun in a belt between the two planets.

Evidence reflecting this remarkable history becomes visibly tangible an hour before dawn on a mid-April morning. I've chosen to meet the dawn on Cedar Mesa at Muley Point, 1,500 feet above the canyons carved by the San Juan River. As my body adjusts to the cold, my eyes acclimate to the darkness and take in the full richness of the night sky. Here in Utah's Canyon Country, there is virtually no artificial lighting for hundreds of miles. My view of the heavens is little different from that which compelled the imaginations of those who inhabited this land ten thousand years or more ago. I assume my perch to watch for meteors, the Lyrids, which appear to shower down from a launching point not too distant from the brightest star in the early summer sky, Vega. These rocky bodies enter Earth's atmosphere every one or two minutes or so and create a fiery trail as they speed through the atmosphere at more than twenty miles per second. Their trail fades in a few seconds, counterpoint in transience to the seemingly eternal presence of the stars.

As dawn approaches, the sky affirms the nature of Earth's origin in a disk of gas and dust. On the eastern horizon a conical glow begins to intrude on the darkness, the arc bisecting it at its apex extending through Venus, Jupiter, and, toward the east, the waning moon. The glow is the Zodiacal light: sunlight scattered from small dust grains released both from icy comets, heated as their elongated orbits carry them through the inner solar system, and from ongoing collisions between asteroids: collisions not unlike those that built Earth. The planets and Zodiacal dust are confined to a common plane, outlining the long-gone primordial disk from which Venus, Jupiter, asteroids, comets, and Earth itself was built. The Moon, its cratered face testament to a lifetime of collisions, lies along the same plane and tells yet another story critical to how the Colorado Plateau's red rock country came to be.

FORMING EARTH AND THE MOON—WITH SPECIAL THANKS TO THEIA

Violent collisions were frequent during the first many millions of years in our solar system's lifetime. Bodies in the inner solar system careened around the sun at speeds of tens of miles per second. When two bodies collide at those speeds, enormous amounts of energy are released, much of it in the form of heat. As a consequence of countless violent collisions with asteroid-size bodies (a tenth of a mile to 500 miles in diameter), the forming Earth was heated continuously and, through much of its early life, remained hot and molten throughout. After a few tens of

millions of years, the basic structure of Earth today began to take form: a molten core rich in iron and heavier elements, a solid crustal surface dominated by light elements such as silicon, aluminum, and calcium, and, between core and crust, a mantle comprising a mix of lighter and heavier elements.

As the solar system matured, the frequency of collisions diminished, and Earth began to cool. The surface cooled first, covering and insulating the still-molten lower mantle and core with a thin crust of solid rock. The stately cooling of Earth, along with the slow rising and sinking of light and heavy elements from mantle to core and back, was interrupted by a cataclysmic event some 20,000,000 to 100,000,000 years after the proto-Earth took form: a glancing but powerful collision with a large body. Theia, about half the size of Earth, struck with a speed of nearly 10,000 miles per hour, launching some of its and Earth's original crust and upper mantle into orbit around the young Earth. Within a century, this light-element-rich material, drawn from the crust and mantle, coalesced into a body that became our Moon. Theia's collision with Earth not only initiated the Moon's formation, but also tilted Earth's axis of rotation by twenty-three degrees and increased its rotation period. We can thank Theia for Earth's tilt—the origin of our seasons—as well as for our twenty-four-hour day.

After the collision with Theia, Earth was able to resume its steady evolution: a downward flow of heavy elements through the viscous mantle to a hot, molten core; the lifting of light elements toward the exterior; and, as the surface once again cooled, the formation of a thin, crinkled, rocky crust. Earth has retained this basic form—solid crust, molten mantle, and hot core—ever since.

FORMING THE OCEANS—
AN UNLIKELY ASSIST FROM DISTANT ASTEROIDS AND COMETS

While the hot, young Earth was developing the rocky surface on which the Colorado Plateau's red rock country now rests, two elements critical to life were missing: water and an oxygen-rich atmosphere. Water was abundant when Earth began to take form; but because our young planet was hot, water on its surface boiled and entered Earth's primitive atmosphere in the form of steam. The speed of the steam molecules was so high that most pulled free from Earth's gravity. When Earth's crust began to solidify, most, if not all, of the primordial water had already been launched into space, leaving the young planet parched. Fortunately, our planetary

neighbors Jupiter, Saturn, Uranus, and Neptune, in collaboration with asteroids and comets, helped to provide a fresh supply of water.

How could water-rich asteroids, located between the orbits of Mars and Jupiter 200,000,000 to 300,000,000 miles away, or comets, located beyond the orbit of Neptune at a distance of 4,000,000,000 miles, reach the surface of Earth in numbers sufficient to fill the oceans? For as long as humans have recorded the motions of planets across the sky, it was believed that their paths were as predictable as the rising and setting of the sun. But we now know that it was not always so. During the first several hundred million years following the formation of the solar system, the orbits of the planets were still struggling to attain stability against the gravitational pulls and tugs of their solar-system neighbors. Our best guess today is that, during this time, the orbits of the massive giant planets migrated significantly before settling into their current paths. As they migrated, seeking orbital stability during the early history of the solar system, their gravitational pull was enough to alter the orbits of both comets and asteroids sufficiently so that large numbers of these bodies were launched toward the inner solar system. Enough of them landed on Earth after its surface cooled to supply the water needed to fill the oceans and flood the land.

Standing on the banks of the Colorado River west of Moab, mesmerized by the slowly changing rippled reflections of copper-colored canyon walls, it seems nearly impossible to reconcile the tranquility of the scene with an imagined picture of young Earth undergoing frequent bombardment by water-bearing asteroids and comets. The story itself humbles the imagination. Think of the unlikelihood of a planet like our own born into a solar system with planets of just the right mass and just the right initial orbital placements so that an asteroid belt would form and, later, that their orbits and those of distant comets would be jostled in just the right way to bring life-enabling water—to Earth. I pick up a stone, toss it into the Colorado, and watch the ripples expand, pondering the meaning of the word "miracle."

FORMING EARTH'S ATMOSPHERE

If supplying Earth with water from afar inspires musings of miracles, the sequence of events that transpired to create and sustain our atmosphere are just as astonishing. When Earth was young and still molten, it was surrounded by a hot, primitive atmosphere comprised primarily of the most abundant gaseous elements contained

in the disk from which it formed: hydrogen and helium, along with traces of water vapor and other, less abundant gases. Nearly all the atoms and molecules in Earth's atmosphere moved at speeds above those at which matter escapes Earth's gravitational pull, about 17,000 miles per hour. As a result, Earth shed most of its initial gaseous envelope.

How did Earth's atmosphere reform? The most likely source appears to be gas released in volcanic eruptions: water, carbon dioxide, and noxious sulphur dioxide, along with nitrogen, hydrogen, chlorine, carbon dioxide, and trace gases such as methane and ammonia. But this mix is radically different from our current-day atmosphere, which consists primarily of nitrogen and life-sustaining oxygen. To evolve to the current mixture of atmospheric gases required a variety of chemical interactions, along with the appearance of primitive life.

Water vapor released during volcanic explosions and the emergence of molten rock or magma from below Earth's crust condensed and fell to Earth as rain, helping, along with water from asteroids and comets, to fill the oceans. Carbon dioxide dissolved quickly into the oceans and from there was incorporated into surface rocks. Absent the oceans, the amount of carbon dioxide remaining in the newly formed atmosphere would have trapped the sun's heat, raising Earth's temperature to a point where it could no longer sustain life as we know it: a situation vividly in evidence on our sister planet Venus, whose carbon-dioxide-rich atmosphere forces its surface temperature to rise to above 800° F.

One extraordinarily crucial constituent was still missing from Earth's atmosphere: abundant oxygen. That began to change 3,500,000,000 years ago with the appearance of a microscopic marine-borne organism: cyanobacteria. Smaller in diameter than a human hair, cyanobacteria hold the distinction of being the first living entity on Earth to produce oxygen from chemical reactions activated by sunlight: photosynthesis. At first, the oxygen released by cyanobacteria was soaked up at Earth's surface to form oxides, the most familiar of which is the red iron oxide—rust—that colors many of the iconic formations on the Colorado Plateau. During the 300,000,000 to 400,000,000 years following the appearance of cyanobacteria, the oxygen they produced quickly combined chemically with available surface rocks.

Following this Great Rusting Event, oxygen synthesized by cyanobacteria began to accumulate in the atmosphere, initiating a Great Oxygenation Event, during which the fraction of oxygen contained in the atmosphere increased from close to zero to about twenty percent. Abundant atmospheric oxygen enabled a dramatic breakthrough in metabolic evolution by providing a new energy-gener-

ating component in living organisms: mitochondria, which take in nutrients, break them down, and create energy-rich molecules for cells. With more energy available from oxygen, organisms for the first time had the means to evolve rapidly toward far more complex life-forms. The rise in atmospheric oxygen content reached its current value of twenty percent around 500,000,000 years ago, coinciding in time with the rapid rise in the number and variety of complex life-forms on the surface of Earth. Within less than 100,000,000 years, a planet once populated only by simple organisms became the home to the precursors of all life-forms presently known. And all the constituents needed to create the mesas, deep canyons, colorful rock layers, and mountains of today's Colorado Plateau were now in place: rocky layers floating on a molten mantle, abundant water, an atmosphere rich with oxygen, and burgeoning life-forms drawing energy from the oxygen created initially by the simplest of organisms.

Abstract thoughts of the Great Rusting Event, the emergence of photosynthesizing cyanobacteria, and the great oxygenation event find concrete realization in the panorama visible from Muley Point. In the distance toward the west, the graceful dome of Navajo Mountain, which emerged a mere 100,000,000 years ago, recalls an earlier era when gas-bearing molten magma pushed insistently upward through the crust of the ancestral Plateau, carrying with it the beginnings of Earth's new atmosphere. Toward the east rise the crimson spires of the aptly named Valley of the Gods and, southward, the iconic rust colored mittens of Monument Valley. To the north lie the twin peaks known as Bears Ears, capped in vivid-red sandstone. This symphony of red rock owes its composition to the iron oxide, first produced when exposed minerals voraciously consumed oxygen produced by cyanobacteria. Above, the molecules of oxygen and nitrogen in our life-sustaining atmosphere scatter blue light from the sun, perfectly complementing the red rock landscape below and evoking the sensation that I stand below a dome that reaches for the infinite. Deeply humbled, I reflect on the seemingly unlikely concatenation of events that gave rise to this planet, this place, and this moment. Little wonder that native peoples have long thought of this land, the land below Bears Ears, as sacred.

LAND ON THE COLORADO PLATEAU TAKES FORM

Over eons, individual plates of crustal rock moved slowly above a mantle of hot, highly viscous fluid— a few inches per year—occasionally colliding with one

another, sometimes gaining, sometimes losing material. In some places, lighter, so-called continental crust was forced over heavier oceanic crust, and, in the process, continental crust was uplifted and mountain ranges and deep ocean trenches created. At the boundaries of colliding crustal plates, molten rock, gases, and ash entrained in chambers of subsurface molten magma erupted to form volcanic shields or domes, and, in the process, lava and ash spread over the surrounding land.

Remarkably, the plate on which the Colorado Plateau now lies was once located at the equator. More than 2,200,000,000 years ago, the ancestral Plateau lurched northward under the relentless push and pull of the mantle's currents, not reaching its current location in the mid-latitude Northern Hemisphere until between 100,000,000 and 150,000,000 years ago.

During its 2,500-mile journey northward from the equator, the land that today comprises the Colorado Plateau experienced multiple inundations by oceans and inland seas, tidal flats, and lakes as Earth's climate warmed and cooled, melting or reforming the ice caps at the North and South Poles and, in sympathy, raising and lowering sea levels. During most of its lifetime, the ancestral Plateau was located not much above sea level. Testimony to its aquatic history is found today in the deep layers of salt, potash, and gypsum deposited during episodes of evaporation and refilling of the ocean bed.

In response to changes in global temperature and its journey northward from the equator, the climate on the Colorado Plateau varied between desertic and tropical. At times, marshes and jungle-like forests covered the land, and, during others, endless miles of sand dunes predominated. The multi-colored sediments now revealed in in the canyons carved into the Plateau bear witness to silt, mudstone, limestone, salt, sand, and volcanic ash, deposited by water and dispersed by wind. Remarkably, some of these ancient strata preserve ripple marks, mud cracks, and raindrop imprints on their surfaces: fossilized evidence of primitive seas, lakes, and ancient rain storms.

Perched on layered sandstone cliffs about 500 feet above the Dirty Devil River to the west of Hite Crossing, I witness the meeting of past and present. Inclined layers of sandstone, crossing at different angles speak to changes in the flow of water or the direction of wind in ancient times. In a few places, the rock appears furrowed, bearing fossilized witness to passing waves in a venerable stream. Examining thin layers of hardened sand, I can imagine waves lapping gently on a primitive shore. Below, the past becomes present, as mud dries under the desert

sun along the banks of the river. Subtle colors coat polygonal motifs, while rippled patterns capture the slow motion of water over mud.

THE COLORADO PLATEAU RISES

All of these strata and the history they reveal were carried upward from sea level to their current mile-high perch sometime between 20,000,000 and 70,000,000 years ago. What drove the uplift is still under debate among geologists. One popular hypothesis advances the notion that the Plateau began its rise when the North American continental plate began to override a ridge of oceanic crust located below the middle of the present-day Pacific Ocean. The resulting uplift of the Colorado Plateau was accompanied by an even more dramatic episode to the east: the rise of the current-day Rocky Mountains. That the strata revealed by the canyons of the Plateau remained coherent over 400,000,000 years is testimony both to chance and to the unusually thick crust and strong rocks underlying the Plateau. The Colorado Plateau is one of the few places on Earth where such ordered geological history was so well preserved in the face of ongoing chaos.

The unveiling of all this history would not have been possible had the Green, Colorado, San Juan, Dirty Devil, and Escalante Rivers not eroded layer after layer of shale, sandstone, siltstone, and limestone to reveal the past in the canyons they carved. At the time the Colorado Plateau and the Rocky Mountains began to rise, waters on the surface of the ancestral Plateau wandered in gentle meanders fed from the snow packs in mountain ranges situated in Colorado and Wyoming. Having these streams cohere into the tributaries of the majestic Colorado and flow relentlessly southwestward across the Plateau required two final geological events: stretching the crust of the western part of the North American continent and opening a corridor for water to flow across the Plateau and down to the Gulf of California. Following uplift of the Plateau, the continental crust in the western United States began to spread. In the process, the structure of alternating wide valley basins and mountain ranges characteristic of the American West was established. One key outcome of the stretching event was the collapse of the Mogollon Mountains to the southwest of the Colorado Plateau, which removed the final obstacle to waters flowing from northeast to southwest.

At the same time, some geological models propose that motion of the North American and adjacent Pacific plates suddenly changed. Rather than riding over

the Pacific plate, the North American plate started instead, to slide along the edge of its continental neighbor, creating crustal faults. About 6,000,000 years ago, relative motion of crustal layers along the most famous of those faults, the San Andreas, ripped open the boundary between current-day Baja California and continental Mexico.

With intervening mountain ranges collapsed, the Colorado and its tributaries had a clear path downward from the mile-high Colorado Plateau to the newly opened Gulf of California at sea level. Free-flowing rivers followed their historic meanders and carved and chiseled deep, labyrinthine canyons across the Plateau. Wind and water continue to serve as the rasps and riffles that remove softer rocks and sculpt finer-scale structures—spires and hoodoos, flat irons and hogbacks— that add a surreal quality to the arresting drama of the larger-scale landscape.

Were these sculpted features merely monochromatic, they would stand as impressive monuments to the shaping hands of plate tectonics, wind, and water. The interplay of the sculptural with chromatic rhythms speaks to the history of the Colorado Plateau in yet another language. Looking downward from the high mesas of Canyonlands National Park, at the very heart of the Colorado Plateau, provides perhaps the richest example of these cadences.

What transforms the view from the merely mesmerizing is the palpable presence of a fourth dimension: time. The landscape conveys almost intuitively the passage of eons. Close to the Colorado are fossil-rich grey shales, muds deposited by shallow seas and mudflats 360,000,000 to 400,000,000 years ago. Above lies red Cedar Mesa Sandstone deposited by sand dunes located on the coast of an inland sea around 250,000,000 years ago and rich in iron oxides. Atop this stratum sits a thin layer of White Rim Sandstone, deposited by wind-blown sand and bleached white by organic compounds. Next is light-red De Chelly Sandstone, whose rhythmic, interleaving cross-beds reflect the role of wind in reshaping sand dunes. Above the De Chelly lie reddish-brown Moenkopi layers deposited by streams, flowing at ages between 210,000,000 and 240,000,000 years ago. Exposed layers preserve patterned ripple marks and mud cracks. The colorful and sensuous red, white-, grey-, and yellow-banded rolling, molded mud hills were formed from volcanic ash carried by wind across the region some 200,000,000 years ago. During the same period, wind and water deposited the constituents of white, yellow, and gray colored sandstones, each color expressing a difference in the concentration of iron-bearing minerals.

Atop the Moenkopi lies pale-orange to red-colored Wingate Sandstone, comprised of wind-blown sand assembled into tall cliffs. Further up lies the multi-colored

Kayenta Formation: thick strata of buff, tan and light-red layers surrounding dark-red, maroon or lavender rock: beds of sandstone, shale, and limestone. Topping this group of 140,000,000–200,000,000-year-old layers is Navajo Sandstone, frequently forming the upper levels of spectacular white-to-pink cliffs. The varied colors reflect the deposit of wind-borne dune sand comprised of iron oxides mixed with silicon-oxide (quartz).

Strata revealed in the deep canyons scarring the Colorado Plateau not only record the flow of water and wind, but reveal as well the ever-increasing complexity of life-forms that arose as the oxygen content of Earth's atmosphere rose toward its current levels. The lowest visible strata reveal coral and brachiopod fossils, while higher levels contain fossilized freshwater sharks, lungfish, and amphibians, ferns, and, later, trees. Those sedimentary strata just below the highest lying levels visible on the Plateau contain footprints and fossil remains of dinosaurs that roamed the area before the great extinction, which 65,000,000 years ago snuffed out nearly 90 percent of Earth's life-forms: likely the consequence of sudden climate change resulting from violent impact by one or more asteroids or comets that crashed into Earth at a speed of tens of miles per second.

That we can utter phrases such as "the landscape before me reveals 400,000,000 years of Earth's history, from the appearance of simple organisms to the richness of life today" with casual ease reflects the rapid advances of science during the past 500 years and how its language and findings have come to permeate our culture. These advances speak to the power of intellect and the human passion to understand the natural world.

Reflecting on the history of the Colorado Plateau—from its beginning as a cloud of gas and dust to the sentient, breathing being standing on Cedar Mesa looking toward the twin Bears Ears Bluffs—what I sense, scientist or artist, is wonder, revelation, mystery, and ecstasy in both knowing and feeling. These photographs are offered in thanks for what this land has given me and in deep gratitude for the preservation of this land of profound beauty and sacredness as a national monument.

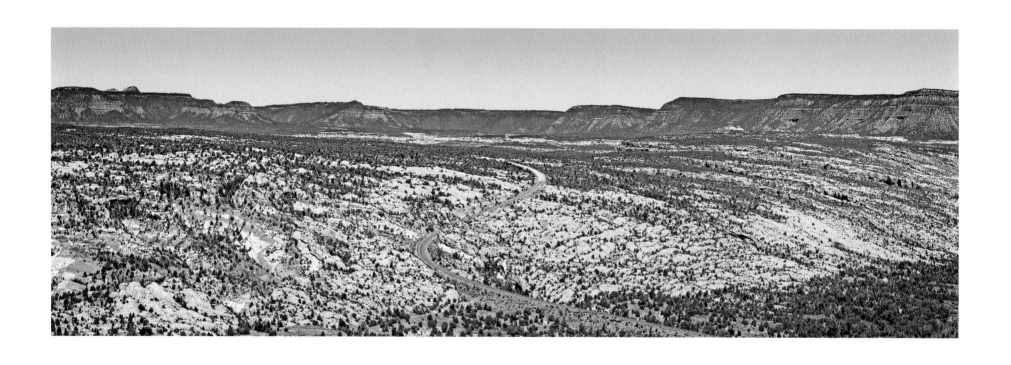

UT 95, THE BICENTENNIAL HIGHWAY, AT SLICK ROCK WEST OF BLANDING.

THE HIGHWAY FORMS PART OF THE TRAIL OF THE ANCIENTS NATIONAL SCENIC BYWAY.

About the Craft

What draws me time and again to Bears Ears country and the surrounding Canyonland Country of Utah and what compels me to photograph there are both its dramatic chromatic and sculptural forms and the subtler patterns of rocks, stones, and desert flora superposed on the grander motif. Until the early 2000s, a typical photographic expedition to southeastern Utah involved packing as many rolls of Kodachrome and 4 x 5 Ektachrome transparencies as a reasonably sized backpack could hold, creating barriers against the intrusion of fine red dust and hoping that a necessarily limited supply of film would prove sufficient to capture both the land's fierce beauty and understated elegance. Selecting the "right" place to capture my emotional reaction to such an amazing landscape, unlike any other on Earth, and harmonizing its multiple rhythms often entailed more than a little agonizing. Most times, I would leave a place with film exhausted and emotions spent, feeling I had failed somehow to express the grace and harmony of place and moment.

With today's digital media, it is now possible to experiment with unlimited abandon, from changing viewpoints and lighting to varying the ratio of complex to fundamental rhythmic modes in a scene. After photographing, the feeling of unworthiness still persists—the land remains beyond comprehension—but, at the very least, I am no longer out of film! In trying to capture the feelings evoked by this landscape, I find that something approaching full expression is best reached not by seeking perfection or a Cartier-Bresson "decisive moment" but by selections made afterward, when the mind is at rest or at play in front of a computer screen.

Many of the early images in this book were made with a long focal-length lens: 450mm for a 4 x 5 view camera and 100 to 300mm for a 35mm single lens reflex (SLR). Use of long focal-length lenses and small apertures (f/45 or f/64 with a view camera; f/22 or f/32 with an SLR) delivers an image with great depth of field (the foreground and background are in sharp focus) and creates the illusion of compressed space.

Information on multiple planes appears projected onto a single plane. As a result, plains and hills in a foreground appear to be superimposed on mountains in the background, thereby creating new rhythms in their juxtaposition.

Until the last few years, all my images were printed in a square format. A landscape presented within this neutral frame forces a viewer to stop to explore the image, usually from left to right and then from top to bottom. By "trapping" a place through a "viewer's eyes," within the square, one can discover the subtle rhythms that drew me to record the image, even a closeup. Moreover, by choosing to eliminate a horizon line and minimizing shadows by photographing under diffuse lighting conditions, the scale of the image is often difficult to discern. Thus, a section of sandstone photographed from a distance of only a few feet can mimic a landscape spanning miles.

To express fully the scale and layered complexity of the landscape in Bears Ears country, I felt compelled to relinquish my preference for square frames and instead make use of panoramic formats. With few exceptions, the panoramic images in the book were created from a sequence of images taken with shorter focal-length lenses (28–50mm) and stitched together using standard Lightroom software. In a number of cases, a landscape spanning miles has been reduced to a narrow strip. This approach, I believe, simultaneously captures the near-infinitude of the desert sky and, by juxtaposition, the vastness of the landscape.

A number of the images in the book were taken while flying in a Cessna 150 piloted by Nate Rydman, of LightHawk Conservation Flying. They were captured digitally, with the ISO settings and shutter speeds adjusted to compensate for lighting, the speed of the plane, and altitude above the ground. Nate and Light-Hawk deserve enormous thanks for their generous support.

All digital images in the book were recorded in camera raw format with a Canon EOS 5D Mark II, and I choose to use no in-camera adjustments for any adjustable parameter (such as white balance and image contrast). They are then cropped and adjusted (largely for brightness and contrast; sometimes with color correction appropriate to lighting conditions) and printed usually on a matte paper so as not to interpose a glossy patina on an image conceived as subtle and muted in palette.

For post-capture processing, I use Adobe Lightroom and Photoshop. My adjustments are relatively modest, mostly some selective cropping and adjusting for brightness and contrast. If there is a highlight that needs to be toned down, I will make use of the digital equivalents of the dodging and burning I once did in the darkroom.

Credits

Page 1. Barack Obama. *Presidential Proclamation: Establishment of the Bears Ears National Monument.* For the complete document, see https://obamawhitehouse.archives.gov (Presidential Actions: Proclamation on December 28, 2016).

10. The map "Bears Ears National Monument as of December 28, 2016" was made by Stephanie Smith, Geographic Information System Program Director of the Grand Canyon Trust, for Stephen E. Strom. Copyright © 2018 Stephanie Smith.

12. Jonah Yellowman, interview with the authors (2 May 2016).

22–23. "Let There Be No Regrets" was written by Joy Harjo for this book. Copyright © 2018 Joy Harjo-Sapulpa.

26. Mark Maryboy, interview with the authors (26 April 2016); and Ty Markham, "Mormon Environmental Stewardship Alliance Chair's Letter to Secretary of Interior Designee Ryan Zinke," *Mesastewardship.org* (9 February 2017).

42. Regina Lopez-Whiteskunk, interview with the authors (24 April 2016); and Marcus Nash, remarks given at the 2013 symposium entitled "Religion, Faith and the Environment," held at the Wallace Stegner Center at the University of Utah in Salt Lake City.

68. Carleton Bowekaty, interview with the authors (27 April 2016).

88. Wallace Stegner, *The Sound of Mountain Water* (New York, NY: Doubleday, 1969), 38.

120. Shaun Chapoose, "Bears Ears Opposition is About Denying Native Americans a Victory," *Salt Lake Tribune* (24 February 2017); see http://www.sltrib.com/opinion/4980362-155/op-ed-bears-ears-opposition-is-about.

144. Jim Enote, "New National Monument Should Come at Bears Ears," *Indian Country Today* (14 October 2015); see http://indian-countrymedianetwork.com/news/opinions/new-national-monument-should-come-at-bears-ears/.

162. Willie Grayeyes, "Dine Bikeyah Is Not Land that No One Wants," an editorial (9 May 2014) in *Utah Dine Bikeyah*; see http://utahdinebikeyah.org/269/; and Mark Udall, *Red Rock Testimony: Three Generations of Writers Speak on Behalf of Utah's Public Lands* (Salt Lake City, UT: Torrey House Press, 2016), 78.

184. Alfred Lomahquahu, interview with the authors (21 April 2016).

204. Luci Tapahanso, "A World Carved from Words: The First Navajo Poet Laureate," *L.A. Review of Books* (20 October 2014); see http://lareviewofbooks.org/article/world-carved-words.

218. Theodore Roosevelt, as quoted at http://theodoreroosevelt.com/theodore-roosevelt-quotes/.

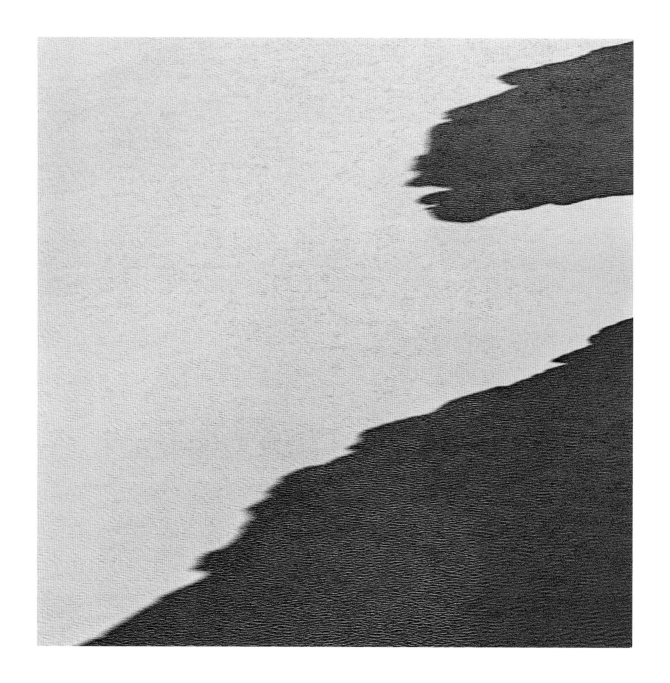

DIRTY DEVIL RIVER AND SHADOWS.

Acknowledgments

Aerial images were captured in the course of flights organized by LightHawk, a non-partisan conservation group that donates flights in small aircraft to conservation groups in the United States, Canada, Mexico, and Central America. Nate Rydman served as a skilled guide and good-humored pilot. His love for and encyclopedic knowledge of the landscape is tangible, and Rebecca and I thank him for his invaluable contributions to this work.

Special thanks to Carleton Bowekaty, Shaun Chapoose, Eric Descheenie, Davis Filfred, Mark Maryboy, Alfred and Sahmie Lomahquahu, Regina Lopez-Whiteskunk, and Jonah Yellowman, for sharing with us the political history of the Bears Ears Inter-Tribal Coalition and Utah Dine Bikeyah as well as their tribes' ancestral connections to the Bears Ears landscape and their own personal and spiritual connections to the land. Thanks as well to Bruce Adams, Rebecca Benally, Bill Boyle, Kate Cannon, Walt Dabney, Josh Ewing, Vaughn Hadenfeldt, Winston Hurst, Phil Lyman, Heidi Redd, Kay and Patsy Shumway, Don and Marcia Simonis, Jonathan Till, and Charles Wilkinson, for their insights on the archaeological and cultural history of the Colorado Plateau and current politics of public-lands issues in southeastern Utah. We are ever grateful for their willingness to meet with us many times in their offices, over meals, and, in some cases, on day-long trips in the wild landscapes of San Juan County, Utah.

Tim Peterson, of Grand Canyon Trust, provided invaluable background information about the maps of the more remote areas within the designated Bears Ears National Monument's boundaries of December 28, 2016, as well as a unique perspective on the political landscapes in Utah and Washington, D.C. Natasha Hale, also of the Trust, facilitated our meeting with key members of the Bears Ears Inter-Tribal Coalition and served as an essential source throughout our efforts. Gavin Noyes, of Utah Dine Bikeyah, provided invaluable background information about the on-the-ground work and key events that laid the foundation for the Bears Ears Inter-Tribal Coalition's proposal for the national monument.

Writers Gwyn Enright and Lauret Savoy reviewed early-stage excerpts of our manuscript, Simmons Buntin, at Terrain.org, provided critical comments on our work as it evolved as well as a space to present excerpts from our books. We are grateful for his editorial guidance. Thanks as well to Bill Hedden, of Grand Canyon Trust, Mark Meloy, founder of Friends of Cedar Mesa, Brian O'Donnell, of Conservation Lands Foundation, and author Stephen Trimble, for providing introductions to sources whose views regarding public land use spanned the full range of perspectives.

Kathy and Dan Huntington are the unsung heroes of this book, doing the unglamorous work of organizing and generally keeping us on task and on deadline. They are also family, and their love, wisdom, and steadfastness anchored us during this project's peaks and valleys. And grateful thanks to George F. Thompson, for his foundational and ongoing work in the book's editorial development and sequence of the photographs, to Mikki Soroczak, for her editorial and research assistance, and to David Skolkin, for his elegant book design and oversight of the production process.

Rebecca also thanks her brother, Daniel Robinson, for being not only an intrepid hiker and travel companion during childhood trips to southeastern Utah's red-rock country, but also a source of inspiration with his passion for the outdoors and work to teach others how best to navigate and enjoy the natural world; her father, Stephen Robinson, whose love of and facility with the written word sparked in her an early interest in becoming a writer; and her husband, Jamie Schlessinger, for his patience through many long nights and weekends of writing and revising, words of encouragement throughout, and shared love of Dark Canyon, Comb Ridge, and Cedar Mesa, and for helping me bring into being this book and its companion volume, *Bears Ears Country: Seeking Common Ground in a Sacred Land*.

Finally, we both recognize Karen Strom, Steve's wife of 54 years, for her eternal inspiration. Not a day goes by without the two of us remembering our lives together.

About the Author, Essayist, and Poet

STEPHEN E. STROM was born in New York City. After receiving his B.A., M.A., and Ph.D. in astronomy from Harvard University, he spent forty-five years as a distinguished research astronomer. He began photographing in 1978, and his work has been exhibited widely throughout the U.S. and is in the permanent collections of the Center for Creative Photography and Museum of Fine Arts, Boston, among others. As he has in *Bears Ears*, Strom has collaborated with distinguished poets, writers, scientists, and curators in his other books of photography: *Tidal Rhythms: Change and Resilience at the Edge of the Sea* (George F. Thompson, 2016), *Death Valley: Painted Light* (George F. Thompson, 2016), *Earth and Mars: A Reflection* (Arizona, 2015), *Sand Mirrors* (Polytropos, 2012), *Earth Forms* (Dewi Lewis, 2009), *Otero Mesa: Preserving America's Wildest Grasslands* (New Mexico, 2008), *Sonoita Plain: Views from a Southwestern Grassland* (Arizona, 2005), *Tseyi / Deep in the Rock: Reflections on Canyon de Chelly* (Arizona, 2005), and *Secrets from the Center of the World* (Arizona, 1989).

REBECCA M. ROBINSON was born in Baton Rouge, Louisiana, and received her B.S. in anthropology at Bennington College. She is a freelance writer based in Portland, Oregon, who previously worked as a staff writer for *Monterey County Weekly* and as a radio producer for Oregon Public Broadcasting. She has written for numerous print and online news outlets about crime, education, health care, social entrepreneurship, the criminal justice system, and homelessness, among other topics. She is the author of *Voices from Bears Ears Country: Seeking Common Ground in a Sacred Land* (Arizona, in association with George F. Thompson, 2018), with photographs by Stephen E. Strom.

JOY HARJO was born in Tulsa, Oklahoma, and is a member of the Mvskoke Nation. She received her B.A. in art at the University of New Mexico and her M.F.A. in creative writing at the University of Iowa. Her thirteen books, including seven volumes of poetry such as *How We Became Human: New and Selected Poems, 1975–2001* (Norton, 2002), *The Woman Who Fell from the Sky: Poems* (Norton, 1994), and *She Had Some Horses* (Norton, 1983; 2008), have garnered many awards. These include the Griffen Poetry Prize in 2016, the Wallace Stevens and William Carlos Williams Awards from the Poetry Society of America in 2015 and 2001, American Book Awards in 2013 and 1991, and the PEN Literary Award in Creative Nonfiction in 2013.

About the Book

Bears Ears: Views from a Sacred Land was brought to publication in an edition of 1,300 hardcover copies. The text was set in Avenir, the paper is Lumisilk, 157 gsm weight, and the book was professionally printed and bound by P. Chan & Edward, Inc., in China. This book is a companion volume to *Voices from Bears Ears Country: Seeking Common Ground on Sacred Land* (Tucson: University of Arizona Press, in association with George F. Thompson Publishing, 2018).

Publisher: George F. Thompson
Editorial and Research Assistant: Mikki Soroczak
Manuscript Editor: Purna Makaram
Book Design and Production: David Skolkin

Published 2018. First hardcover edition.
Printed in China on acid-free paper.

George F. Thompson Publishing, L.L.C.
217 Oak Ridge Circle
Staunton, VA 24401-3511, U.S.A.
www.gftbooks.com

26 25 24 23 22 21 20 19 18 1 2 3 4 5

The Library of Congress Preassigned Control Number is 2017916434.
ISBN: 978–1–938086–56–4